추신경의료원
QUIROPRACTICA

여행사
EL SERVICE (213)483-2500 #204

737-894

945-955
Western San marino Plaza
LEASE INFORMATION
(323) 733-7979

TRI-TECH
WE MAKE THINGS BETTER

APEX
310-746-7810

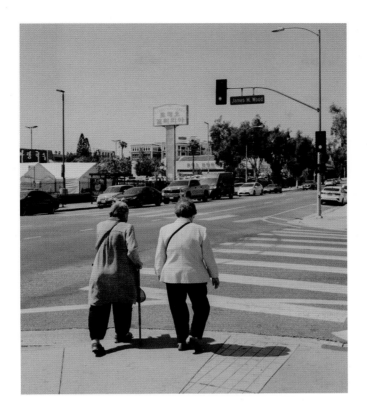

Koreatown Dreaming

STORIES & PORTRAITS OF KOREAN IMMIGRANT LIFE

Emanuel Hahn

Running Press

PHILADELPHIA

Running Press
Hachette Book Group
1290 Avenue of the Americas, New York, NY 10104
www.runningpress.com
@Running_Press

Printed in China

First Edition: October 2023

Published by Running Press, an imprint of Perseus Books, LLC, a subsidiary of Hachette Book
Group, Inc. The Running Press name and logo are trademarks of the Hachette Book Group.

The Hachette Speakers Bureau provides a wide range of
authors for speaking events. To find out more, go to
www.hachettespeakersbureau.com or email HachetteSpeakers@hbgusa.com

Running Press books may be purchased in bulk for business, educational, or promotional use.
For more information, please contact your local bookseller or the Hachette Book Group
Special Markets Department at Special.Markets@hbgusa.com.

The publisher is not responsible for websites
(or their content) that are not owned by the publisher.

Print book cover and interior design by Amanda Richmond.

Library of Congress Cataloging-in-Publication Data has been applied for.
Library of Congress Control Number: 2022050391

ISBNs: 978-0-7624-8458-4 (hardcover),
978-0-7624-8459-1 (ebook)

APS

10 9 8 7 6 5 4 3 2 1

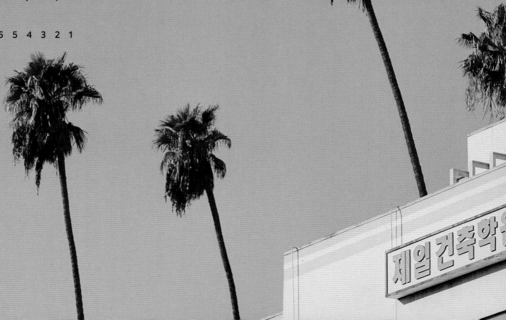

CONTENTS

Retail 소매

Services
서비스

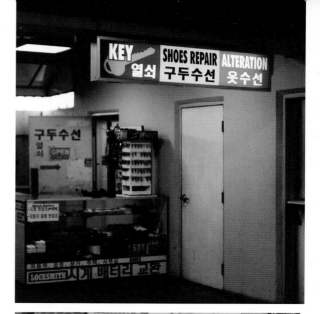

Restaurants
음식점

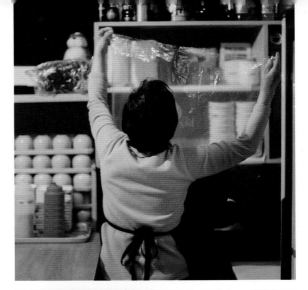

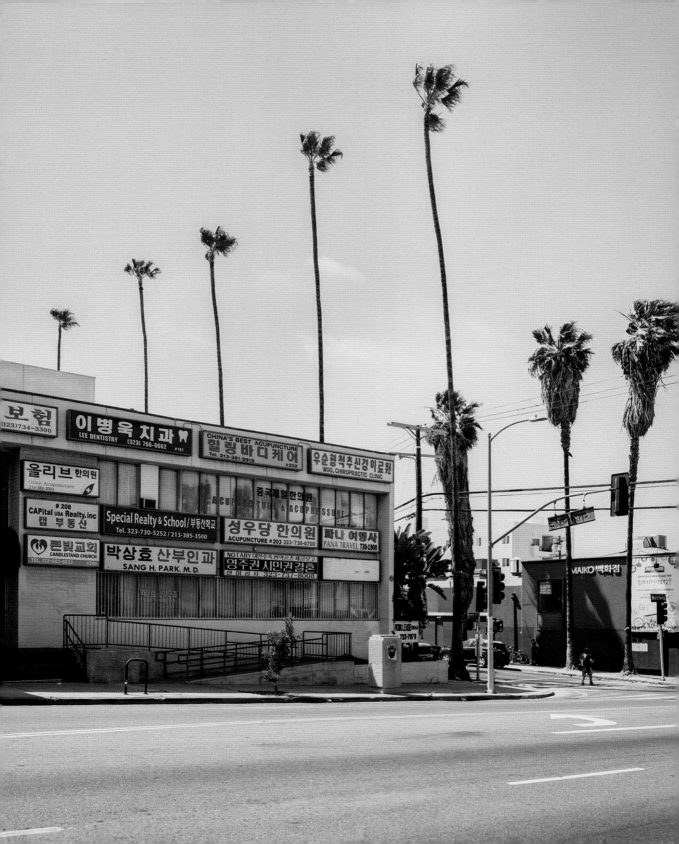

Introduction

IN OCTOBER 2020, I BOUGHT A USED PRIUS AND DROVE WITH ALL MY belongings west, toward Los Angeles. I'd lived in New York for more than ten years, spanning careers in finance, technology, and photography, all of which culminated in a desire to make films. I figured Hollywood was my best bet for meeting people in the industry. When I arrived in Los Angeles, the 2020 election season was in full swing, and the city was still largely shut down because of a resurgence of COVID-19 infections. I was unable to explore Los Angeles or meet anyone new. I fell into a deep creative rut.

After many weeks of going on long walks to alleviate my poor spirits, I made a commitment to start a new project about Koreatown. I told myself I would drive myself to Koreatown every day for a month and photograph something, perhaps exteriors, or people on the street, anything really. Koreatown fascinated me because whenever I'd visited over the years, the area seemed stuck in time, a snapshot of South Korea in the '80s or '90s overlaid on the topography of Central Los Angeles and peppered with palm trees everywhere. I was attracted to the numerous building signs and murals that employed old Korean fonts and images that harked to a different time.

Koreatown Dreaming began as a simple documentation project—to show how Koreatown was surviving in an unprecedented time. The typically bustling and chaotic neighborhood had been brought to barely a hum, often not a single soul on the street, an occasional vehicle passing by at random intervals. As I photographed various intersections and points of interest, I found myself going inside buildings, curious to see whether businesses were still operating. One of the first malls I ended up in was Rodeo Galleria, a flat, rectangular, single-story mall that is quite the antithesis of what its name inspires. The interior was lit with muted fluorescent bulbs, and the simple, brutalist structure evoked memories of when I visited South Korea as a child. After meandering through various stores, I arrived at Home Plus Mart Co., where I witnessed an elderly lady in a pink sweater tidying up wares that had clearly been untouched for days. A nervous fixation borne out of slow business, perhaps.

Under the guise of purchasing some fruit forks and back scratchers, I asked her a few questions about the products. And then I asked her how business was going. As she sat behind the counter with her arms folded, she sighed heavily and began pouring out

her frustrations. Business was so slow that it cost her more to operate the store than not, and yet she couldn't just sit at home and do nothing. She was thinking of retiring. From there, she began telling me about her life in the United States; how she had immigrated in the '70s and moved to Chicago, then to Los Angeles for warmer days, and wound up starting her home goods store.

As I listened, I felt that the moment was significant; I was getting insight into a deeply personal story. I asked for a photograph, to which she retorted, "What are you photographing a granny for? Who wants to see that?" She acquiesced to one shot on my clunky medium-format camera. She removed her mask; I composed and pressed the shutter. She put her mask back on and excused herself to continue working. When I received the scans from my film lab, the expression looking back at me was one of pride, fatigue, and, most strikingly, warmth.

I felt a connection to this woman. When I shared her story and others on Instagram, the response was overwhelming. Many people who had lived in Koreatown, or had ties to the area, were moved by the interviews and photographs. More than that, they seemed excited to see these business owners' lives documented and shared with a wider audience. I was gratified to see the stories resonating and continued documenting more businesses, focusing on retail

stores and service providers that often get neglected in mainstream media coverage.

My approach was straightforward: I showed up at businesses I had either researched or felt intrigued by in passing, and I explained to the owners what my project was about. Some were open, while many others were suspicious and reticent. I encountered close to thirty or more rejections, with some owners telling me to get lost.

I learned about the various circumstances that brought Korean immigrants to Los Angeles, whether it was to escape political turmoil, or live in a country where rock 'n' roll was born, or, for the vast majority, to take a chance at the American Dream, in which one might shape one's own destiny.

Over the course of eight months, I photographed forty small businesses and decided to run a Kickstarter campaign to self-publish a small run of books. While it was gratifying to see positive responses on social media, I wanted the stories to have a more permanent home. I had no publishing experience whatsoever but leaned on my community to bring this project to fruition.

The first iteration of this book was a true labor of love. Together with my friend and design extraordinaire Jiyoon Cha, we created a look for the book that would resonate with Koreatown and its residents. I reached out to other creatives, who shared their experiences of Koreatown in essays that made the book more complete. When

the books finally arrived from the overseas printer in March 2021, they sold out in two months. I received messages from countless people who were touched by the stories of shop owners they had seen so often but had never gotten to know. When I shared the books with the store owners, they were thrilled to see themselves represented. They seemed proud that their legacy would carry on in some small way and that their grandchildren might one day read about them.

The way people in my community showed up for the book—from sharing the Kickstarter, to purchasing the book, to attending readings and events—was special, and something I'll always treasure. Even before I decided to expand the project into its current iteration, *Koreatown Dreaming* already had a life of its own. The edition you're reading includes more businesses in L.A. along with eight features on Korean businesses in other cities, exploring how Korean immigrants have made livelihoods and communities across the country.

As a Korean third-culture kid who grew up in many different countries, I've constantly wondered about where I belong. I felt that I stood on the peripheries of the cultures I was situated in, peering in and hoping to be a part of them. When I arrived in the United States to attend college and pursue a career, I felt that same sense of otherness, living my life not knowing whether this country would truly accept me. I had to learn how to "be American"—how to speak colloquially, adopt mannerisms, and learn pop culture references, like putting on clothes to fit in. But the more natural and intuitive parts of me were and are Korean, and whenever I'm in a Korean enclave, whether it's in L.A. or New York or Atlanta, I relax a little, putting aside my "American" outfit to simply appear as I am. I was usually the one with a camera, but in a way, every time I talked to a Korean business owner about their life, they were the ones seeing me.

Throughout the project, I was reminded of my own parents' wild ambitions to make something of themselves, moving our family to Saipan in their early thirties to have a chance at a self-made life. Throughout my whole childhood I witnessed the winding journey they took and saw reflections of that devotion to striving in each of the shop owners I met. Working on this project put me in touch with the world in a way I never could have imagined, making me think about my life and about what it means to be Korean in America. I think part of the reason this project took off in the way that it did was because others were asking the same question, and collectively we have been searching for the answer. I don't know what the future holds for Koreans in America, but in our communal seeking—for identity, for each other, for a place to call home—I feel I have found my people. I feel like I belong here.

A Brief History of Koreans in America

FIRST WAVE (1903–1949)

THE FIRST WAVE OF KOREAN IMMIGRANTS TO THE UNITED STATES ARRIVED IN Hawaii starting in 1903 to work on sugar cane and pineapple plantations, their contracts brokered and facilitated by American missionaries who believed that labor was an opportunity for these immigrants to improve their lives. These Korean laborers worked ten-hour days, six days a week under the sun for fifteen dollars a month plus lodging. Between 1903 and 1905, an estimated seven thousand Koreans immigrated to Hawaii, most to work on plantations, but there were also some students, diplomats, and merchants. Upon completing their work contracts, many Koreans migrated to the mainland, especially to the West Coast, to pick fruit on orange and lemon groves.

The first Koreatown in the United States was founded in Riverside, California, and was made up of approximately three hundred Koreans in a thriving, family-based community called Pachappa Camp. The constituents worked on the orange groves nearby. The settlement was short-lived, lasting only fifteen years, as a deep freeze hit the orange farms, forcing Korean laborers to fan out elsewhere in search of opportunity.

SECOND WAVE (1950–1964)

The second wave of immigration occurred as a result of the War Brides Act, enacted in 1945, that allowed alien spouses into the country, as well as the natural and adopted children of American soldiers who had fought in the Korean War. Between 1950 and 1964, an estimated six thousand Korean women were brought over to the United States via their American GI husbands. These Korean women, many of whom immigrated to escape poverty in a war-torn country, often experienced discrimination at the hands of a society that associated them with the enemy. Many war brides sponsored visas for their family members, which was one way more Korean immigrants entered the country. Often the only Korean or minority in their area, these women faced culture shock and isolation, and meanwhile had to navigate the pressures of being the perfect American wife. "Bride schools" existed to teach them how to assimilate to American culture, with lessons on etiquette, cooking, and customs. Many of these marriages ended in divorce.

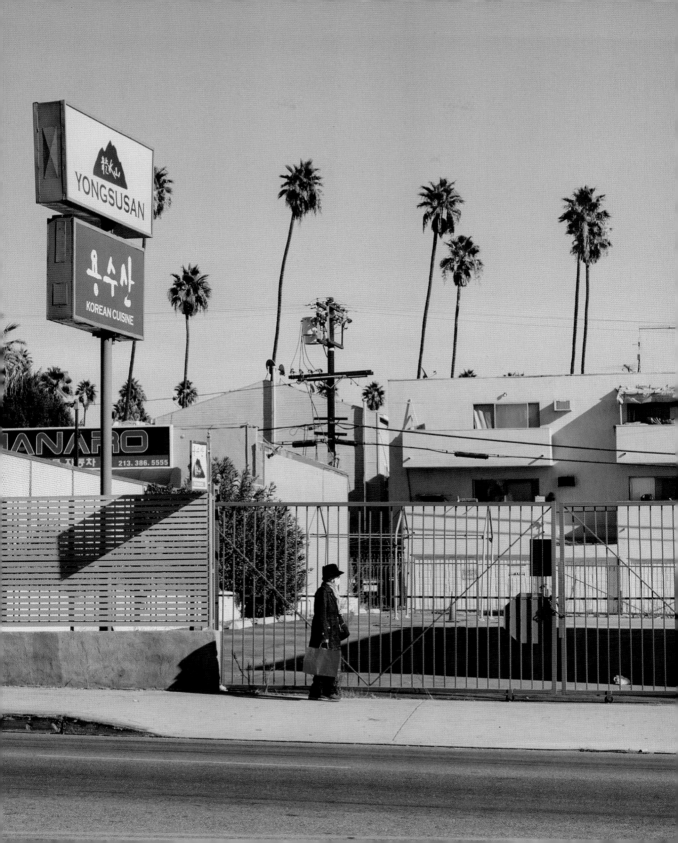

THIRD WAVE (1965–PRESENT)

The third wave of immigration, which extends to today, was spurred on by the Immigration and Nationality Act of 1965. Signed into law by Lyndon B. Johnson, this act abolished immigration quotas based on ethnic and national origins, which up to then had prevented immigration from many Asian and non-western countries. Since then, the annual number of Korean immigrants steadily increased every year, peaking between 1985 and 1987, when about thirty-five thousand people emigrated annually. From 1976 to 1990, the Korean diaspora community was the largest group of immigrants to move to the United States, alongside the Mexican and Filipino communities. The reasons motivating immigration include escaping an oppressive political regime, better financial opportunities, higher education, and, for some women, to escape the steep and unbridled misogyny that existed in South Korea. According to a 2019 American Community Survey, there are an estimated 1.9 million members of the Korean diaspora, including naturalized citizens, American-born Koreans, undocumented Koreans, and mixed-race Koreans, making it the twentieth largest diaspora group in the United States.

KOREATOWN LOS ANGELES

Third-wave Korean immigrants moved to denser cities in states like California, New York, New Jersey, and Virginia, given the already existing Korean communities there and better opportunities to start businesses. Many Koreans arrived in Los Angeles in the '70s and '80s and found low-cost housing in the Mid-Wilshire area. The Watts riots in 1965 led to white flight from a once-affluent area dotted with art deco buildings and inhabited by wealthy Hollywood types. Their exit allowed many non-white low-income residents to move in. Through the enterprising efforts of people like Hi Duk Lee, who envisioned Koreatown as a hub for the Korean diaspora to gather, many businesses sprung up. Lee opened Olympic Market in 1971 and purchased five blocks in the area, creating the first Korean village, which attracted forty shops and restaurants. In 1975, he started VIP Palace restaurant in a traditional Korean architecture, importing blue tiles from his home country; the market and restaurant became a meeting spot for Koreans in Los Angeles. Through extensive lobbying from the Korean community, mayor Tom Bradley was persuaded to put up Koreatown signs for the first time in 1982. Koreatown was officially designated between 8th and 11th Streets from north to south, and Western

and Vermont Avenues from east to west, bisecting Olympic Boulevard. Koreatown has grown gradually in a sprawling fashion since then.

KOREAN ENTREPRENEURSHIP

The Immigration and Nationality Act gave preference to immigrants with highly skilled occupations and to those with money to invest in the American economy. Despite the fact that many third-wave immigrants were highly skilled professionals back home, upwards of 70 percent could not practice their profession in the United States because of a lack of proficiency in the English language and conflicting licensing systems. Most Korean immigrants hence chose to start small businesses, seeing it as preferable to working for someone else. Korean communities operated rotating pooled money investment schemes, known as *kye*, to allow participating family members to accumulate enough capital to buy or start a small business. Each participating member would contribute a sum of money to a pool at various intervals, taking turns to use the pot of capital to pursue their entrepreneurial endeavors. Through personal funds and investment schemes like kye, many Korean business owners took over low-capital-

intensive grocery stores, laundromats, and liquor stores, especially in low-income neighborhoods in places like Los Angeles, Chicago, Philadelphia, and New York.

MODEL MINORITY

Third-wave Koreans, lumped with other East and South Asian immigrants, have been categorized as "model minorities" by mainstream media, implying that they are diligent, quiet, and grateful for opportunities in the United States. This was a shift from the portrayal of Koreans as devious, uneducated gooks in the aftermath of the Korean War. Suddenly, Koreans were lauded as hard-working and were pitted against other minority groups, especially Black and Hispanic people, who are among the urban clientele that Korean businesses often serve. Left unspoken was the fact that Koreans experience high rates of poverty and poor mental health, and many are undocumented.

L.A. 1992 RIOTS

On March 16, 1991, a fifteen-year-old girl named Latasha Harlins entered Empire Liquor in South Central Los Angeles. The owner, Soon Ja Du, working behind the counter, noticed Harlins putting a $1.79 bottle of orange juice in her backpack, and without seeing Harlins clutching money

in her hand, assumed the Black girl was shoplifting. When Du questioned Harlins about whether she was going to pay, a scuffle broke out. Security footage shows Du grabbing Harlins by her sweater and snatching her backpack, prompting Harlins to strike Du twice with her fist, knocking the shop owner backwards. As Harlins turns around to leave the store, Du reaches under the counter, retrieves a revolver, and fires at Harlins, killing her instantly.

On November 15, 1991, at Soon Ja Du's trial, the jury found her guilty of manslaughter, which faces a maximum prison sentence of sixteen years. However, the judge sentenced Du to five years of probation, ten years of suspended prison, four hundred hours of community service, and a $500 fine, in effect absolving her of any real penalty. This miscarriage of justice, paired with the fact that tensions between the Black and Korean communities had been building for years, led to tense debates, boycotts, and deaths.

The killing of Harlins came thirteen days after the videotaped beating of Rodney King. On March 3, 1991, King and two accomplices were pulled over by the police after a high-speed chase. Police officers tasered King, hitting him multiple times with batons and kick-stomping and beating him before tackling and hog-tying him by his legs. The brutal acts of police violence were recorded by a local civilian, and the clip was soon on every news channel around the world. When the trials effectively acquitted the police officers on April 29, 1991, a series of uprisings began around Los Angeles, eventually culminating in Koreatown and leading to widespread looting, violence, and destruction of property.

When looters came for Koreatown, the police offered no support. Store owners dialed 911 every five minutes and received no response. Korean-American men, many of whom had served in the Korean military before immigrating, armed themselves and formed barricades around their stores. Some even took to rooftops with guns to dissuade looters from entering. Beyond the physical damage, Korean immigrants suffered the heartbreak of watching their small piece of the American Dream crumble. In footage captured by the news, an elderly woman holds out her frail arms in a futile attempt to prevent looters from entering her store, while desperately yelling, "This is America!" Other footage shows despondent shop owners falling over in tears over the dissipation of their life savings. All told, more than 2,300 Korean mom-and-pop shops were damaged, sustaining close to $400 million in damages, roughly half of the total damage done throughout Los Angeles during the uprisings.

HOW KOREATOWN RECOVERED

Following the L.A. uprisings, many organizations and nonprofits led efforts to rebuild closed businesses in Koreatown and South Los Angeles. Because of the loss of property and capital, as well as the intense psychological trauma, as many as 40 percent of Korean Americans said they were thinking of leaving Los Angeles (although only 7 percent indicated they would return to South Korea), according to a *Los Angeles Times* survey. The same survey found that 50 percent of Korean American merchants were in dire financial hardship. Federal assistance funds to Korean businesses were fraught with logistical challenges and delays. Half of the business owners lacked insurance and needed help with basic necessities like rent, utility bills, and medical treatments. Because of enduring Black-Korean tensions, which resulted in robberies and homicides, many Korean merchants left South Los Angeles and relocated elsewhere.

Eventually over the years, Koreatown has recovered as shop owners found the will and support to reopen. Additionally, investment poured in from South Korea to aid with larger real estate developments. More crucially, the uprisings provided opportunities for Korean Americans to be more culturally sensitive and politically aware and to fight for their voice to be heard.

POLITICAL IDENTITY AND ENGAGEMENT

Koreans began to identify themselves as Korean Americans after the riots, according to the scholar Edward Chang. Within a matter of days, more than thirty thousand Korean Americans in Los Angeles came together for a peace march that is said to be the largest gathering of Asian Americans in all of Asian American history. The march highlighted Korean Americans' desire for solidarity with Black and Latino Americans and to acknowledge their common marginalization in the United States. While Korean immigrants had been narrowly focused on their own survival before, the shared suffering of the community and lack of support from the state made Korean Americans realize how important it was to become politically active.

KOREATOWN TODAY

Koreatown today is a relatively peaceful and thriving neighborhood filled with restaurants, shopping malls, condominiums, and residences. The neighborhood is diverse. Over the years, with the boom of Korean pop culture, Koreatown has become an attractive destination for young

people from all over the world to visit and live in. Housing costs have gone up as more people move in, making it difficult for low-income residents and senior citizens to find affordable housing. Today, there is nonstop construction of new condominiums and mixed-use buildings, led by Korean American real estate developers as they capitalize on Koreatown's central location and the opportunity to redevelop derelict buildings and land. This development has led to the further marginalization of long-standing low-income residents who can no longer afford rent. Koreatown also has a significant unhoused population, some of whom live in tents near the homes they have been evicted from.

JOBBER (JABBA)

One of the lesser-known immigrant stories is that of the jabba market centered in the garment district in downtown Los Angeles. Many Korean immigrants made their living, and fortunes, in the clothing industry, with many of the proceeds going directly toward Koreatown, whether through patronage or investment. In 2015, according to the Korean American Apparel Manufacturers Association, Korean businesses comprised between one-third and one-half of the businesses in the garment district, generating at least $10 billion in annual revenues and providing twenty thousand jobs. There was a common refrain that went, "It's the jobber market that feeds Koreatown"; entrepreneurs in the garment industry invested heavily in businesses and real estate in Koreatown, ensuring that the areas' assets would remain in Korean hands. Perhaps one of the best-known business success stories is that of Forever 21, which started off as a wholesale supplier that then went on to create trendy designs that dominated the world. In recent years, the jobber market has waned as wholesale manufacturing and trading have moved abroad to other countries like China and Vietnam.

UNDOCUMENTED KOREANS

While many Koreans, along with other Asian Americans, are perceived today as enjoying a secure status in the socioeconomic strata, Koreans constitute a significant percentage of the undocumented population. According to the 2019 Migration Policy Institute Study, an estimated 173,000 undocumented Koreans live in the United States, about a third of them in Southern California. Korea is one of the top ten countries from which undocumented immigrants arrive. Many unauthorized Koreans overstay their visa, while others are victims of immigration fraud. Young children who were brought to

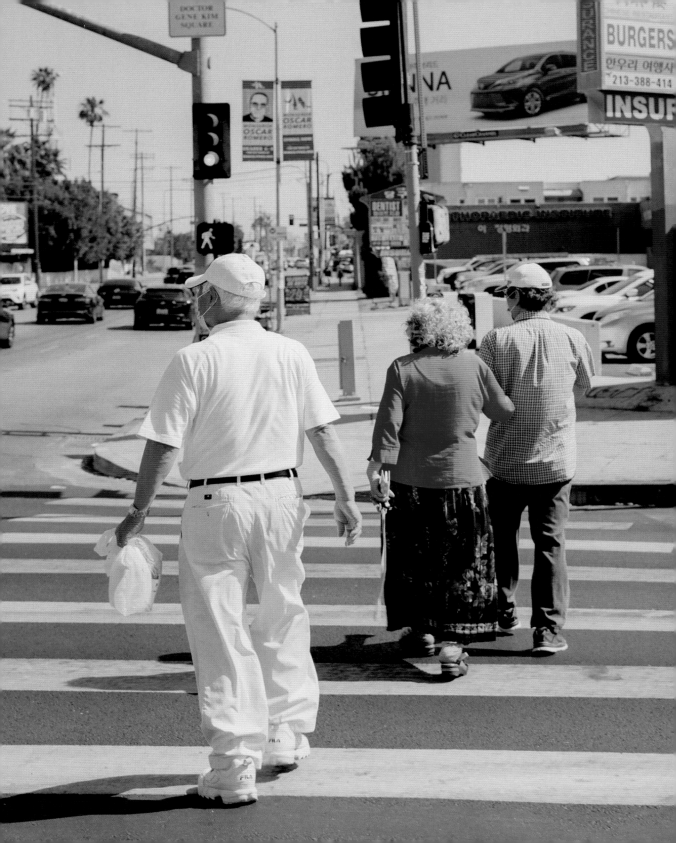

the United States became DACA (Deferred Action for Childhood Arrivals) recipients and continue to live in the liminal space of not having full citizenship rights. Employers often exploit undocumented Koreans who work in the shadow economy and have no recourse when they are mistreated.

One of the best-known unauthorized Koreans is Tereza Lee. Born in Brazil, Lee and her family moved to Chicago as undocumented immigrants. Growing up, Lee taught herself to play the piano and qualified to enter the Merit School of Music in Chicago, where she excelled. When her adviser found out that Lee was not planning to attend college because of her undocumented status, she reached out to Senator Dick Durbin, who was so inspired by Lee's story that he cosponsored the 2001 DREAM (Development, Relief, and Education for Alien Minors) Act with Utah Senator Orrin Hatch. The US Senate was scheduled to vote on what would have been a landmark development in immigration policy on September 12, 2001, with Lee ready to testify. However, the terrorist attacks on September 11 changed everything, and the DREAM Act was not passed. The first DREAM Act set the template for President Barack Obama to pass DACA in 2012, which temporarily shields some "Dreamers" from deportation but does not provide a path to citizenship.

GENTRIFICATION OF KOREATOWN

Once an affordable working-class neighborhood dominated by small businesses, Koreatown is increasingly commercialized.

The response to this movement has been mixed. Some shop owners, remembering the chaotic years of gang violence and robberies, welcome the safety that these new developments will purportedly bring. The influx of wealthier residents and potential customers is also good for business.

On the other hand, rents have risen astronomically as many transplants move into the area for its proximity to Hollywood and the exciting culture and nightlife. Many long-term residents, Korean and Latino, are being pushed to the brink of what they can afford. As affordable housing complexes make way for new developments, many low-income residents and senior citizens are essentially forcibly ousted away from their longtime homes to strange new neighborhoods. Every new news article proclaiming some exciting trait of Koreatown draws in eager residents and tourists, crowding the small neighborhood even more.

Retail

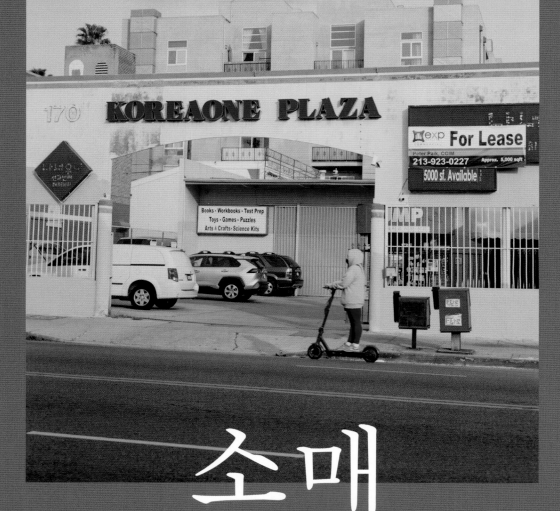

소매

We Do What We Want Here

BY LISA KWON, WRITER AND REPORTER

A fan, of all things. One of my most memorable "big girl" purchases to date is a summer white, oscillating three-speed fan from Kim's Home Center. I bought it after a blistering July night, overcooked and heat-sick in my Koreatown apartment, coming to adult consciousness about the amenities I took for granted when I lived under my parents' roof. Nervous and overwhelmed by the choices at Kim's, I will always remember how the ahjussi sold it to me: it has a timer! You know, so it couldn't kill me in my sleep from blowing air into my face! Long debunked is the Korean fan death myth, but I was moved nonetheless.

Kim's Home Center is a time capsule. It first opened in Koreatown in 1979, then moved into its current two-story building a few years afterward; it has maintained its Streamline Moderne facade accentuated by undulating red, yellow, and green ceramic tiles. Your Asian parents probably went there to furnish their first American homes. Your aunt in Toronto may have asked for things from there, too. Kim's Home Center has been a one-stop shop for modern Korean family units before there even was a QVC or a home shopping channel to huddle around. Light summer blankets (because what even is a "duvet"?), lemon-yellow Italy towels, bamboo ear picks . . .

not to romanticize consumerism, but it feels special to find things here that you still cannot find on algorithmically driven e-commerce sites.

In Koreatown, many merchants, grocers, street vendors, and day laborers have stuck to what they've known since they set up shop. There is a charm to resisting new trends, the way that our mothers rock the same haircuts for years or look for the brand name they know before buying geem (dried seaweed). What a relief that not everything has to pivot, expand, scale, and fit.

Many of the portraits in the following pages are of people who are amused by frivolous change. Their storefronts are the same

from day one: insignia of Christian faith hang on window displays, and giant banners drape over awnings without area codes on the telephone numbers, a giveaway that these stores have been here since before the California Public Utilities Commission issued a split of the 213. The shelves are stacked with a discord of fabrics, earthenware, or cardboard boxes, all reaching up toward dusty neon lights that haven't been switched on for decades. Only the best things are for sale here.

Still, real estate development is a monster. Many of Koreatown's time-burnished small businesses have had to adapt in the face of speculative building and the monopoly of land ownership. In a renter's neighborhood where space is governed by the quiet wealthy, landlords thrive on rent increases because they have nothing else to lose; they can always give up their buildings to commercial giants.

Then the situation worsened in 2020. The COVID-19 pandemic gutted our small businesses that couldn't pay rent without their customers. GoFundMe reported a 150 percent increase in survival campaigns over the year, many of whom were started by Korean business owners who were once reluctant to ask for help. But Los Angeles's Koreatown was just among the tens of thousands of ordinary people seeking aid. Crowdfunding supporters lamented how these sites became a place for small-business owners

and tenants to try and simply survive. The sea change spurred Koreatown to reflect on its preservation in a new way.

In recent years, the storefronts with Korean-only signage started displaying more English and Spanish translations cobbled together, then taped to windows to bring in passersby. The hand-painted sandwich boards welcomed explorers on foot with a word cloud of the shop's offerings. Merchants claimed Yelp and Google pages to specify their business hours, a quiet surrender to how younger shoppers find their floral bouquets, art supplies, or posters. Many haven't had to change drastically, but they were open to change amid unanticipated forces like the ones we faced in 2020.

The adjustment would not have been possible without the support of the shopkeepers' children and grandchildren. Within, you'll see portraits of the new faces of Korean kimchi shops and dduk (rice cake) houses who have made the neighborhood feel more accessible for the next generation of Korean Americans who grew up learning English and developing their tastes on the Internet. The next in line of business owners redefine Koreatown by marrying tradition and contemporary trends. Though the shops that our parents and grandparents frequented are dwindling, there remain a handful run by those who believe that running the last of their kind is a sign of hope.

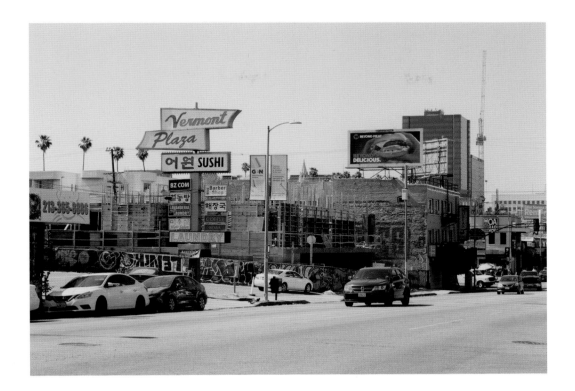

Kim's Home Center was one of the first places I visited after the pandemic loosened its grip on Los Angeles. Among the men and women who look like my parents or my old hagwon (tutoring) friends were the Korean Angelenos who speak crystalline English in the store, sorting through sesame seed grinders and mini fruit forks with their green- and blue-eyed friends and partners. When I went back home, I checked to see whether Kim's Home Center was on Instagram. I chuckled as I tapped through a promotion for LocknLock's stackable storage containers written in Korean and a

tag-to-win giveaway for a new rice cooker. Our Koreatown merchants are resilient yet steadfast in doing things their way, even in the known unknowns of running a business.

Perhaps these portraits feel personal because you see your bodies and your histories in them. They share stories of loss, rebuilding, and upholding. They tell us that when we revisit the places that our parents took us to, we have to make our own decisions inside them now. We walk into Koreatown with a deep appreciation for the things that are for sale. We are relieved that the neighborhood is not.

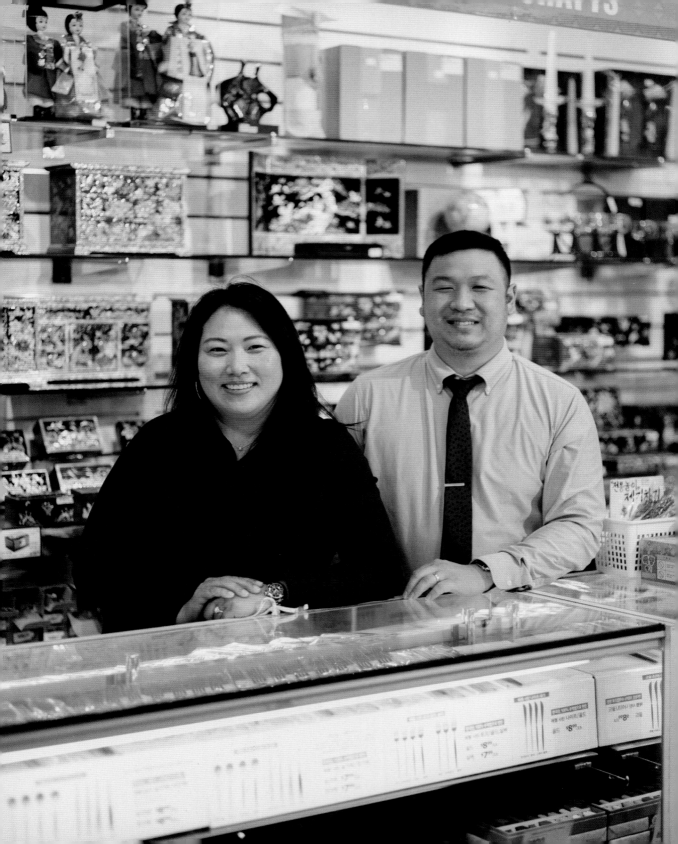

KIM'S HOME CENTER

CYNDI KIM AND SCOTT KIM
2940 W. Olympic Blvd., Los Angeles, CA 90006

KIM'S HOME CENTER IS PERHAPS THE MOST ICONIC ESTABLISHMENT IN Koreatown. Its owners, Dae Soon Kim and Kwee Yul Kim, arrived in the United States in 1973 and attended swap meets to find items to fix and resell. They eventually became experts at repairing vacuum cleaners and opened a small repair store in Torrance. After several years of saving, they opened the first Kim's Home Center at VIP Plaza.

Mr. Kim wanted to open a store where Korean people could find the goods that they wanted from back home, especially rice cookers and other kitchenware. He was incredibly resourceful in obtaining a large variety of items for the store, even back when the Internet didn't exist. He would make phone calls and go on scouting trips to far-flung places like New Zealand to source goods that his customers wanted. He was so savvy that he could acquire high-quality items and sell them at an affordable price.

In the early days, the Kims advertised heavily on TV, and they had a jingle, which went "Even if we don't cut our prices, we are still the best." This combination of offering one-of-a-kind quality goods at a great price made Kim's Home Center an iconic institution, able to withstand competition from huge retailers and online marketplaces. Customers trust Kim's, thanks to its steadfast offerings and service over the years. Moreover, Kim's has continued to support community organizations and nonprofit organizations that serve the elderly for a long time.

As the parents age out, the store will likely be in the hands of Cyndi and Scott Kim, the descendants. Cyndi has been intimately involved in sourcing products for the company, accompanying her dad on multiple buying trips over the years. Scott manages the day-to-day operations of the store and is modernizing the business for a changing customer base. As Koreatown evolves, the presence of Kim's will serve as a comfort for many of its longtime residents.

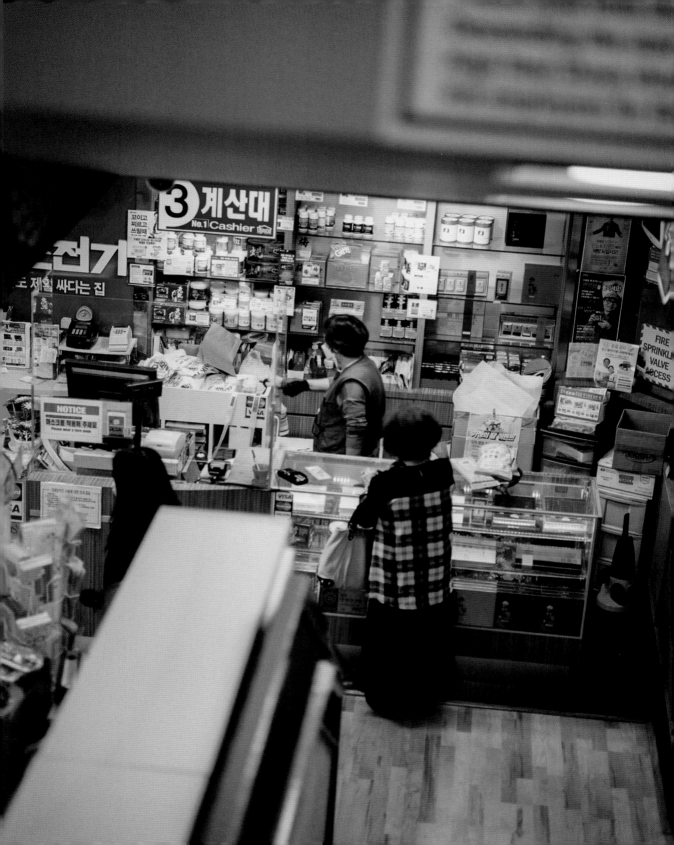

HOME MART PLUS CO.

YEON SOOK JO
조연숙
833 S. Western Ave. #14, Los Angeles, CA 90005

MS. JO IS A SHOPKEEPER AT HOME MART PLUS CO. IN RODEO GALLERIA on Western Avenue. She initially moved to the United States in the '70s and lived in Chicago for many years before moving to Los Angeles in the 2000s. In a mall that caters predominantly to the elderly in Koreatown, this store saw a huge drop in foot traffic due to COVID-19. She told me she was in an uncomfortable position where she couldn't just yet retire even though she was losing money from her overhead costs. Ms. Jo is able to stay in business by offering an extensive range of products at a good price.

Despite intense competition from nearby stores, her kind demeanor and helpfulness, especially toward her older customers, have helped her business keep going. She proudly showed me a picture of her son, who was working an "office job." When I requested to take her photo, she said, "What are you trying to take photos of seventy-year-olds for?" I said she aged very gracefully. Then she told me that in her twenties she had loved taking pictures and wanted to be a model, until she met her husband and moved to the States, and the rest was history.

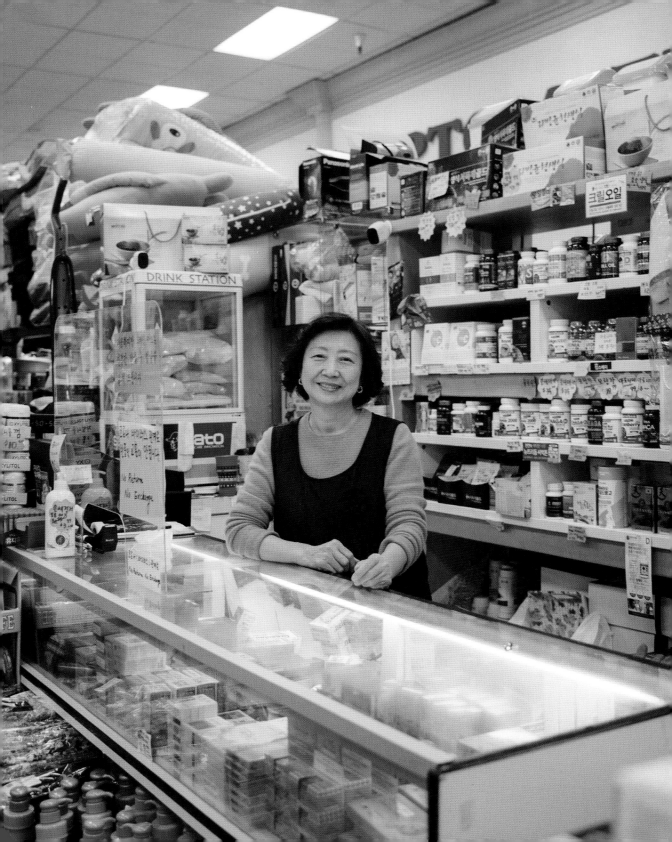

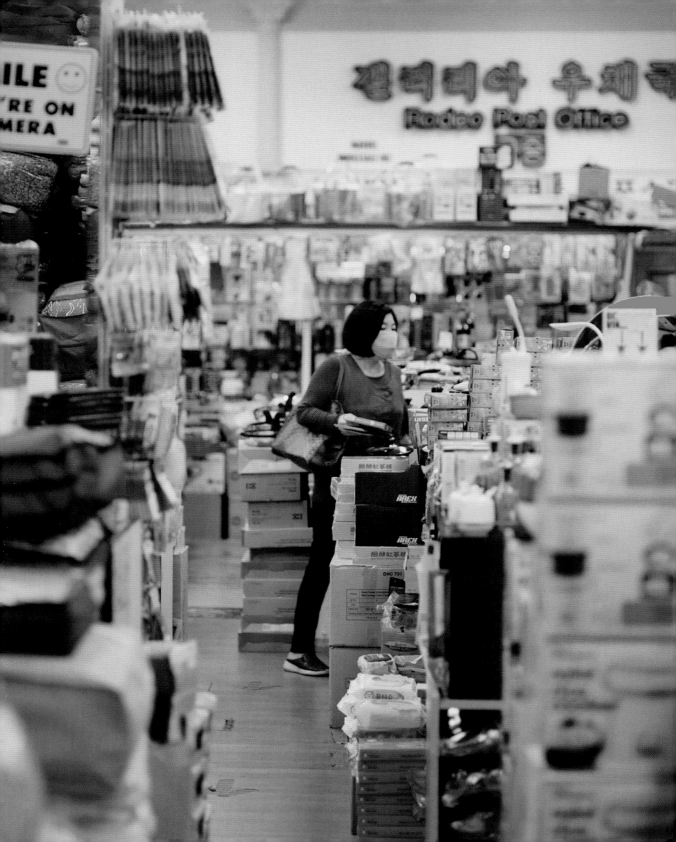

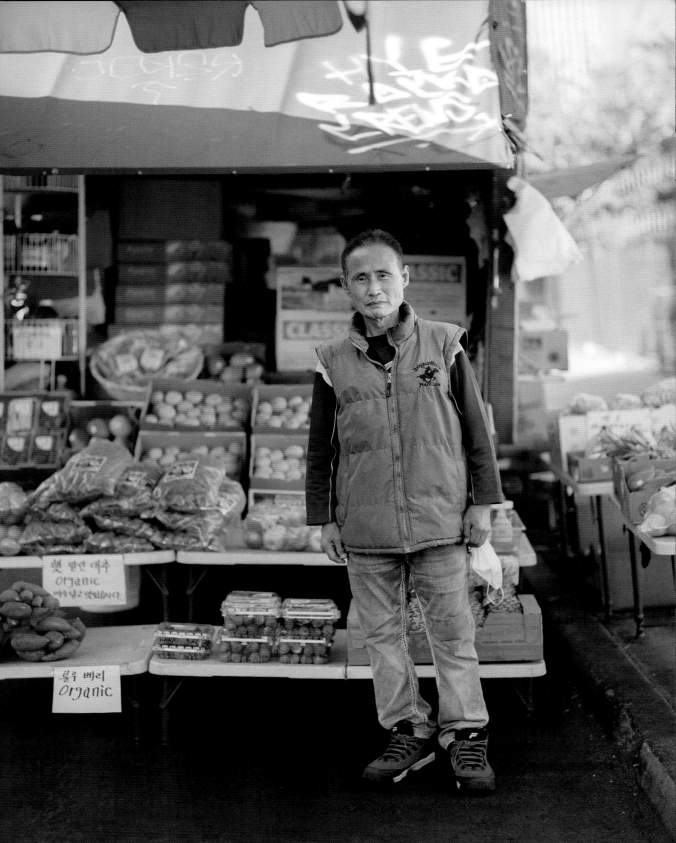

EDEN FOOD

SUNG RAE YANG
양성래
833 S. Western Ave., Los Angeles, CA 90005

BEHIND RODEO GALLERIA ON MANHATTAN PLACE, THERE'S A FRUIT TRUCK. The owner told me that while business has declined significantly, he's grateful that he doesn't have huge overhead expenses. When he first came to the United States, he worked at a fruit market and noticed how much sellers were paying for operating expenses like rent, electricity, delivery, labor, and so on, so he hatched a plan to buy a fruit truck. All he pays for now is his truck, fruit supplies, and an annual permit fee. He told me that Eden Foods and many of the vendors with brick-and-mortar stores were struggling with rent and other business costs.

His advice: 1. keep your operating costs low; 2. deal in cash if you can; 3. give discounts so customers keep coming back; and 4. take care of your health. When I met him, he was practicing for his citizenship interview in his basic English—Who is our president? Joe Biden. Who is our vice president? Kamala Harris. He didn't seem convinced that citizenship had much to offer him at this point, in his mid-seventies, wondering out loud whether he should even do the interview. I had a sense he was nervous about answering the questions incorrectly and was putting his interview off. I also wondered how his life would materially change if he did become a citizen. He seemed pretty content with his life.

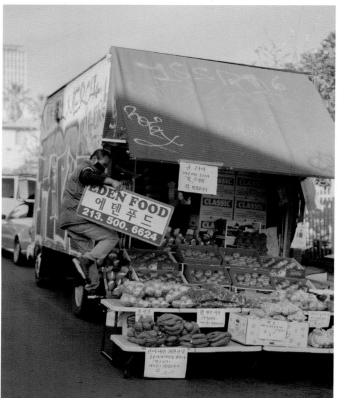

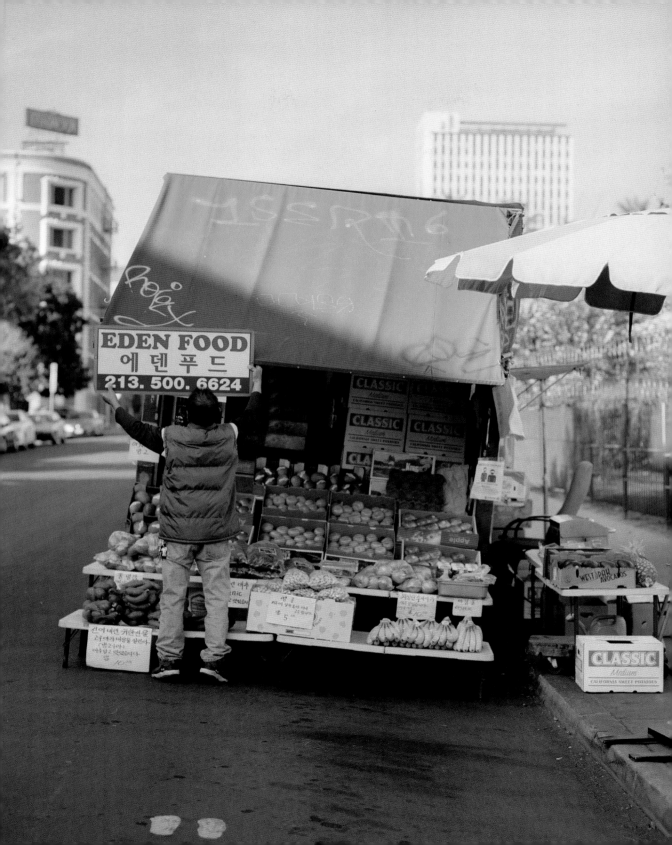

LUCKY RICE CAKE

EUNICE PARK

476 N. Western Ave., Los Angeles, CA 90004

WHEN HER FATHER ABRUPTLY PASSED AWAY IN DECEMBER 2020, EUNICE quit her fashion design job and took over Lucky Rice Cake. For the first few days, she was grieving and couldn't muster up the energy to keep the store running. But gradually the business became a way for her to heal, to be busy, and to honor her father's legacy. Lucky Rice Cake was one of the first rice cake stores to open in Koreatown about thirty years ago. Eunice's father started off as an employee, working for many years before buying the business and running it himself. Their rice cake–making techniques haven't changed much, and they still use some of the same machines from when they opened.

A few years ago, Eunice created a custom rice cake service—@designbyeunice—for events like weddings and birthdays. For her, selling cakes is not just transactional. She gets to have a personal relationship with her clients by being involved in key moments of their lives, such as their babies' one-hundred-day celebrations and their weddings. Over the years, her clients keep returning, and she gets to see how their lives change. Her work brings a lot of purpose into her life and allows her to feel connected to her father by carrying on his legacy.

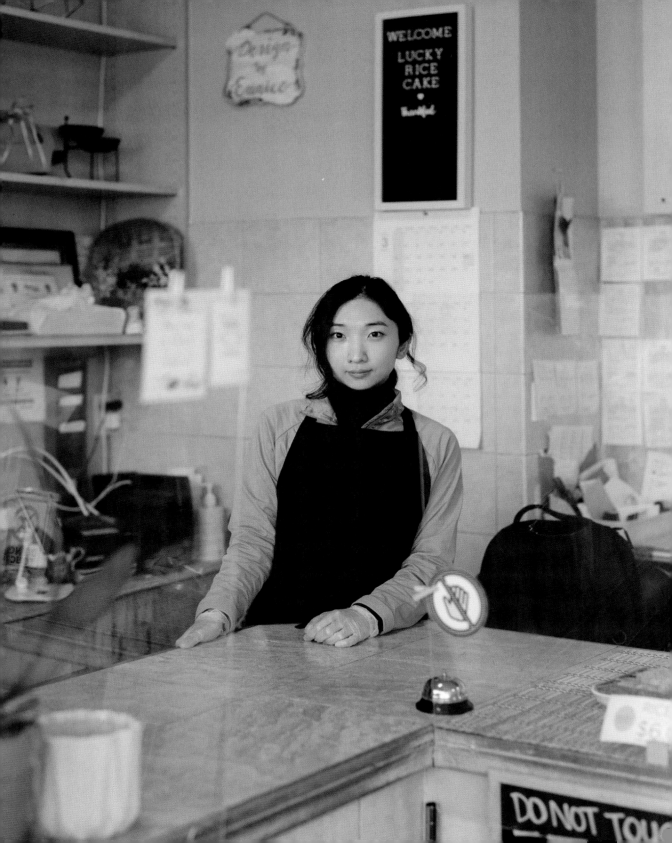

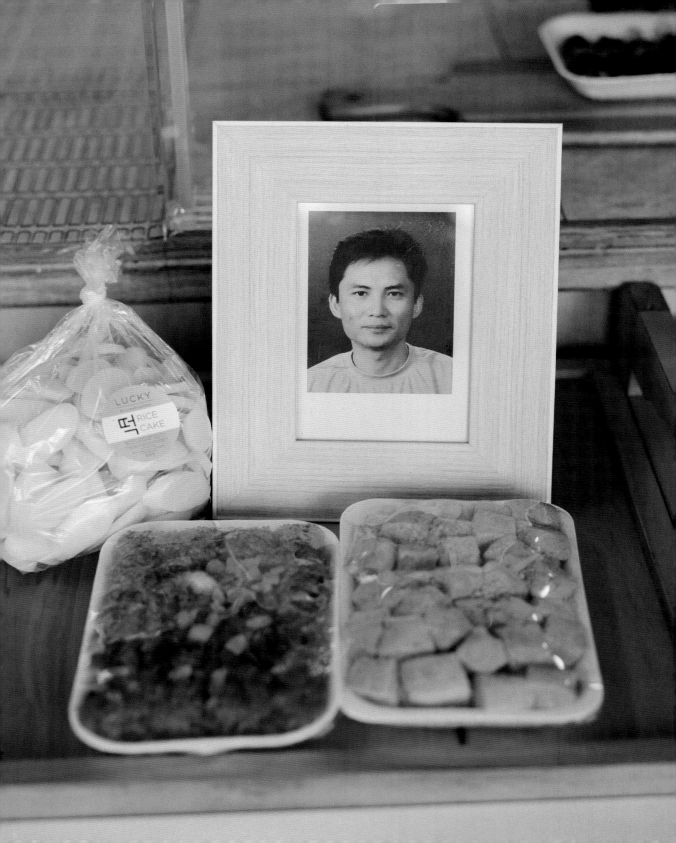

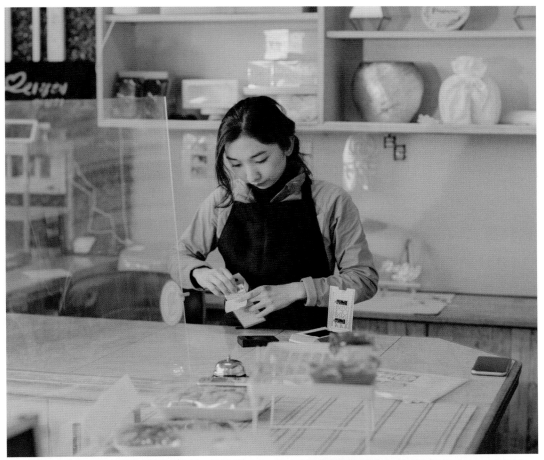

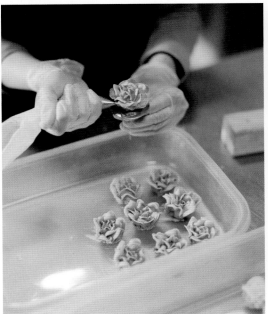

KAE SUNG KIMCHI

GUI YONG YANG, IN WOO YANG, KYUNG SOOK OH, HARRY YANG

1010 St. Andrews Pl., Los Angeles, CA 90019

KAE SUNG KIMCHI WAS FOUNDED IN THE '80S BY SOOK-JAE CHO, WHO fled from North Korea during the war and immigrated to the United States in the '70s. The store is named after her North Korean hometown. After working for more than thirty-five years, Ms. Cho passed the store on to the Yang family, who've been running operations since 2016. The family takes pride in being one of the few, if not only, kimchi makers still left in Koreatown. Ms. Cho still lives next door and drops in from time to time.

While keeping the recipe unchanged, the new operation expanded their reach to restaurants, grocery stores, and customers in other states. So even when the lockdown started in 2020, the Yang family was hard at work, making kimchi to fulfill their orders. Kae Sung Kimchi makes numerous types of kimchi—napa cabbage, radish, spring onions, white napa, mustard leaf, and so on—to fulfill the many tastes of their customers.

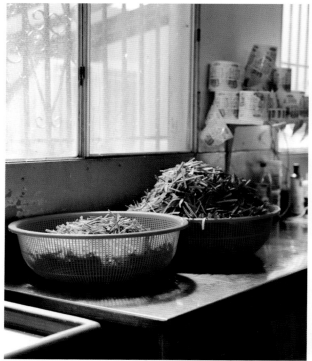

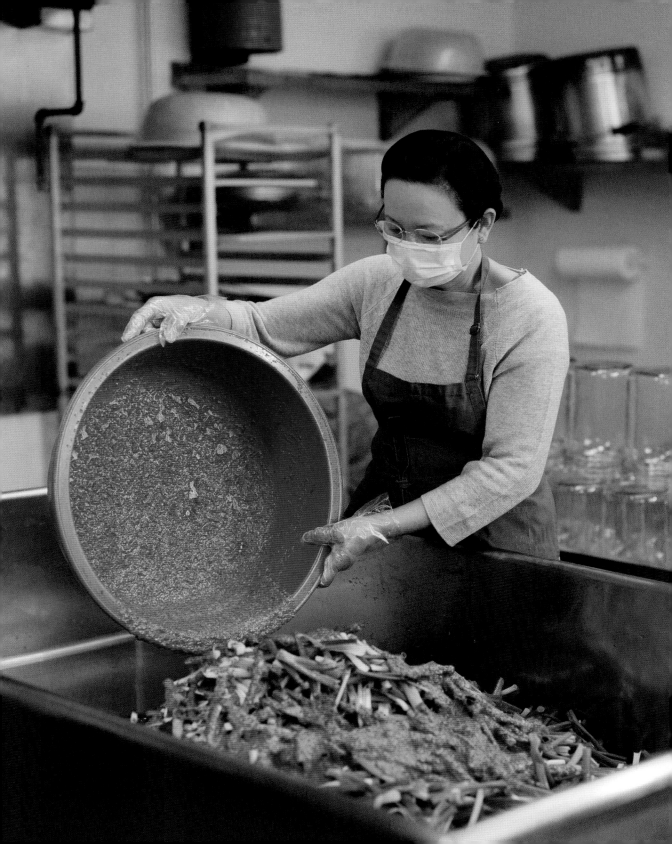

EIGHTH STREET FLORIST

SUN YOUNG KONG
공선영

801 Vermont Ave. #101A, Los Angeles, CA 90005

EIGHTH STREET FLORIST IS AN ICONIC ESTABLISHMENT IN THE HEART OF Koreatown. Its unique architecture—a steep, sloping roof that gradually ends to form a corner shop—even predates the plaza that was built next to it. In my early days photographing Koreatown, I would constantly peer in, attracted by the long ribbons that read "Funeral," "Anniversary," and "Congratulations."

Sun Young is the fourth owner of Eighth Street Florist. She took over the business last year after working with the previous owners for many years. She was part of a group of migrants that arrived in the late '90s, when the IMF (International Monetary Fund) crisis hit South Korea. It was a difficult time for people in their twenties with scarce job opportunities.

Through a friend, she immigrated to the United States to seek a better life, and on arrival, she worked various jobs—waitressing, working in sales, and other part-time jobs. After grinding for many years, she realized that she had to learn a skill if she were to make it in this country. Through the introduction of a friend, she started working in floristry, apprenticing at different stores and learning the trade. When her boss could no longer work, Sun Young took over the business in June 2020, amid the COVID-19 pandemic. It was a difficult time. While customers stopped coming in, she still had to continue buying flowers and make rent. There were more funerals because of COVID-related deaths, but those were a pittance compared to the usual volume of business that came in through weddings and other events. There were many days when she would not have a single customer enter her store.

As the pandemic has waned, many events have returned, and Sun Young finds herself busy once more, preparing floral arrangements for the weddings, funerals, and birthday celebrations that continue as social life goes on.

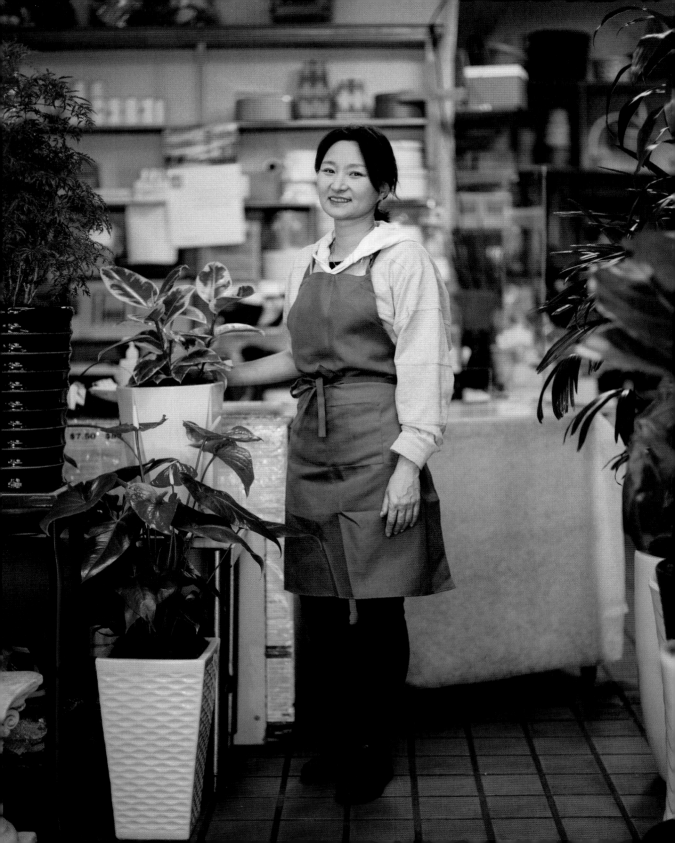

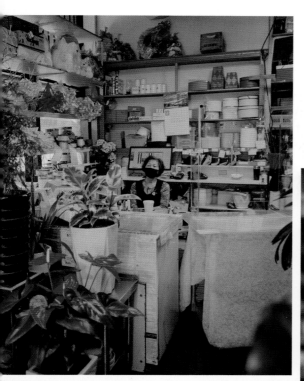

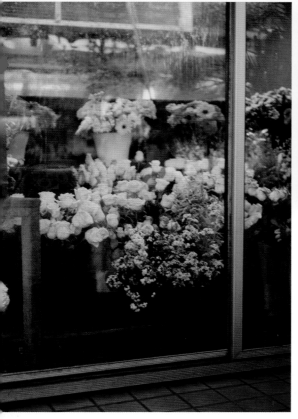

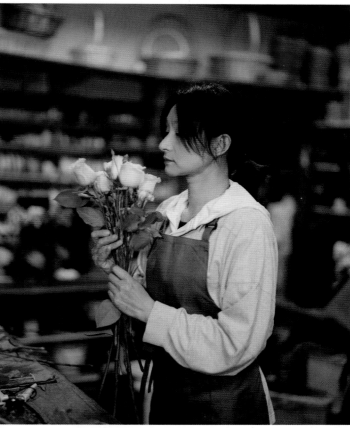

Koreatown During the Pandemic

BY KATHERINE YUNGMEE KIM,
AUTHOR OF *LOS ANGELES'S KOREATOWN* AND *LONGITUDE*

In late February 2020, on a one-night layover from her regular Incheon-to-Los Angeles route, a Korean Air flight attendant, unknowingly infected with the coronavirus, restaurant-hopped to many of K-Town's most beloved spots—Han Bat, Agassi Gopchang, and Hangari Kalguksu among them. This story, with its detailed itineraries and suffused paranoia, launched when COVID-19 had hard hit South Korea but had yet to spread as virulently in L.A. Once the rumor posted on MissyUSA (a popular and wildly active online community of ajummas, or middle-aged, married Korean women), within hours it spread across social media, K-Media, church message boards, and Koreatown workplaces. Handwritten signs were placed on the restaurants' front doors calling out the "fake news," and booths were sanitized, but patrons were irreparably spooked. Tables remained empty.

It didn't matter that within days the South Korea Consulate in Los Angeles dispelled the rumors. It was just a harbinger of the economic catastrophe about to hit small businesses in Koreatown. A few weeks later, the rest of Los Angeles went under the Safer at Home orders and all restaurants and retail food facilities across the city were prohibited from serving food to diners.

Like many immigrant enclaves, Koreatown suffered enormously during the coronavirus pandemic. There were disproportionately high infection and death rates among those living in multifamily residences. Many held jobs in the essential workforce and were not required—or financially able—to quarantine for months on end. Despite PPP (Paycheck Protection Program) loans and other governmental interventions, Koreatown small businesses weren't as quick to apply, or adapt, or pivot. Many shuttered permanently.

Los Angeles's Koreatown formed in the early '70s and centered around Olympic Market on the corner of Olympic and

Harvard Boulevards. This small store was the only place to procure Korean groceries for miles; even Korean Americans from San Diego would travel to buy their changki-reum (sesame oil) and ssal (rice) and other necessary provisions. A few years later, the grocery's proprietor, Hi Duk Lee, opened the VIP Plaza and VIP Palace—a shopping arcade and a buffet restaurant—across the street. These two establishments, with their blue-tiled, Korean-style roofs, served as anchors to other small businesses that started to pop up along Olympic Boulevard.

These businesses were formed by the recent influx of Koreans during the third wave of Korean immigration to the United States, a direct result of the Hart-Celler Immigration Act of 1965. President Lyndon B. Johnson signed this immigration reform bill and famously demurred that it wouldn't "affect the lives of millions of Americans." The bill effectively abolished the quota system of national origins, which included the Asian Exclusion Act, which was established by nativists in 1924. LBJ's landmark bill changed the ethnic landscape of the nation, ushering in millions of immigrants from Asia, Latin America, and Africa.

Around the same time, South Korea passed the Overseas Emigration Law,

encouraging its citizens to move abroad for demographic, economic, and technological reasons. In the late '50s, while South Korea was still recovering from the devastation of the Korean War, there were fewer than five thousand emigrants leaving the country each year, with the vast majority venturing to Japan. By 1977, there were more than thirty-five thousand South Koreans emigrating annually to the United States alone.

Many who came to Los Angeles struggled with language and acclimation and were self-employed or worked for a Korean-owned establishment. Small retail shops and family-run restaurants proliferated, and Hangul signage became a familiar sight for Angelenos. By 1982, the neighborhood was given an official city designation. Blue signs heralding "Koreatown" hang from stoplights on the neighborhood's periphery: Western to Vermont, Olympic to Beverly, and then some. Centrally located within the city, the boundaries bled into other areas as the Korean American presence in the city expanded.

By the next decade, the image of Korean Americans as small business owners was integrated into the city's landscape: the liquor store owner behind the plexiglas, the man or woman gathering shirts and pinning pants at the dry cleaners, the waitress at the mom-and-pop restaurant serving specialized regional fare. People complained about menus not being in English and about the perceived xenophobia of Koreans in L.A.

Why weren't they learning to acculturate? Why were they so rude to their Black customers? Why were they undercutting their Latinx kitchen staff? Why were they profiting in "the inner city" and leaving at night to go back to their homes in the suburbs?

In 1991, a Korean store owner named Soon Ja Du shot and killed a fifteen-year-old Black girl, Latasha Harlins, at Empire Liquor in South Los Angeles. There was a scuffle by the register where Du thought Harlins was shoplifting a bottle of orange juice, and as the young girl was leaving the store, Du shot her in the back of the head. Du was convicted of manslaughter, but her sentence was later reduced to probation. The murder and the commutation of Du's sentence were widely seen as catalyzing the targeting of Koreatown businesses during the 1992 Los Angeles riots. More than half of the 3,100 Korean-owned small businesses were vandalized or destroyed in three days of civil unrest across the metropolis.

Over the next few decades, Koreatown rebuilt with a mix of domestic and multinational investors. Some residents picked up and moved to the suburbs, or back to Korea, or to other parts of the city. But many stayed and reopened their businesses, despite the deep financial losses and psychological trauma.

Nowadays, the "Korean population" in Los Angeles is about 326,000, which includes residents in other cities in the county and beyond. The number is remarkable, given

that eighty years ago, there were only five hundred Koreans in Los Angeles, many of them first- and second-generation from a small number of families that had emigrated from Korea in the early 1900s.

Koreatown is in the midst of gentrifying and diversifying, its prime central location—close to downtown L.A., Hollywood, and the beach—attracting real estate developers, national restaurant chains, pilates studios, boba shops, urban professionals, hipsters, young families, and the like. There's a certain nostalgia for the grit of the old-school small businesses in K-Town, a reverence for the owners and the hours of hard work they clocked—sweeping the floors, counting the change in the registers, locking the doors after a long week, enduring endless indignities—that granted opportunities to so many Korean American children. They walk into their shops and restaurants to an offering of deep filial respect and unspoken gratitude.

The false rumor that set off the shunning of Koreatown businesses unknowingly ushered in a new era for the neighborhood. "Please share with everyone to avoid these ktown spots," a KakaoTalk post implored, and panicked people complied. But COVID was coming anyway. Older businesses were already slowing down and changing hands, and the younger, second generation was signing new leases for places that looked

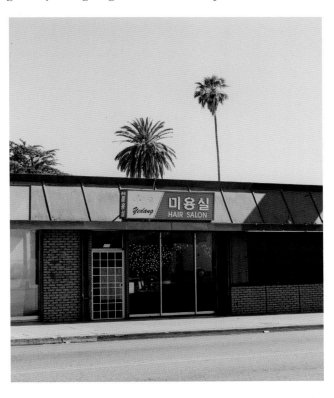

pretty on Instagram. People from "outside" of the community moved in, in droves. Witness the retirement and graceful bowing out of a community and generation who came to this country to dream. But as we see what arises in its place, we'll always know from where it came.

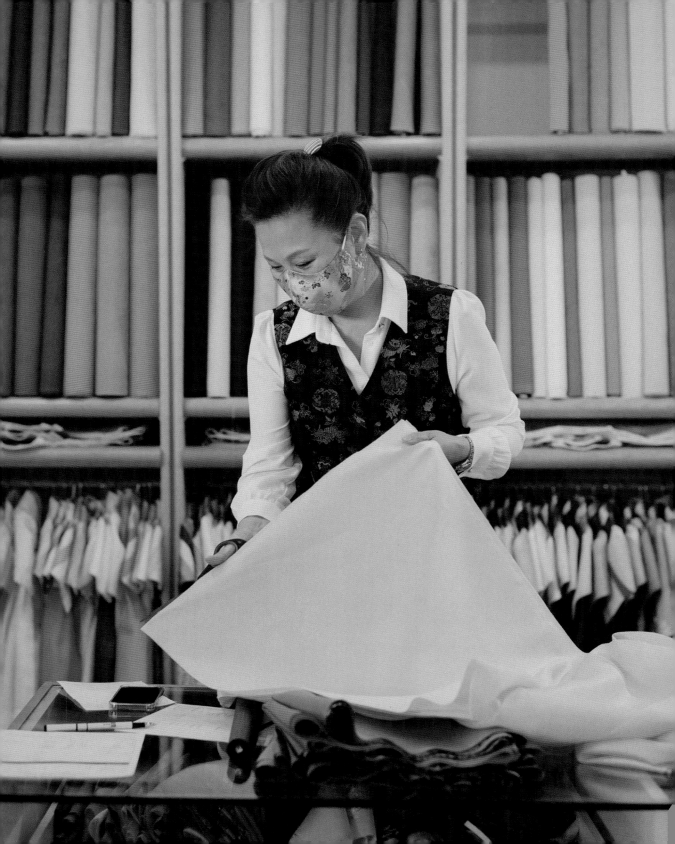

LEEHWA WEDDING AND HANBOK

LAURA PARK (이화) AND ESTELLA PARK
555 S. Western Ave. Suite #210, Los Angeles, CA 90020

LAURA IS A FOURTH-GENERATION HANBOK MAKER WHO BROUGHT HER trade to the United States in 1986. Going against her mother's expectations to be a domestic housewife, Laura arrived with a few bundles of hanbok fabrics, determined to succeed stateside. In the early days, she peddled her fabric to established wedding stores while carrying her infant daughter, Estella, on her back. As some clients took pity on her and took a chance, Laura learned how to sew hanboks on an old sewing machine in her home, and thus her business was born. Over the years, she helped popularize the hanbok within and outside the Korean community, and she established her store at 555 Western Avenue, at a mall that had been rebuilt after burning down in the '92 L.A. riots.

Laura never stopped adapting and learning. She had an epiphany that she had to modernize her hanbok to stay competitive. She enrolled in FIDM (the Fashion Institute of Design & Merchandising), a fashion school in L.A., in her forties so that she could improve her design and sewing skills and also to study what the younger generation found trendy. She would hang out with twenty-year-olds, buying them food and ice cream and even going clubbing with them to check out the fashion scene. At that time, Estella was studying Korean at the University of California in San Diego while Laura had supplemental English classes at FIDM; they would switch their homework to help each other.

Laura has been through the '92 riots and the '94 earthquake, but the COVID-19 pandemic was unprecedented. While the physical shop had to close, Laura and her daughter worked to modernize their product offerings, making masks and chic hanbok dresses that were sold online. Laura created a more configurable hanbok system that could be mixed and matched and worn as an everyday piece. Her customers come from diverse backgrounds through their interest in Korean culture. She once had a group of ten friends who were Korean adoptees who came to her store to reconnect with their Korean roots.

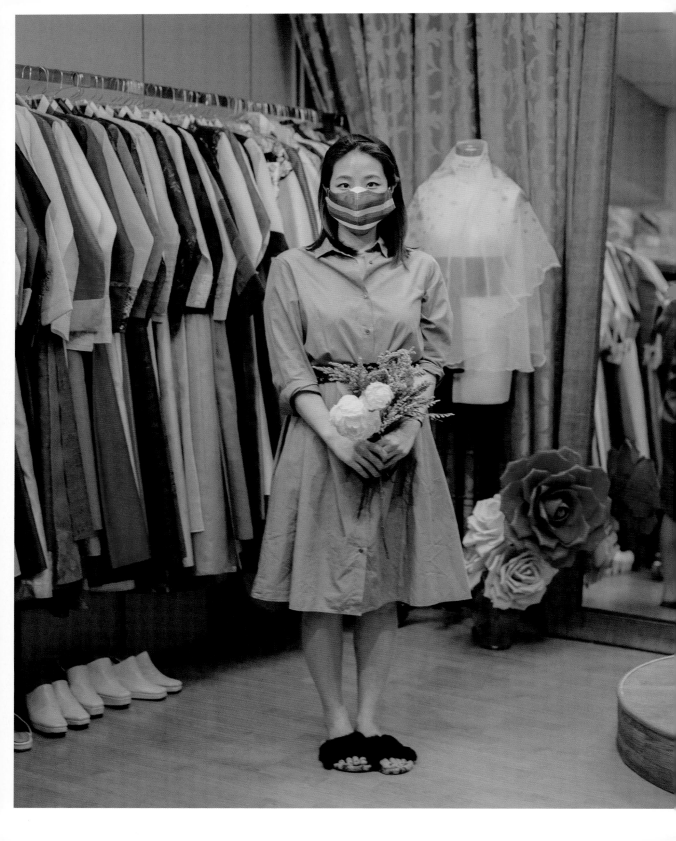

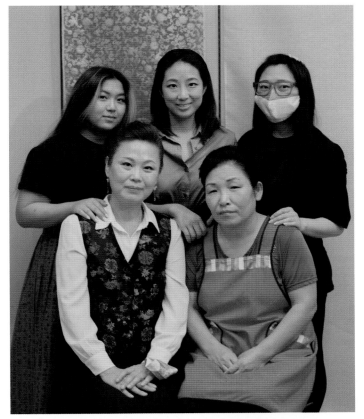

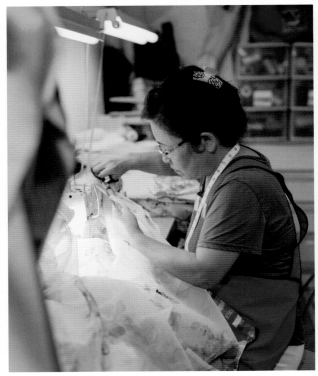

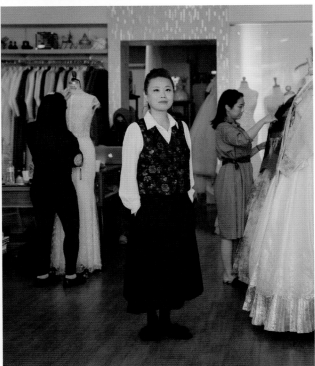

MUSIC PLAZA

SEON HEE CHON
전선희
928 S. Western Ave. #107, Los Angeles, CA 90006

WHEN MS. CHON FIRST ARRIVED IN LOS ANGELES IN 1986, SHE WASN'T impressed. She thought the area was underdeveloped and that America was slow to catch up to the rest of the world. She observed how people worked hard at various jobs just to make ends meet. Ms. Chon and her husband worked at a swap meet, selling American music to their customers. When Koreatown Plaza opened in 1992, Ms. Chon started Music Plaza to bring Korean music to a community that missed home.

In the early days, they would create brochures with top hits in both the American and Korean music charts to introduce their customers to new music. Though Ms. Chon had no background in music, she learned about the music industry through her work. Through the rise of YouTube and the popularity of K-pop in recent years, her store experienced a resurgence in activity, with most of her clientele now being non-Korean. There are throngs of K-pop fans who visit to purchase music albums and merchandise of their favorite bands. As part of her job, she keeps herself informed on all the new bands that come out. Though she might not know the names of her friends' kids, she knows the names of all the members of NCT.

Ms. Chon is grateful for the resurgence of her business through K-pop but remarked that she still operates her store one day at a time. There's no guarantee that K-pop will maintain its relevance forever. The music industry is constantly changing, and she is unsure how tenable it is to operate a small store like hers as she competes against big-box retailers.

These are her current favorite K-pop acts: Pentagon, TWICE, NCT, Stray Kids. She also likes classical music by Mendelssohn and Tchaikovsky.

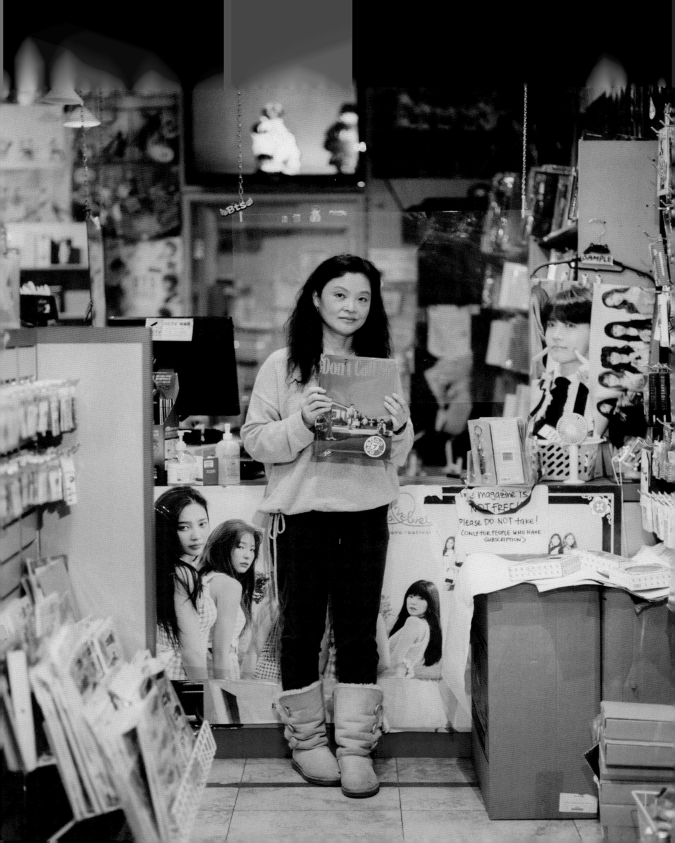

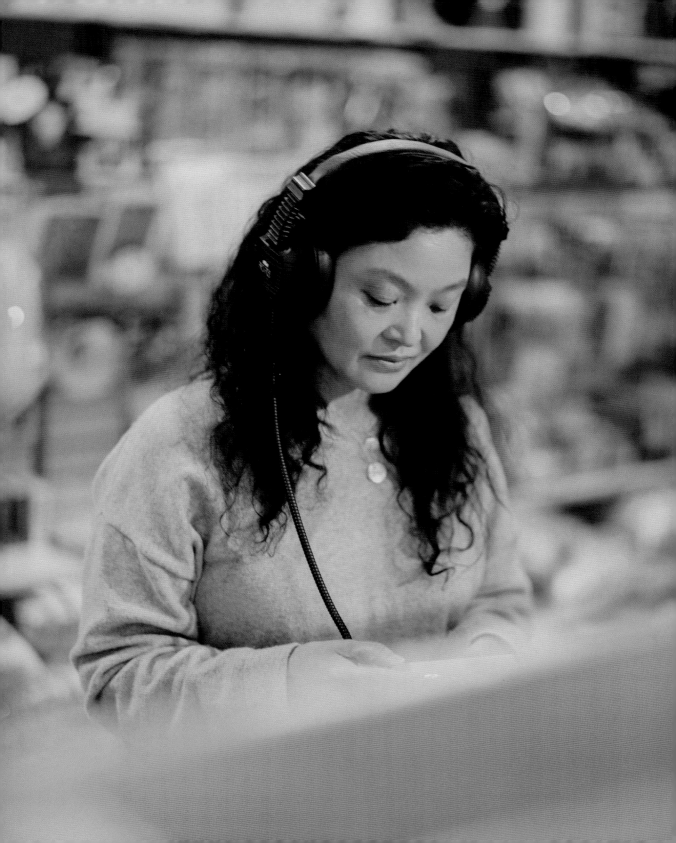

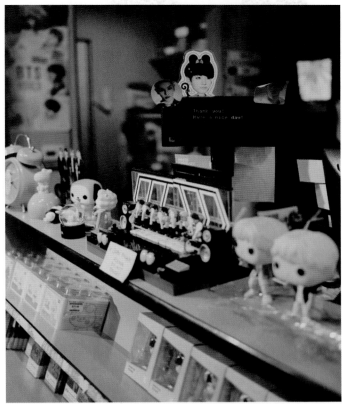

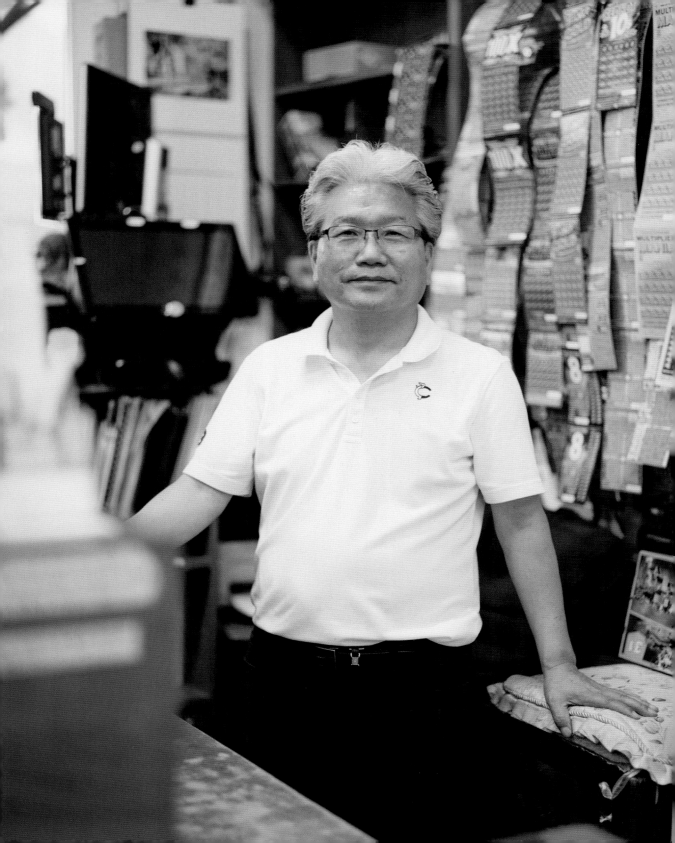

SEJONG BOOKSTORE

CHANG WOO PARK
박창우
3250 W. Olympic Blvd. #326, Los Angeles, CA 90006

MR. PARK MOVED TO THE UNITED STATES IN 2003 TO SUPPORT HIS CHILDREN'S education here. He bought Sejong Bookstore from an owner who had been here two years prior. At that time, there were more than sixteen Korean-language bookstores, and that number has dwindled to fewer than five now. He believes that physical bookstores still need to exist even in the digital age, especially for his older clientele who are tech-illiterate. He can offer a level of service that ensures that the older generation can get the Korean books they need. Younger mothers and fathers can obtain teaching material for their children.

For him, maintaining a good relationship and upholding high-quality service is essential for a small bookstore like his. He tries to anticipate what books his customers would like and order them in advance. He'll also make personal calls to his customers to inform them of new availabilities. He likes working the counter personally so that he can talk to everyone who walks through his doors. As an amateur poet, he spends his free time writing poems about his life and immigrant experience.

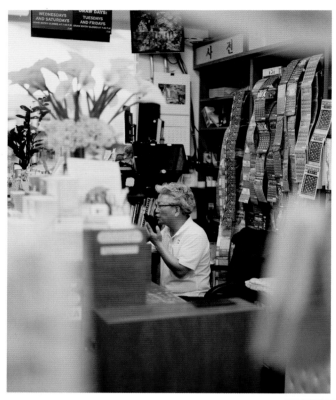

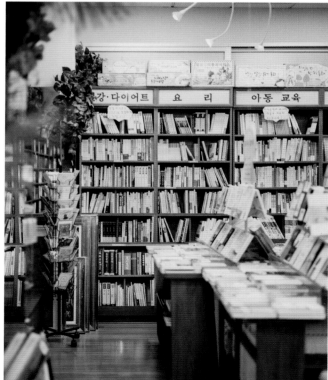

TOP'S ART SUPPLIES

JOANNA

3447 W. 8th St., Los Angeles, CA 90005

WHEN JOANNA FIRST MOVED TO THE UNITED STATES, SHE KNEW SHE wanted to run her own business, something that almost no other Korean immigrant was doing at that time. So she flipped through the Yellow Pages, stumbled upon "Art Supplies," and went on to start Top's Art Supplies in 1987. In the early days, she would bring her art supplies to art colleges and wait outside classrooms so that she could catch professors as they were leaving to sell her goods with her then-rudimentary English. Back then, she would approach up to twenty professors on a busy day, and soon enough she had a consistent order for art supplies and her business grew from there. I asked her how she felt confident to do that as a new immigrant and she replied that she developed a motto while majoring in social work in college: "Reach out and touch someone." She applies that principle to even the most basic tasks like customer service. I noticed that whenever customers came into the store, she would greet them warmly and ask them to reach out if they had any questions.

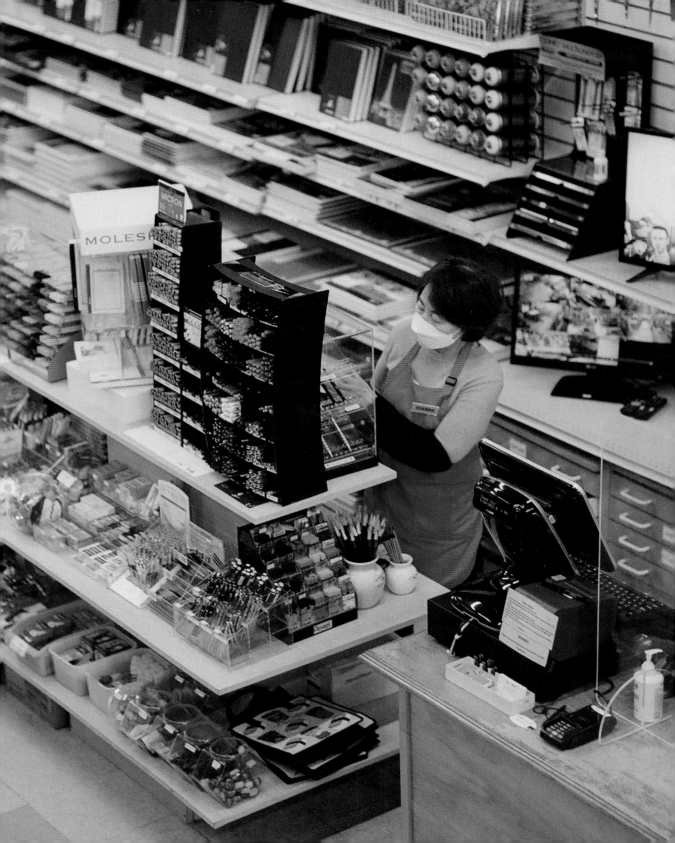

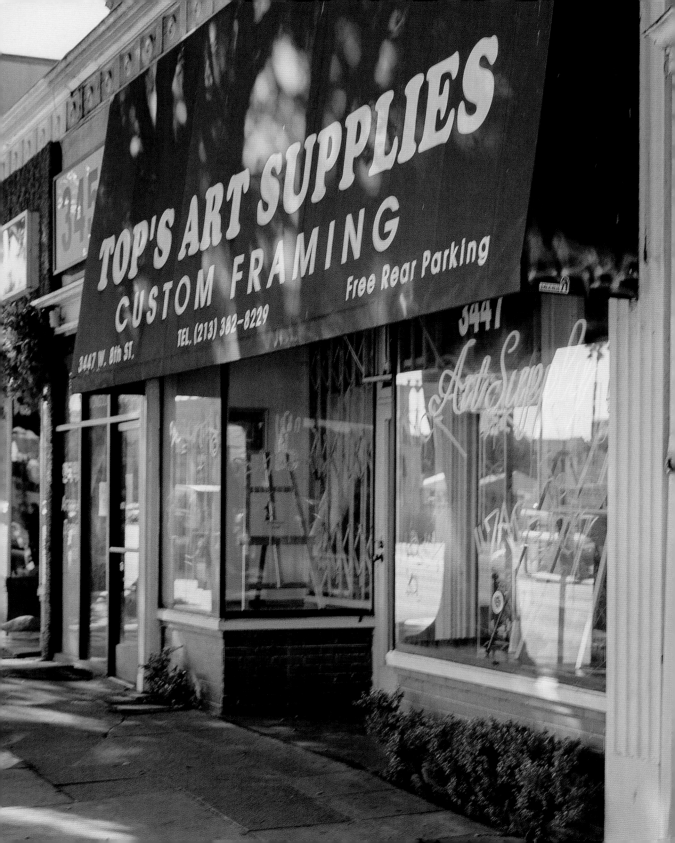

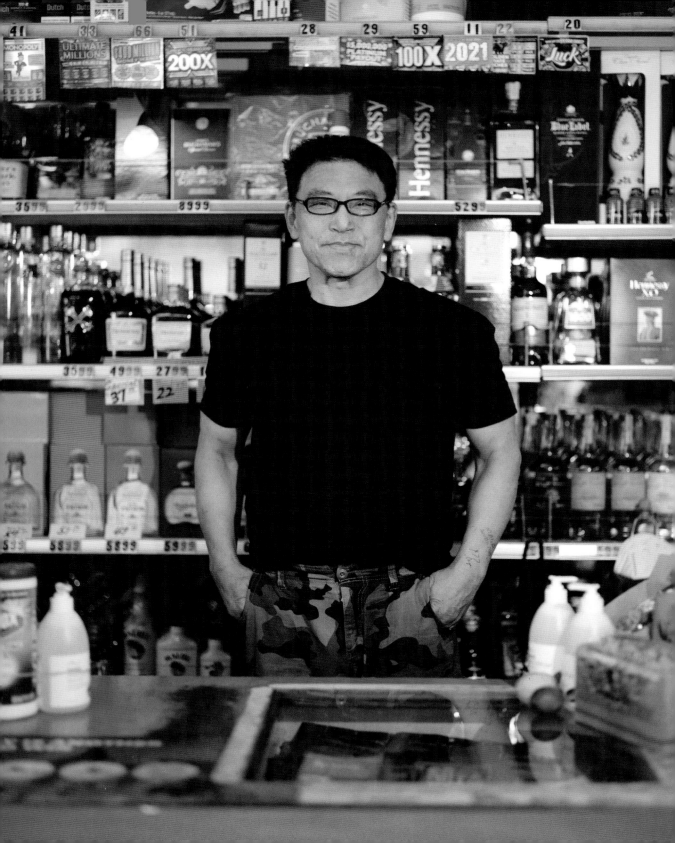

MARK'S LIQUOR

TOM KIM, DAVID KIM, JON KIM
1259 W. 6th St., Los Angeles, CA 90017

TOM KIM ARRIVED IN THE UNITED STATES IN THE '70S AFTER WORKING in South Korea as a teacher. When he first immigrated, his first job was pumping gas at a station while his wife worked at a sewing factory. Eventually, they saved a small amount of money and bought a liquor store in Inglewood. After that, he bought his current business, Mark's Liquor, more than forty years ago, and after running it for twenty years, sold it to a third party in anticipation of retirement before buying it back four years ago. The job is a time-consuming and challenging one, with sixteen-hour days and no days off, all while raising his kids. They had to deal with constant theft and robbery, and any losses would simply have to be written off.

For Tom, the United States is still THE land of opportunity for his whole family. Many of his family members persevered through hardship, surviving robberies at gunpoint, all the while saving enough money to send their kids to college. The pandemic forced Tom to be creative and adopt new strategies like offering delivery services to compete with other nearby convenience stores. While Tom easily could have retired, he enjoys keeping busy and serving his loyal customers.

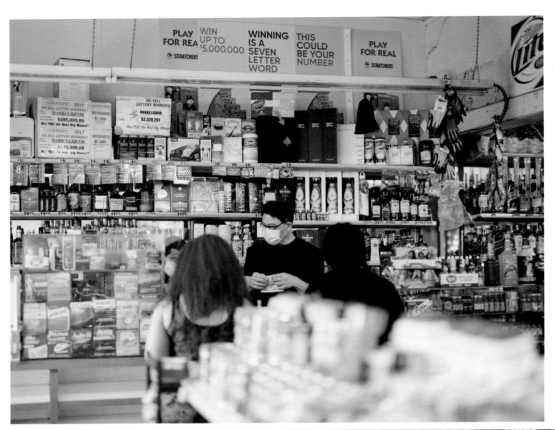

KWAK'S ANTIQUE FURNITURE

KEVIN KWAK
125 S. Western Ave., Los Angeles, CA 90004

KEVIN KWAK STARTED IN THE ANTIQUE FURNITURE BUSINESS WHEN HE was fifteen years old, starting as a trade apprentice in postwar Korea. He remembers working many years without pay, learning all aspects of making and repairing traditional Korean furniture. Kwak had finally opened his own furniture store in Seoul in his thirties when his brother invited him to the United States through a visa sponsorship. Kwak sold his business and prepared to make his move. However, it would be another ten years before he arrived in the United States because of the strict quota system.

After working at various furniture factories, Kwak saved up enough money to open Kwak's Antique Furniture in 1994. At first, he aspired to make beautiful custom furniture for his clientele but realized over the years that most people preferred cheap and mass-produced furniture at big-box stores. He lamented that people don't value the artisanal quality of handmade furniture anymore. Gradually, he pivoted his business to repairing furniture—many of his clients bring in antique pieces that have sentimental value that they want restored.

Kwak has been in the antique business for more than sixty years and may be one of the few Korean antique masters left in the world. He mentioned that as manufacturing processes become more automated, the deep expertise required to restore antiques will soon be lost. Young people lack the patience to learn the intricacies of restoration and the history behind an object. Still, he told me that he is grateful for the opportunity to work on his craft daily and will do so as long as his body can keep up.

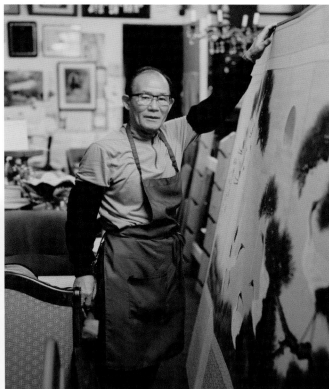

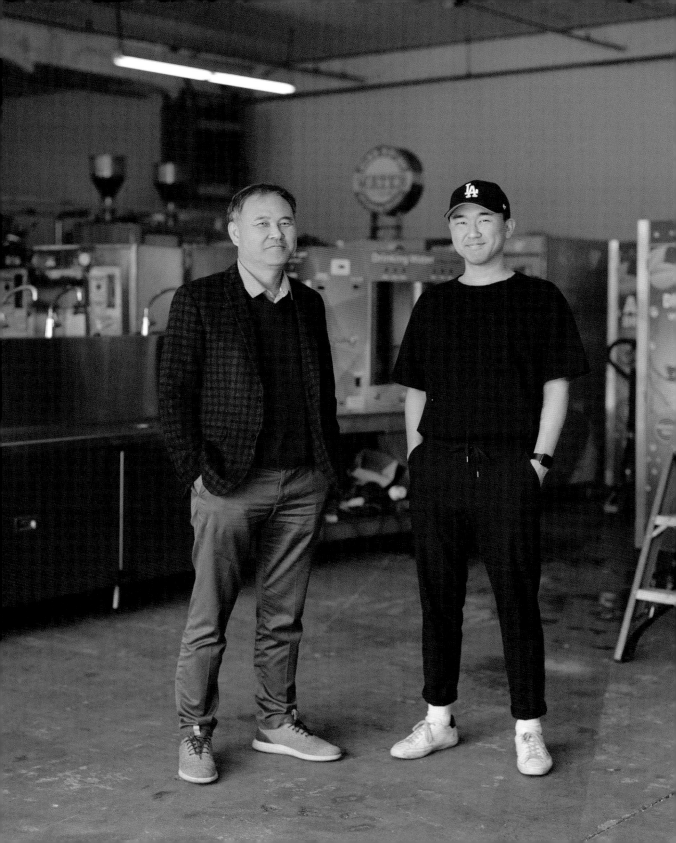

AQUA 9+

SAM PARK AND JAMES PARK
100, 1/2 S. Vermont Ave., Los Angeles, CA 90004

SAM PARK, FOUNDER OF AQUA 9+, TOLD ME THAT IN MANY PARTS OF California, tap water is considered hard and potentially unsafe. People either get filtration systems installed in their homes or purchase water from these stores. AQUA 9+ creates machines that purify water and also dispense alkaline water, which has purported health benefits.

In South Korea, Sam majored in music and hoped to become a professional flutist when he moved to the United States. However, as an immigrant, he put aside his musical ambitions to provide for his young family. After working odd jobs like house painting and operating small thrift stores, Sam got into the water business through the introduction of a friend. He saw an opportunity to provide a vital service to his community and decided to learn the mechanics of building a backend water filtration system so that he could be more competitive. In two decades, through sheer hard work, Sam built multiple proprietary filtration systems and now provides his machines to both small water store businesses as well as prominent brands like Whole Foods and Erewhon. As his company expands, Sam wants to support efforts to bring clean water to countries abroad, either through financial support or sharing technologies. He continues to play the flute in his free time and leads his church choir as a conductor.

James Park finds it remarkable that his father, with his rudimentary English and humble demeanor, was able to build a growing business. The water and beverage business is dominated by incumbent white men, and James is excited to see his father, an immigrant, continue to rise in this industry. As a way of diversifying the family water business, James wanted to experiment with opening hybrid boba-water stores and created H2BOba, a place where you can buy water and boba at the same time. A boba product offering attracts new customers to the store while the water business is a constant source of revenue. James works with his father to explore new ways of expanding and diversifying the business.

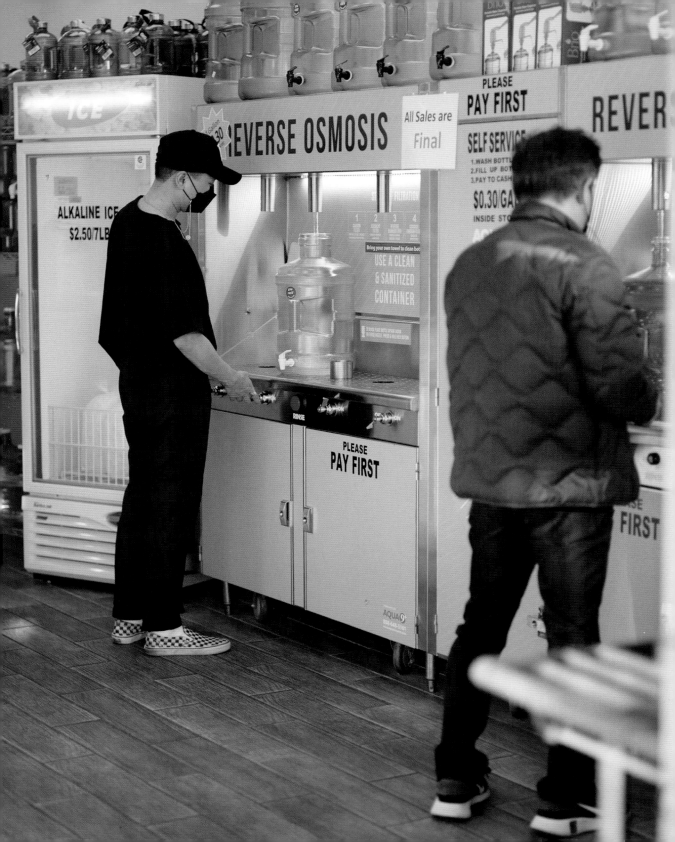

FABRIC MART
(HONOLULU, HI)

DANIEL LEE
98–023 Hekaha St. Bldg. 1, Unit #1, Aiea, HI 96701

WHEN DANIEL LEE FIRST ARRIVED IN HAWAII, HE DIDN'T HAVE A CLEAR vision of what his American dream would be, just that he knew there were opportunities here. Through a connection, he met a factory owner who allowed him to buy scrap material at a discount to sell at a flea market. In the early days, Lee remembers simply laying out the fabrics on a tarp on the ground and selling them to whoever was interested. He eventually upgraded to a table instead of the ground, and over the years, his business grew as his customers spread the word about his affordable prices and high quality. From a humble flea market booth, Lee opened a retail store specializing in Hawaiian prints, which he sold to tailors, home sewers, dance schools and studios, and others. Eventually, he designed his own prints and began producing fabric for wholesale. Over the past thirty-seven years, as Lee experienced a rags-to-riches story, he has also given back to the local Korean and Hawaiian communities that he finds himself in.

When Lee first moved to Hawaii, he felt that the Korean community didn't really have a unified presence. While Koreans have been immigrating to the United States through Hawaii since the early 1900s, many were quick to pursue opportunities on the mainland. Those who arrived in the 1980s and stayed faced prejudice from locals, being told to "go back home," but that attitude has since changed. Beginning in the early 2000s, many Koreans became more involved with businesses in Hawaii, running well-known companies like Honolulu Cookie Company, Liliha Bakery, as well as numerous hotels and real estate developments. Korean food has become integrated with local cuisines as well, with dishes like kalbi, meat jeon, and kimchi now a staple in many Hawaiian restaurants.

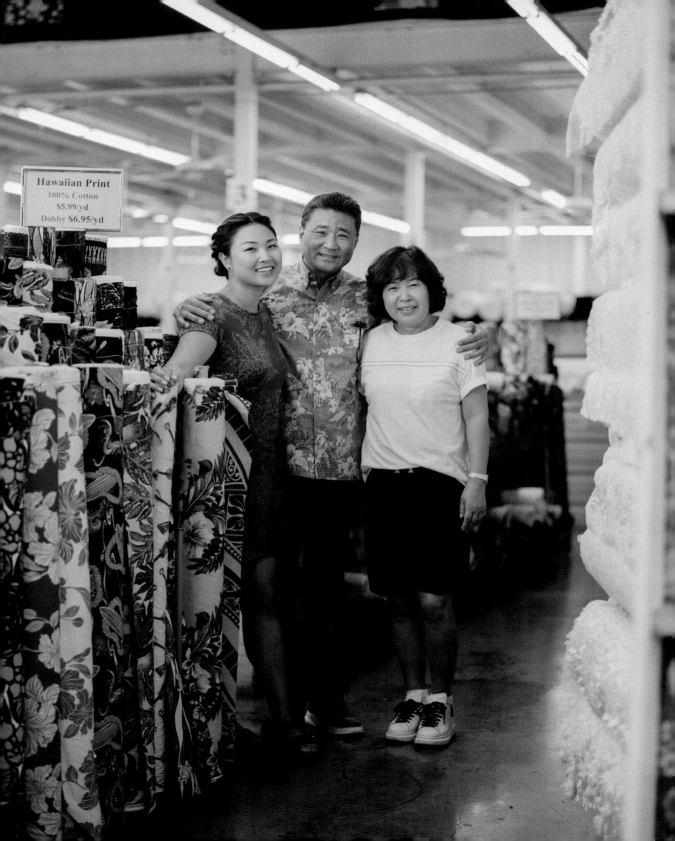

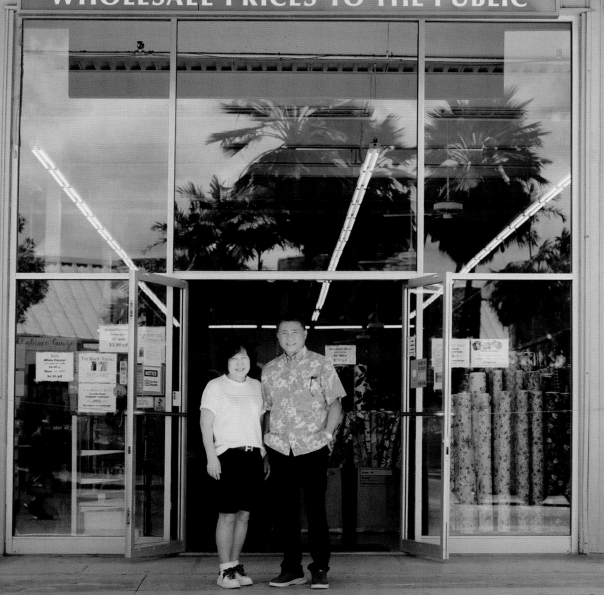

Services

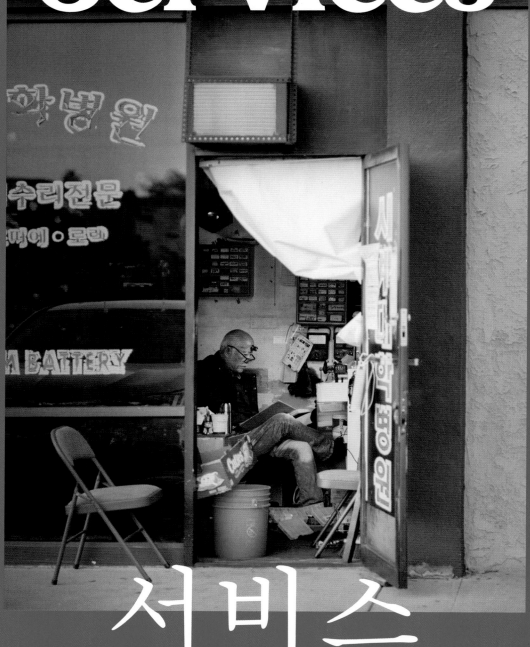

서비스

We Made It Less Lonely

BY LISA KWON, WRITER AND REPORTER

When I go out at night, my north star is the Southwestern Law School, dazzling in its art deco ornamentation; formerly Bullocks Wilshire, the shopping center lured wealthy homeowners who moved west to cash in on the burgeoning automobile culture. Hemmed in these days by tubular skyscrapers and rolling hills, Koreatown has a sobering prewar elegance that reveals itself after I walk out of soju-soused noraebangs (karaoke rooms) at 3 a.m. Once upon a time, it was white and wealthy, but today Koreatown is home to a dense population of more than 124,000 residents, many of whom are renters who come home from their rank-and-file posts in food service, hospitality, and community development. Sixty-eight percent of Koreatown's residents were born in another country. As Los Angeles's affluent families began to move westward to neighborhoods in the '60s, a new group of Angelenos moved in and took care of one another, giving this once-ritzy swath of Los Angeles a new lease on life.

Many of our ethnic Korean families, friends, and peers moved here against all odds. Though the Hart-Celler Act of 1965 allowed for greater passage of Korean families into Los Angeles, it also changed lives in irreversible ways. It required many to master a new language that felt thick on the tongue. It pressured them to shunt aside the imminent grief of leaving siblings and parents behind. It favored those who could make themselves useful right away. Heads spinning with new customs, vowels, and consonants, many ethnic Koreans arrived in America with easily translatable trades—or at least the curiosity and humility to learn handiwork.

The following portraits are of Koreatown shopkeepers and business owners who work in the service of their communities. Meet Mr. Lee, a cobbler who sits in his workspace stacked with buy-it-for-life boots and heels, the mark of more than sixty years of mending shoes, thirty of which were spent in Seoul. Find Mr. Kwon at his Happy Barber Shop, one of the last remaining barbers in Koreatown who still uses stainless steel scissors to work and style thick Asian hair. Get to know Jessica Pak at her alterations store where chickens abound; her new hobby of raising fowl hatched during the pandemic, but it was born out of her

childhood memories of living near a farm. Though the gestalt of the neighborhood is frenetic, these shops up and down the block hum of patience. After the exodus of movie studio executives and automakers, it began teeming with new ideas, hands, and love that make Los Angeles feel a little less, well, Hollywood.

It is funny that over time, we reeled back in the people of the West. The radiant, well-tailored dresses on red carpets are pinned and stitched by Koreatown's seamstresses. Many of the actor headshots clipped to resumes are shot by our portrait photographers in their hole-in-the-wall studios. The working mothers and daughters of Beverly Hills, Brentwood, and Pacific Palisades come to our spas because they melt into the vinyl beds when the coarse scrubbing towels push on their backs. The West loves our services.

Remember when six-time Grammy Award winner Kacey Musgraves catapulted Tom's One Hour Photo into pop culture headlines two years ago when she Instagrammed selects from her portrait session before heading to a show? And when is the last time your out-of-state friend asked if you could go to Wi Spa together when she's in town? For every Tom and Wi Spa, there are so many others who have thrived in town. Our busiest shopkeepers are bewildered by sensational reviews and warm reception because they never worked for fame or luxury (at least, not at the level that old Los Angeles empires attained). Their work is simply so that they can breathe in this country where nothing has been guaranteed. Everything else that came with it has been simply lovely.

I think it is a very Korean quality to appreciate preservation, especially in our later generations who walk through Koreatown for traces of our lineage. The thought makes us act urgently and soulfully as we keep businesses alive or commit them to memory through photos or words. After all, we know the feeling of being dispensable. In the back of our minds, we know that this city has benefitted from pushing even the most sacred caretakers off of their land.

I wonder if there's any more room for nostalgia today when every day another historic building gets listed on the market to turn into an office compound or "affordable housing." One day we'll lose the buildings with their dignified names affixed to Spanish revival and art deco buildings, but at least Koreatown's ideas have never wavered. Just as how we helped revitalize a dimming glamorous town when it was no longer wanted, we have to believe that we will always be needed elsewhere. The rest of the city will follow our labor.

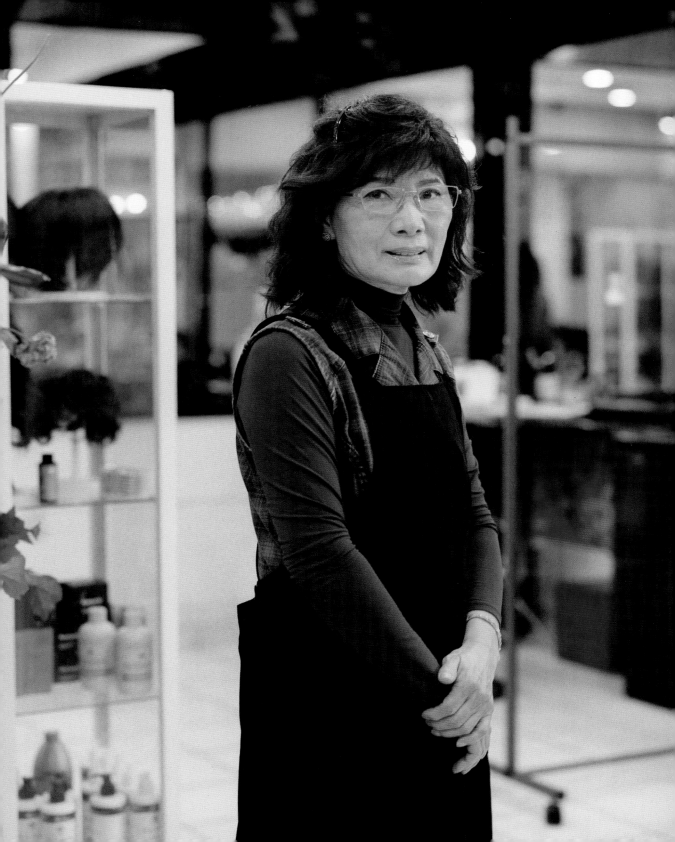

KIM IM SOOK HAIR FASHIONS

IM SOOK KIM 김임숙
928 S. Western Ave. #203, Los Angeles, CA 90006

MS. KIM CAME TO THE UNITED STATES IN 1983. HAVING ALREADY BEEN A hairdresser in South Korea, she was motivated to work a less physically demanding job and ended up working for a wig company for a few years. But she realized quickly that she would do better financially with hairdressing, and with her children growing up, she decided to get back into hairdressing. In 1989, she started Kim Im Sook Hair Fashions (KIS) as one of the first stores in the newly opened Koreatown Plaza. Through word of mouth, her salon quickly grew, almost to the point where she couldn't handle it all. She remembers working twelve-hour days and driving to Pasadena to pick up her kids from school and almost getting into car accidents because she was so hungry and exhausted.

In the early days, Ms. Kim repeatedly won the Long Beach International Beauty Expo makeup competitions. In addition, she created her own KIS Hair Show to showcase different hairdressers. She was also one of the primary hair and makeup artists for the L.A. Miss Korea Pageants that took place in Koreatown. Nowadays, Ms. Kim is content with running her store and serving her loyal customers. She wants to continue working as long as her body can keep up.

Ms. Kim's salon is a community hub and one of the only stores that has been around in Koreatown Plaza since the plaza's inception in 1989. I casually remarked to her that it has been more than thirty years, and as she reflected on the early days of the store, she got emotional thinking about how hard it was for her and her family to survive. She said that in the United States, you can't do anything by yourself—you need good people around you. For her, that was her family. They believed in her and initially invested in her store. Then she got lucky with her employees, many of whom stuck around for a long time. And finally, she got lucky with her customers, who kept coming back because they trusted her.

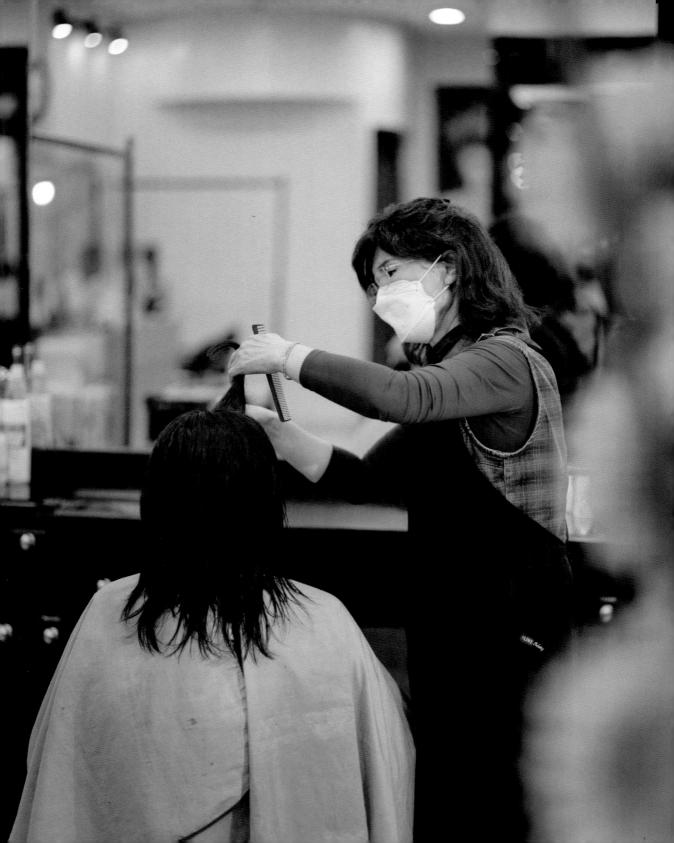

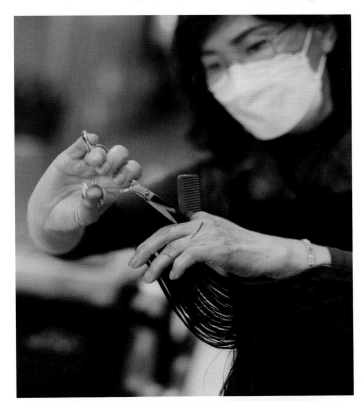

HAPPY BARBER SHOP

SOON AHM KWON
권순암
801 Vermont Ave. #101A, Los Angeles, CA 90005

HAPPY BARBER SHOP IS ONE OF THE FEW KOREAN-OWNED BARBERSHOPS left in Koreatown. According to Mr. Kwon, at least five long-standing barbershops closed during the pandemic, some because its owners had COVID and others due to financial difficulty. Out of my short list of four barbershops to check out, Happy Barber Shop was the only one still open. For the senior community in Koreatown, these barbershops are a vital service provider because they are located within the community, can communicate in Korean, and are dependable. With the closure of barbershops around Koreatown, senior citizens have to travel farther to barbershops that they are unfamiliar with and pay higher prices.

Mr. and Mrs. Kwon moved to the United States from Daegu because of the IMF Crisis. They sought a better economic situation for themselves and their children. The store was founded in 1992, but Mr. Kwon and his wife took over formally in 2017 and renamed it Happy Barber Shop. Mr. Kwon remarked that for many of his customers, getting a haircut in a peaceful environment amid the hubbub of a busy week was the happiest time for them, hence the name Happy Barber Shop. The old details and appliances remain—many of the chairs persist from the store's inception. Even Mr. Kwon's style of cutting, which he learned in the '70s, is considered the traditional method.

As COVID restrictions lift, customers have begun returning to his store. The Kwons are still not ready to bring back employees, so for now it's just the two of them running the store. Mr. Kwon handles the haircuts and Mrs. Kwon does the shaving. With their kids grown up and busy off working in the world, Mr. and Mrs. Kwon relish the time they can spend together at Happy Barber Shop.

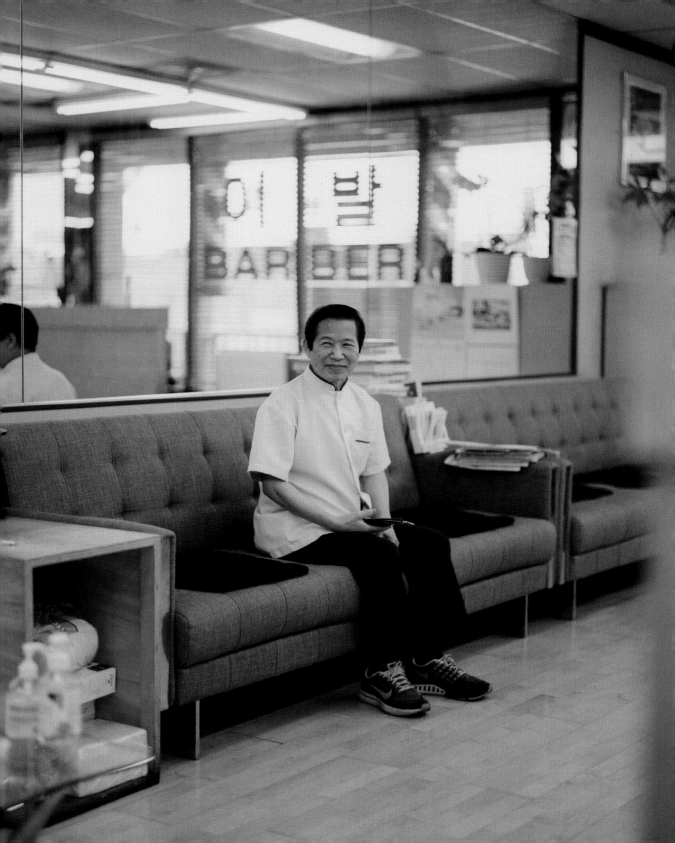

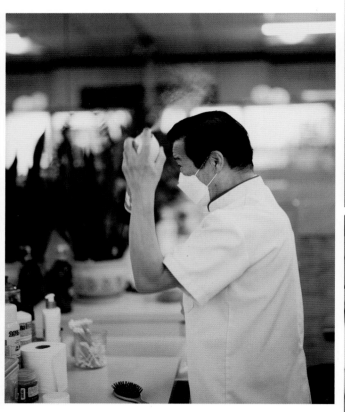

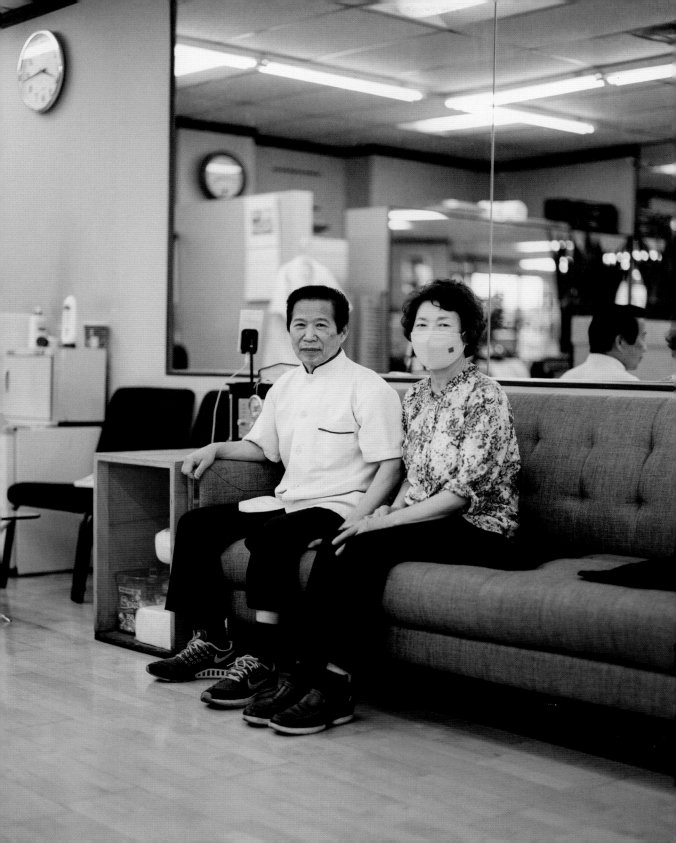

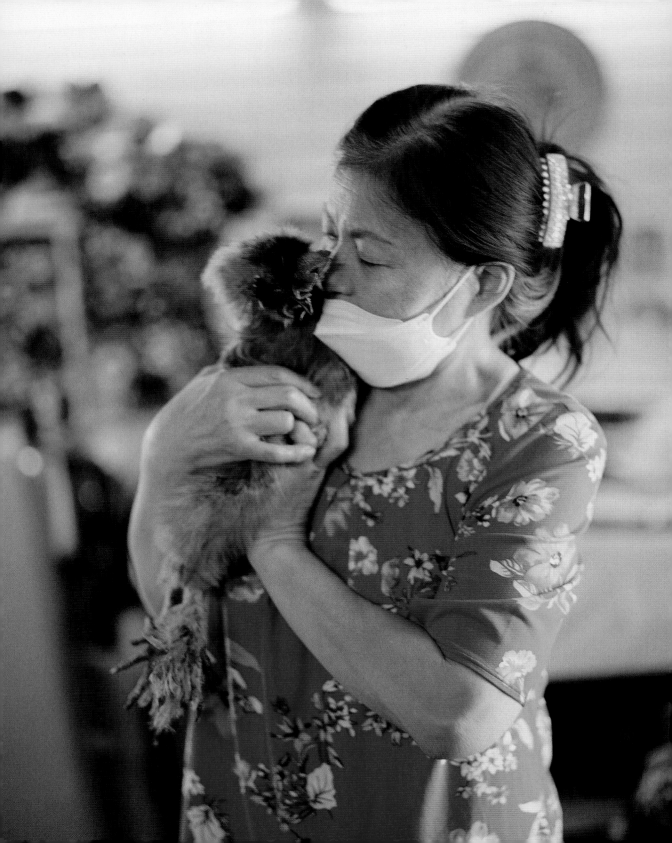

JESSICA PAK
ALTERATIONS

JESSICA PAK
2901 W. 8th Street, Los Angeles, CA 90005

THE FIRST THING I NOTICED WHEN I ENTERED MS. PAK'S STORE WERE the chickens running around. She told me that when lockdown started, business slowed down and she wanted to try a new hobby, so she decided to incubate organic eggs. I guess some people bake bread and others crochet, but she built a DIY incubator with Styrofoam and experimented with different eggs until a couple of them hatched. Over the course of more than a year, she's accumulated more than 150 chickens in L.A. and Phelan, claiming that she's gone mad for chickens. She thought about selling the chickens and eggs but said that God told her to simply share them with people around her.

Ms. Pak grew up in Chungcheongnam-do near a farm and was used to being around livestock. When her husband passed a few years ago, she wanted to return to working with living things. She said doing so gives her purpose and meaning. She's never been busier, but she's satisfied. Sometimes, she walks her chickens on a leash outside, where they peck at grass and run around. As I was leaving, she gave me a huge jar of pa kimchi, which might simply be the best I've ever had.

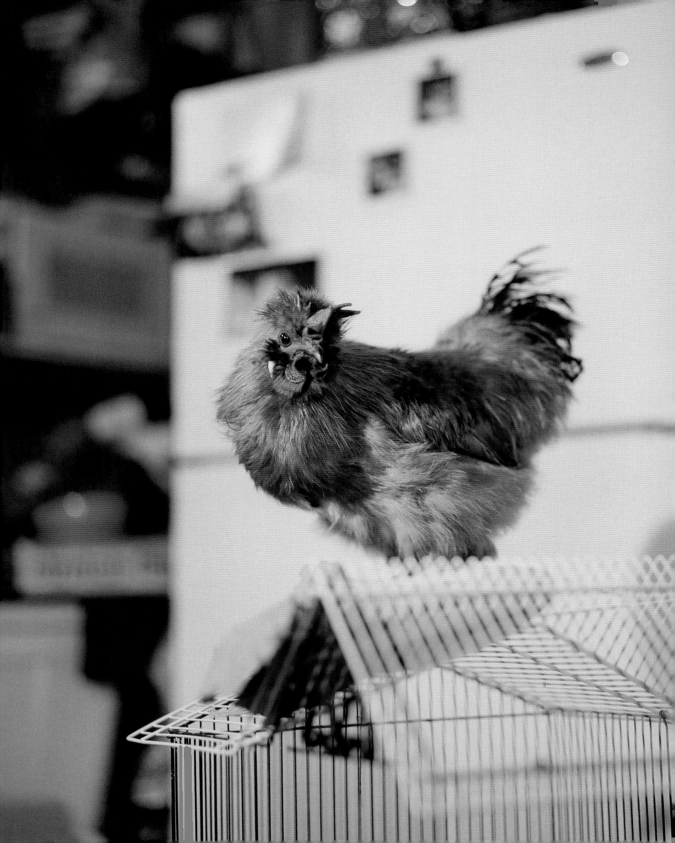

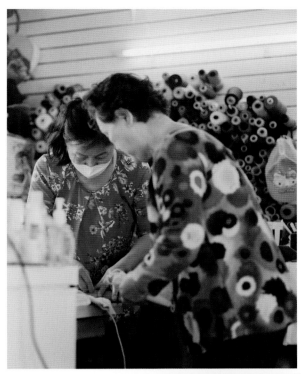

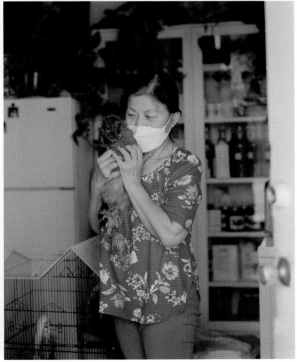

UNIVERSAL CLEANERS

YONG SEOK CHOI
최용석
4650 Beverly Blvd., Los Angeles, CA 90004

UNIVERSAL CLEANERS OPENED IN 1989 IN AN AREA THAT WAS THEN considered to be on the outskirts of Koreatown. When Mr. Choi and his wife arrived in the United States, they thought they would work in the auto repair business, given that they took classes to obtain a license. But their family member who picked them up from the airport was a tailor and needed someone to help clean his clothes. Sometimes, that's how your destiny is decided for you—the person picking you up from the airport determines what line of work you end up in.

Another truism seems to be that for people working incessantly, the years and decades seem to float by. The Chois never seemed to think of their work as noble or significant—it was just another means to feed themselves. But over time, they have become a staple in their neighborhood, known for their quality of work and consistent service.

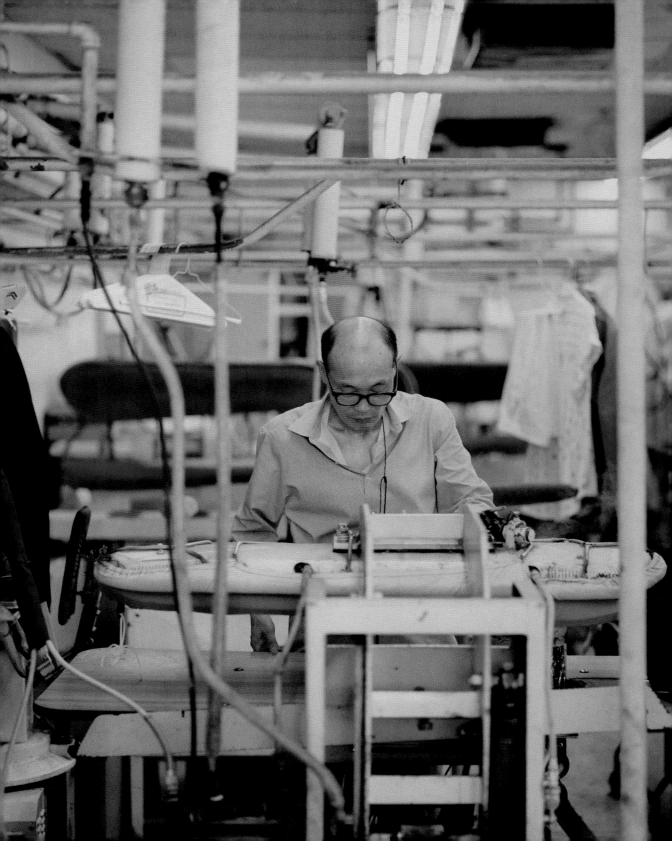

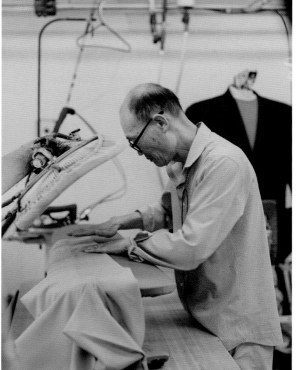

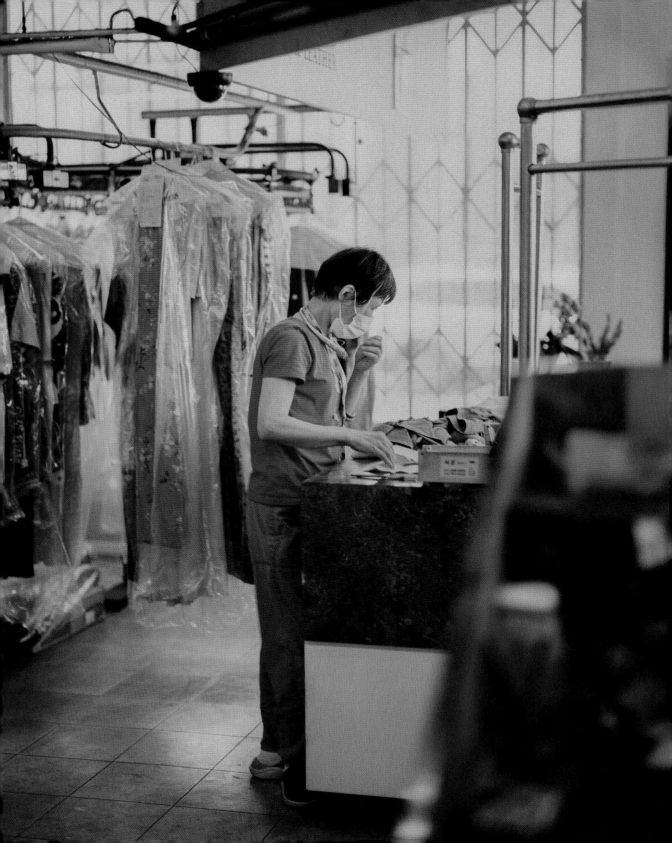

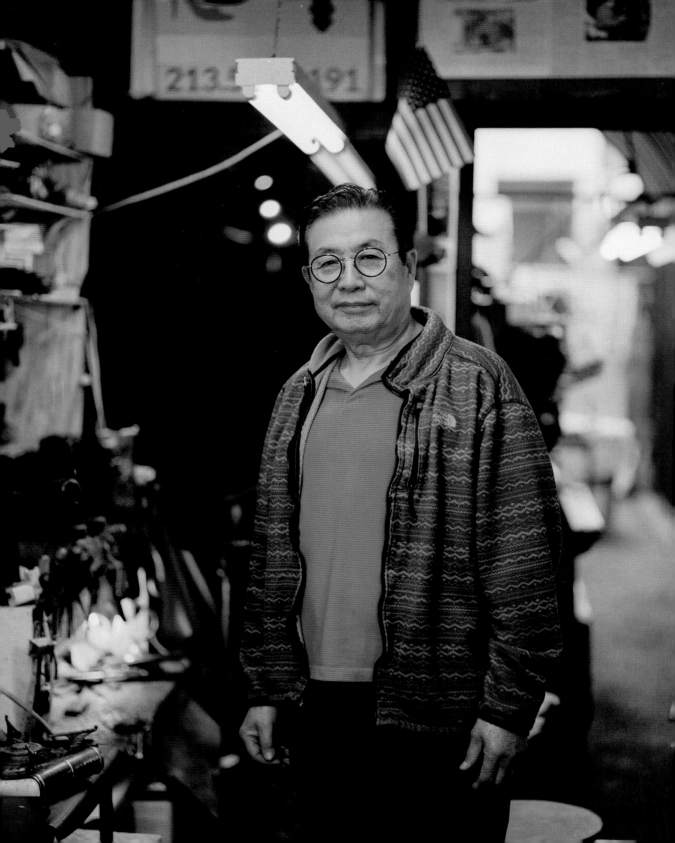

SHOE EXPERT

SUNG CHUL LEE
이성철

439 S. Western Ave., Los Angeles, CA 90020

MR. LEE HAS LIVED AND BREATHED SHOES FOR MORE THAN SIXTY YEARS, starting from his days in Seoul selling shoes in Myeong-dong (a popular shopping district) for thirty years and spending his next thirty years in Los Angeles, working as a shoe repairman. Given his experience and longevity in the shoe business, he is a self-proclaimed 구두박사, which translates as shoe doctor/professor/expert. He claims to be able to tell what sort of personality a customer has just from looking at how a shoe's soles are worn—for instance, if the back of the soles are worn, a customer might move and walk about slower, while if the inside arches of the soles are worn out, a customer might be more active and have a rushed personality.

Unlike many of his peers, Mr. Lee moved to the United States in his fifties, enticed by the numerous stories he had heard of a better life and education for his children. His shoe repair business thrived in his early days, when shoes were still made to a high standard, with better materials and meticulous stitching. He laments that these days, shoes are mass produced—materials are synthetic and cheap, and soles are simply glued on, which lead them to fall apart more easily. The machinery that he invested in is losing its value because many of his customers do not own shoes that require such meticulous handiwork. However, he does have customers who bring damaged leather goods like shoes and handbags that have sentimental value, and he can restore them to new life. That brings him joy and meaning.

At the age of eighty, Mr. Lee keeps going. He does not want to slow down, because he enjoys being busy. He said he is aware that most shoe repair shops in the neighborhood are closing as his generation approaches retirement age. His most recent obsession is cowboy boots from Mexico. When I visited him, he showed off his latest pair that he had bought from Tijuana for $130—a really good price. It feels really good when you wear them, he exclaimed.

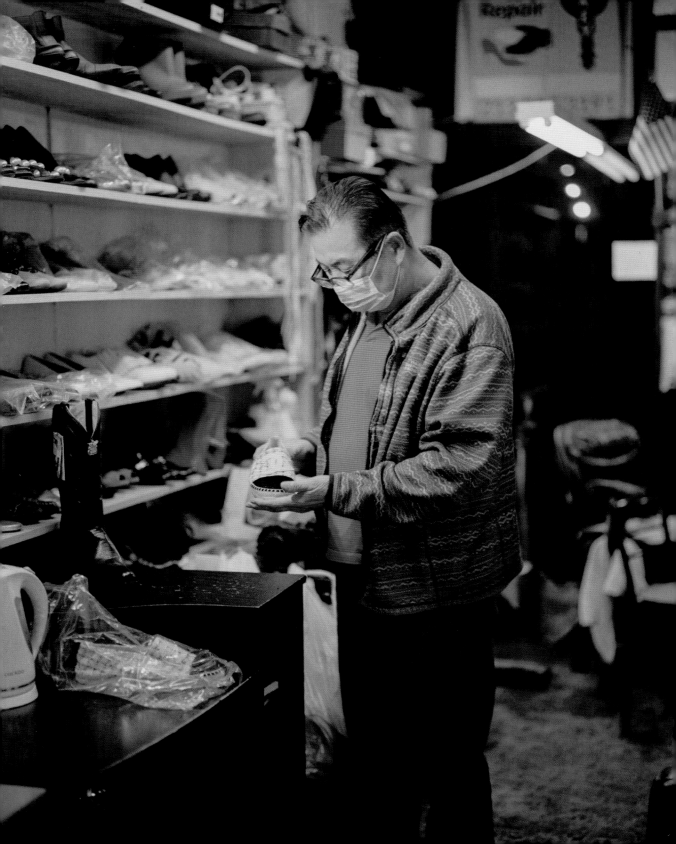

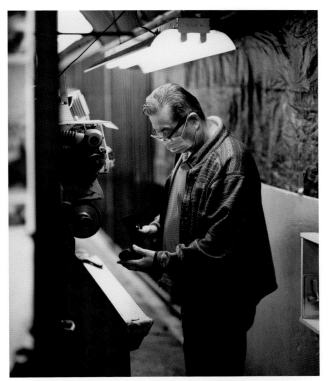

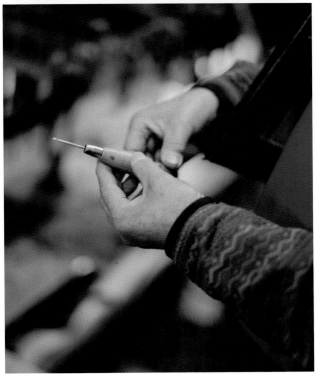

WILSHIRE PHOTO STUDIO

GILBERT LEE

439 S. Western Ave. #205, Los Angeles, CA 90020

GILBERT LEE FIRST MOVED TO THE UNITED STATES TO WORK A CORPORATE job at Daewoo but quit after a few years to pursue photography. He worked as a photojournalist for four years at the *Korea Times*. Then the '92 L.A. riots happened. He recalls putting his life on the line and being in the thick of action, photographing on his thirty-five-millimeter camera and then spending all night working in the darkroom to process the photos to be ready for print.

When the riots and his stint at the *Korea Times* ended, he started a photography studio focused on events and weddings. Back in the '90s and early 2000s, business was good for photography studios—Lee estimates that there were up to thirty photography studios in Koreatown. That was a time when customers depended on photographers to shoot on film for important events like weddings and family gatherings. It was very common for weddings to be shot on Hasselblad film cameras, which was extremely complicated in tricky lighting conditions.

However, with the advent of digital photography, many photo studios ran out of business as demand dropped for their services. There is barely any future left in brick-and-mortar photography stores. Most photo studios shoot events to cover their costs, but in the early days of COVID-19, work was almost nonexistent. Lee doesn't know how much longer he can operate his studio—his advice to me was to shoot more commercial work. Still, it was heartening to me to witness someone who shared a similar path to mine—dropping out of the corporate world to pursue something creative. We geeked out over the various film cameras he used over his career and he took some passport photos for me.

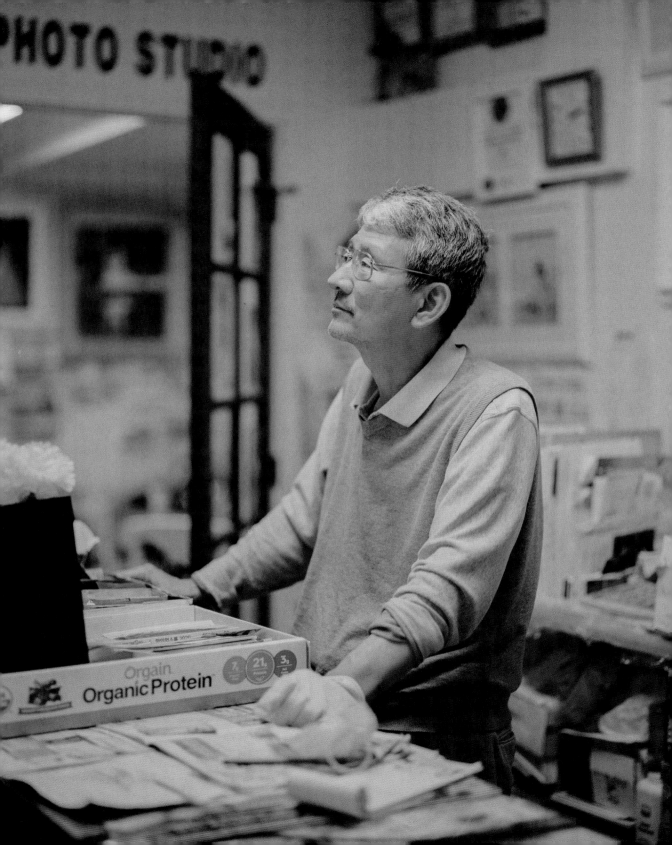

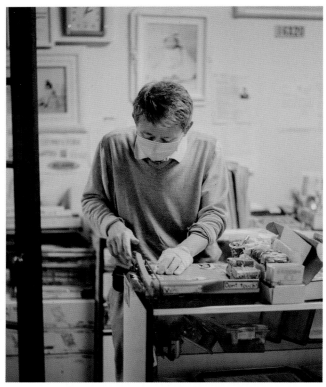

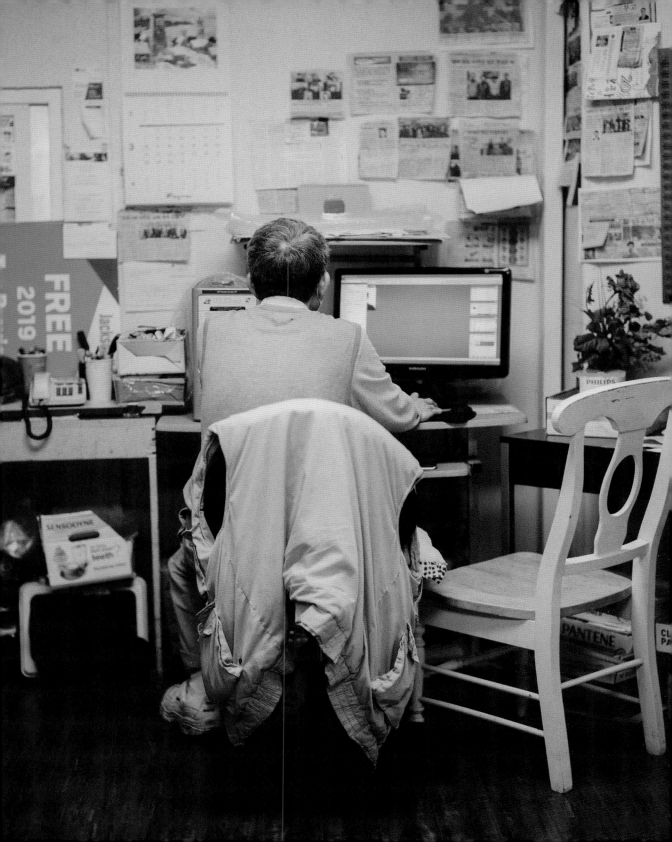

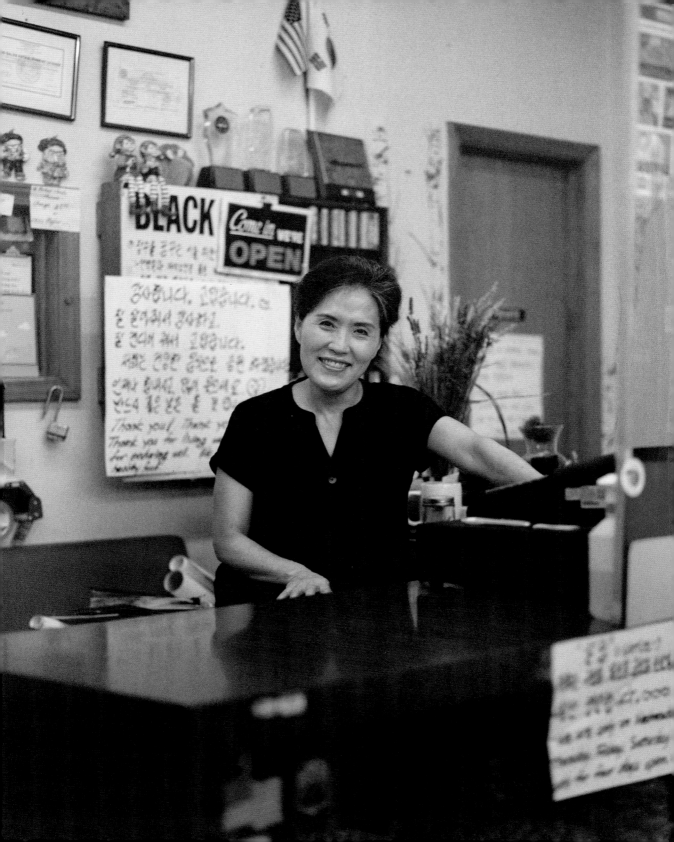

PN RICE CAKE HOUSE
(ATLANTA, GA)

GRACE YU
5273 Buford Hwy. NE, Doraville, GA 30340

GRACE YU OPENED PN RICE CAKE HOUSE IN 1985, FIRST AS A GROCERY store around a military base in Columbus, Georgia, then later as a rice cake and banchan (Korean side dish) purveyor in Atlanta, Georgia.

Grace met her husband, Peter, in South Korea, where, she admits that she was not drawn to him until she learned of his plans to move to the States. Her dream was to study in the United States and work in humanitarian organizations like the United Nations. Over the years, this dream was pushed to the side to make ends meet. Today, more than thirty years since the original PN Rice Cake House began, her business flourishes and has become a staple in the Korean community for anyone looking for a taste of home. Mrs. Yu, who has a refined palate and a commitment to using only the healthiest ingredients, creates hard-to-find products like doenjang, gochujang, and rice cakes in-house. Customers drive from as far as Philadelphia and Colorado for her goods. She even delivers kimchi abroad, where she has customers in places like Germany.

The journey of maintaining a business hasn't always been smooth; she has battled cancer four times since the store opened, and each time the medical bills have jeopardized the business. Her last cancer episode was the most intense. She endured fourteen hours of surgery and joked with the doctor that she would give her body up for study if he would give her a discount.

It became clear to me as I was speaking to Grace that she possessed an indomitably positive spirit. She recalled how during the fifteen years in which she took care of her sick mother-in-law, she realized if she wasn't optimistic and lighthearted toward life, she would be constantly suffering. She considers her store her playground, where she can merrily interact with her customers and share her joy. Sometimes, lonely customers come into the store and ask for a hug, which she freely gives. When young customers come in, she admits that she wants to give them an allowance because they all seem so lovable to her, like they could be her son or daughter.

Recently, to keep herself busy, she picked up painting through the support of her two artistic daughters. Her works of art now hang on the walls behind the counter. Some customers have asked to buy her paintings, but she has refused to sell them, insisting that an artist's first works end up being the most valuable in the long run. She's going to hold out for as long as she can.

Atlanta is home to the ninth largest Korean population in the United States, and Korean is the third most spoken language in the city, after English and Spanish. The low cost of living and ample opportunities to start businesses attracted many Koreans to the Duluth area of Atlanta. In May 2021, a gunman targeted three massage salons and killed eight women, half of whom were ethnic Koreans. This tragedy led to the Stop AAPI Hate movement and was part of a nationwide reckoning with violence toward Asian people.

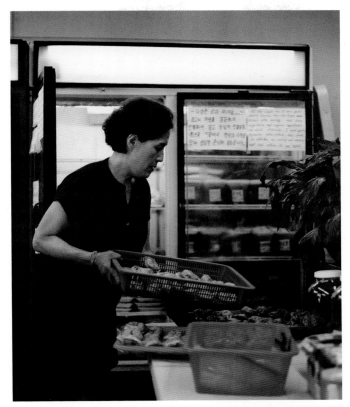

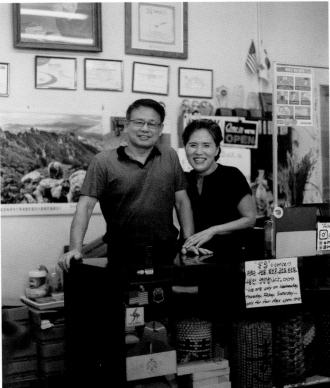

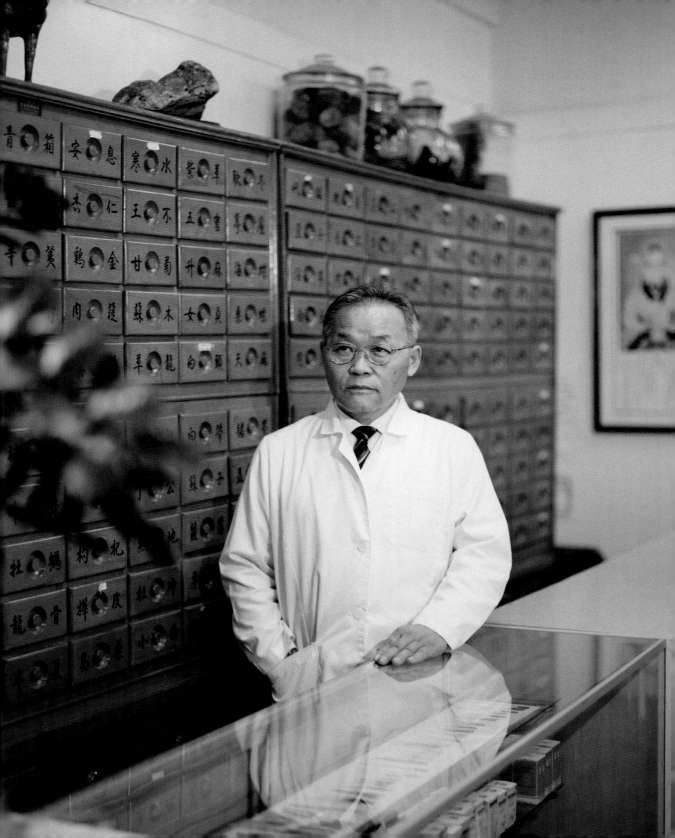

CHINESE BEST ACUPUNCTURE & HERBS

PETER SONG

13341–A W. Olympic Blvd., Los Angeles, CA 90019

PETER SONG MOVED TO THE UNITED STATES IN THE LATE '80S TO GET A graduate degree in life insurance. However, he struggled with picking up English and quickly dropped out of his program within four months. While trying to figure out his next move, he started a small acupuncture shop in Flushing, New York, back when there wasn't a licensed supervision board. As he experienced some success, he moved to California in 1993 where he formally received his training at Emperor's College and subsequently earned his license. Since then, he's been working in the industry for more than thirty years with many repeat customers.

He considers himself a lifelong learner and finds meaning and joy in augmenting his knowledge of the body. Eastern medicine is perhaps seen as less direct and linear than western medicine—he had to learn about various acupuncture methods over time through trial and error. But over time, he has gleaned an extremely nuanced understanding of the body, beyond what western medicine prescribes. Moreover, he understands the recurring conditions of his repeat customers and is able to build a library of knowledge for their individual bodies. Perhaps that's why his customers constantly return to him, even many non-Koreans. He told me that many Hispanic customers have become loyal customers, often driving hours so that they can receive treatment and herbal medicine.

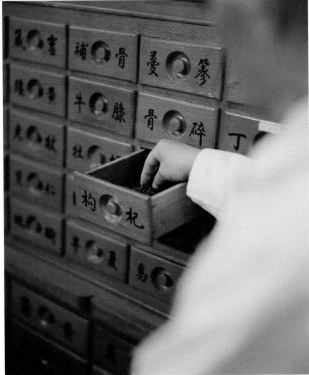

VERMONT AUTO CENTER

YONG MAN KIM AND OK MI KIM
2241 Vermont Ave., Los Angeles, CA 90007

YONG MAN AND OK MI KIM MET AND MARRIED IN TEXAS IN 1985. YONG
Man worked at various gas stations and attended a technical college, where he learned
to be a mechanic. While he rapidly gained skills in Waco and then Houston, he
recounted the amount of racist abuse they encountered. Back then, there was serious
racism against Asians—they would be shot at sometimes, and once when the couple
were lost in Galveston, they were yelled at by white kids. Mrs. Kim was working at a
dry cleaner at that time and remembers that her customers, while seemingly kind on
the surface, would be condescending in their speech and behavior toward her.

In 1988, with Mrs. Kim pregnant with their first child, the couple moved to California,
and Mr. Kim eventually opened up an auto shop in South Central. It was a tough time for
them as they endured repeated break-ins and animosity from the community. Despite
that hostility, Mr. Kim was constantly kind to his customers, and he worked hard. When
the '92 uprisings happened, some of his customers banded together to protect his store
from being burned. Mrs. Kim recounts that period as the toughest time of their lives, as
they were constantly working hard to make money, and repeatedly losing it from theft,
while raising their four kids. She remembers eating ramen for days to scrimp and save,
and even fainting on several occasions from overwork and exhaustion.

In 2003, the Kims moved closer to Koreatown and opened Vermont Auto Center.
It started slow, but as word spread of Mr. Kim's professionalism and workmanship,
their business grew. Many of Mr. Kim's customers are non-Korean, with some former
customers coming from as far as South Central because they trust him. While the Kims
want to retire eventually, Mr. Kim genuinely loves fixing cars and helping his custom-
ers. Just like you need a good lawyer or doctor, you need a good car mechanic.

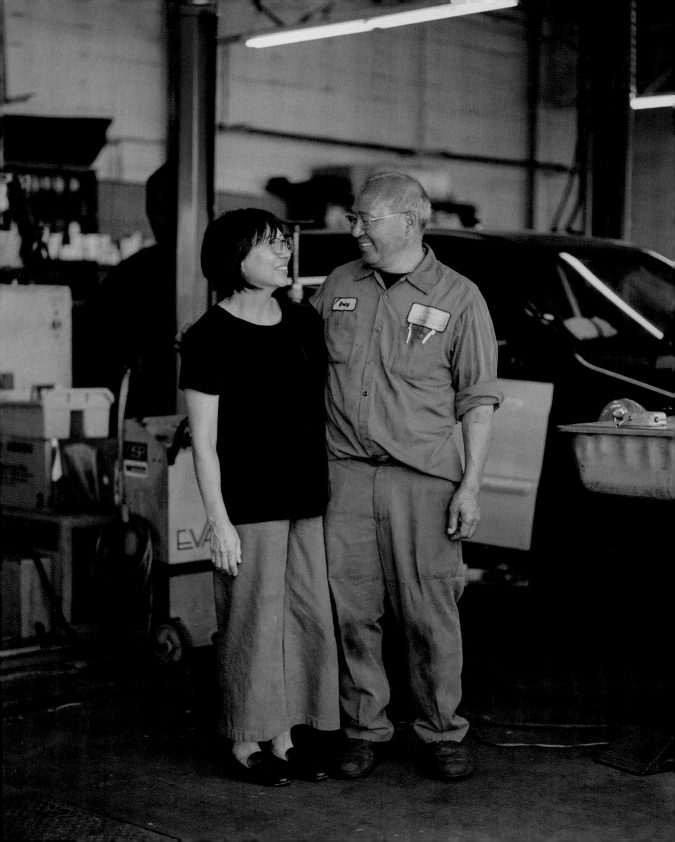

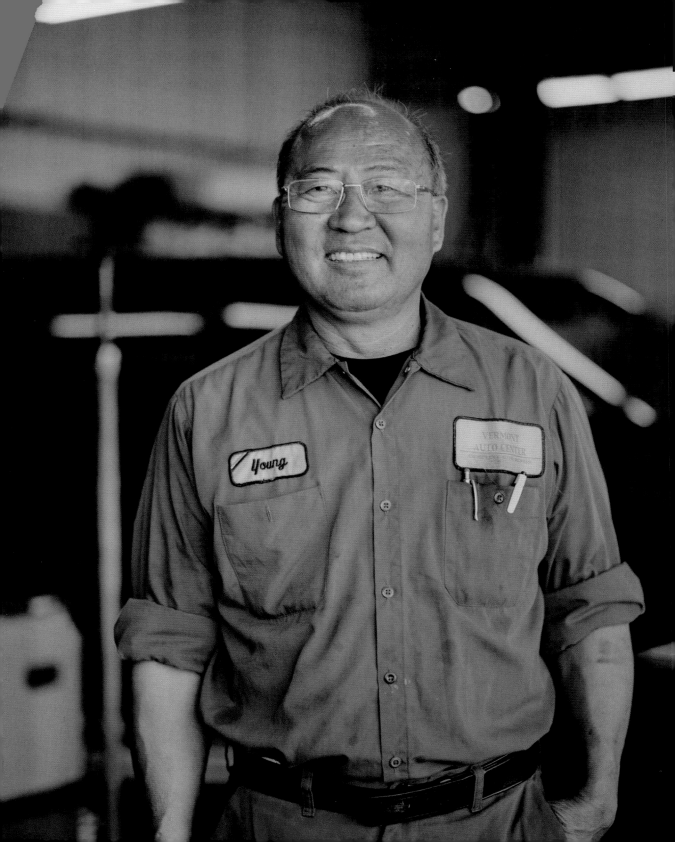

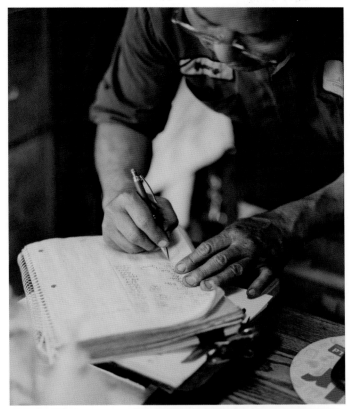

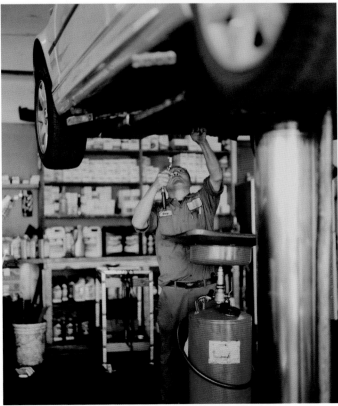

NEW STAR TROPHY

SAMUEL AND REBECCA SEO
2533 W. Olympic Blvd., Los Angeles, CA 90006

MR. SEO HAS BEEN RUNNING NEW STAR TROPHY FOR THE PAST TWENTY years. In postwar Korea, his father was a self-taught commercial photographer and graphic designer, which was a rare occupation back then. His father's creative endeavors must have rubbed off on Mr. Seo, as he left his corporate job to start New Star Trophy. There's a lot of creative work involved in the creation of trophies, plaques, corporate paraphernalia, and so forth.

His daughter, Rebecca, has plans to take over the store. When the pandemic arrived, business dried up as corporate and private clients cut their spending. Rebecca helped modernize the business by creating a strong web presence and also starting an Etsy shop, which has since almost overtaken traditional sales. Her bestselling items are customized hammers and other tools. The pandemic forced the family business to pivot and seek new opportunities. Koreans are a resilient and adaptive group, finding ways to make it work through the most difficult times.

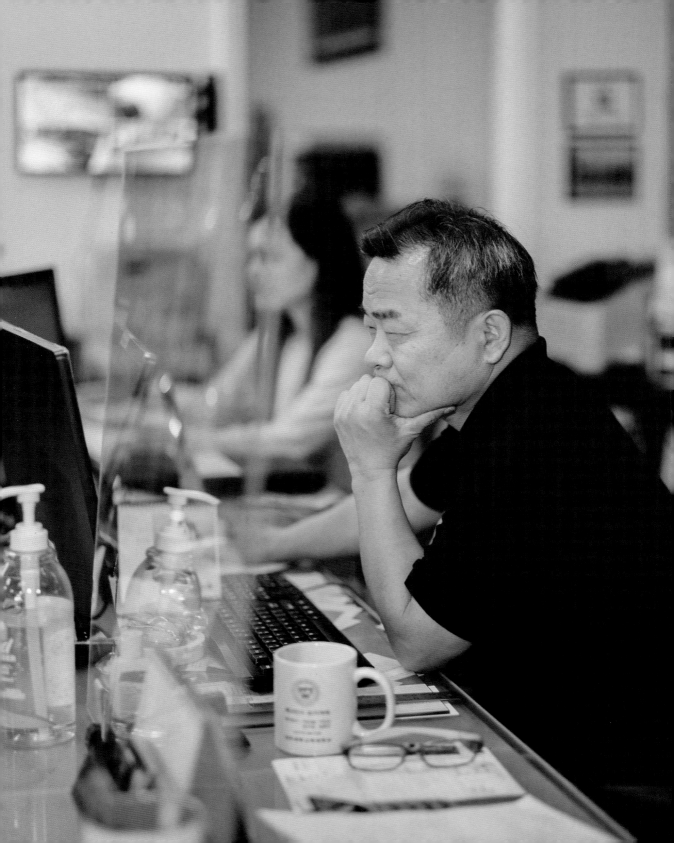

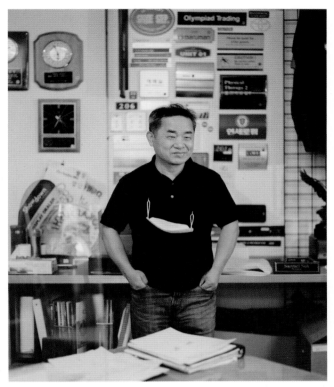

TIME WATCH
AND MAIL SERVICE

HENRY CHAE
채홍건
4001 Wilshire Blvd. #F, Los Angeles, CA 90010

HENRY CHAE MOVED TO THE UNITED STATES IN 2002 TO PROVIDE A better education for his children. When he arrived, he looked around for potential businesses to open so that he could obtain a visa. He bought a watch repair store because he was good with his hands and he figured he could learn quickly. Over time, he also operated a cell phone business, which did well for a while until most of the business went online. After considering other options, he augmented his watch repair business with a mail business, obtaining a license from the US Postal Service. Because it was his wife's idea to start the mail business, she became his boss.

The mail business offers a stable life, enough to cover their living expenses and their children's tuition. Now that their kids have grown up and moved on, the couple keeps the business running to provide for themselves. During the pandemic, the number of shipments actually increased, and they were able to ride out the difficult time. As his neighborhood diversifies, Mr. Chae's customers have become majority non-Korean. To him, living in Koreatown offers the perfect balance of convenience and comfort.

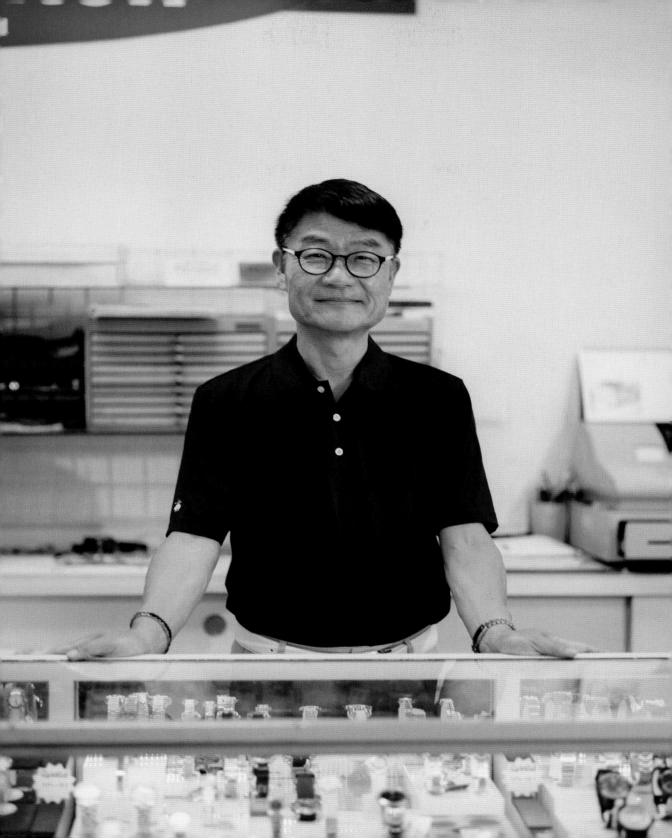

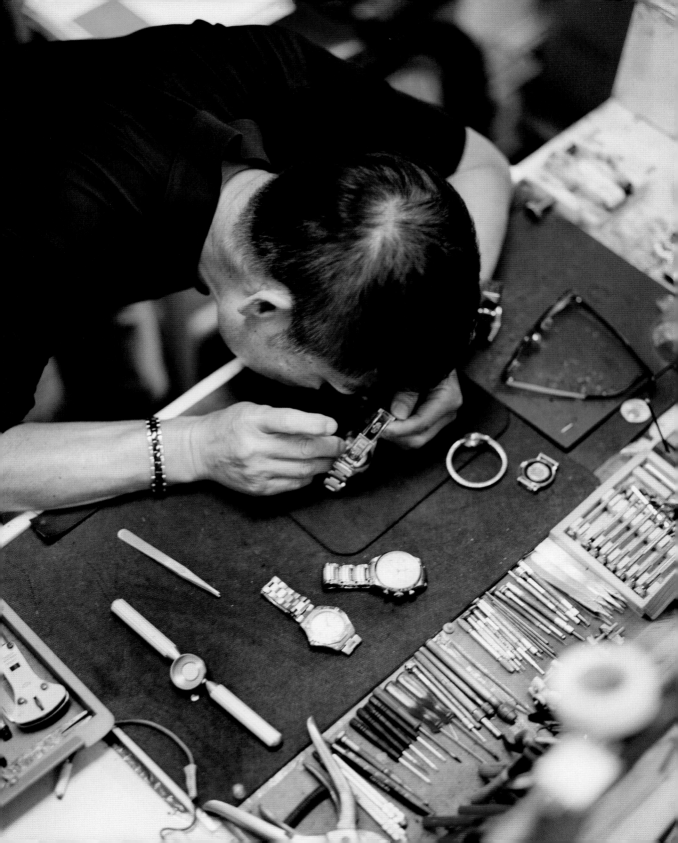

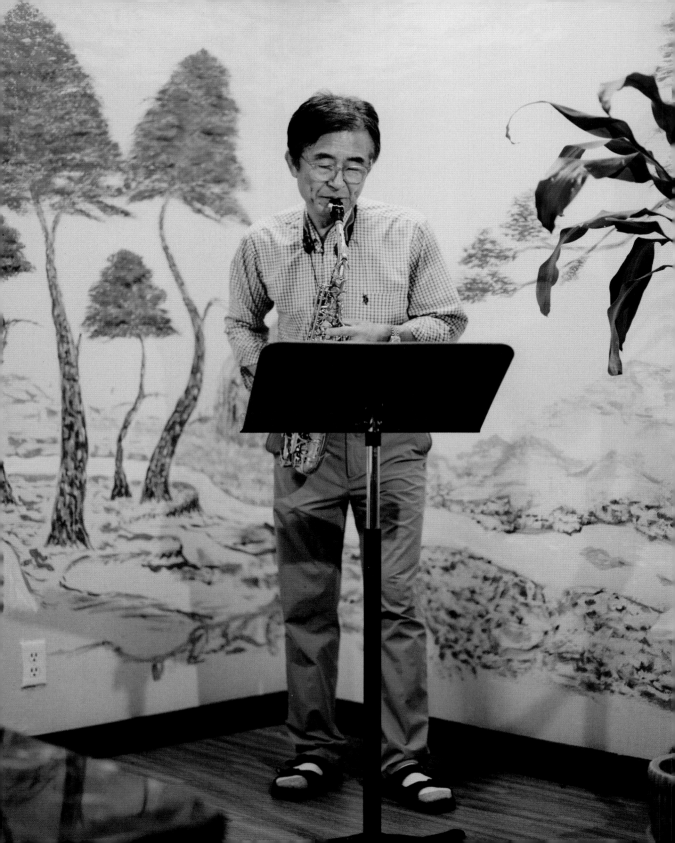

HAPPY MUSIC

DO HYUN KIM
김도현
2426 W. 8th St. #212, Los Angeles, CA 90057

WHILE WORKING ON MY BOOK, I WAS INTRIGUED BY A SIGN IN A PLAZA on 8th Street that simply read "Happy Music." After dragging my feet for months, I finally decided to go in. That's where I met Mr. Kim.

Mr. Kim moved to the United States in 2012 when his father's health started worsening. As he moved here to care for his ailing father, he looked for opportunities to start a business, especially one that pertained to his love of music. After noticing the growing number of elders in Koreatown, Mr. Kim opened Happy Music—a music school, karaoke room, and party hall for the elderly—three years ago. He teaches singing, saxophone, and drums, but perhaps the biggest draw of his business is the karaoke rooms for the elderly. When I visited him, there was a large group of senior citizens bellowing "Living on a Prayer" in a karaoke room and having raucous fun.

Mr. Kim explained that there are few places in Koreatown where elders can gather where they feel comfortable and safe to let loose. Interior spaces like this are vital for seniors to express and enjoy themselves. Most of the elders who frequent the place live in Koreatown—they hold birthday parties, class gatherings, and even business meetings. Koreans love to sing and dance, and for many elders who have kept a strict exterior facade in their daily lives, this space allows them to be themselves, even if for just a few hours.

Mr. Kim himself loves to practice the saxophone and drums when there aren't customers around. He enjoys jazz, particularly Louis Armstrong, and Korean folk music known as *trot*. Trot has recently experienced a resurgence in Korea, and Mr. Kim is riding that wave fully, writing and composing his own songs. However, he said he was too shy to play any of his songs for me.

TOM'S ONE HOUR PHOTO

TOM TUONG AND LISA LE
4158 Beverly Blvd., Los Angeles, CA 90004

I WALKED INTO TOM'S ONE HOUR PHOTO FOR SOME PRESS PHOTOS FOR *Koreatown Dreaming,* and of course I ended up talking to the owner. Tom Tuong and Lisa Le arrived from Vietnam forty years ago and have been running their photo business since 1991. Business was good in the early days of film processing, but with the advent and proliferation of digital photography, demand for their services fell.

Their store catapulted to fame after Kacey Musgraves had her photos taken there while on tour and shared it through social media. Since then, it has become a phenomenon. As a younger generation discovers the beauty of analog film and yearns for nostalgic aesthetics in their self-expression, Tom's One Hour Photo is perfectly poised to meet that demand. It was incredible to be directed by Tom and observe his attention to detail. A slight tilt of the book so that the gold foil would catch light perfectly. The perfect hand arrangement to not obscure the book. The rose to bring out the romance of the American dream.

While Koreatown in name, the area is home to a variety of Asian immigrant communities and businesses. Before the Watts riots in 1965, Koreatown was home to many Japanese residents, some of whom still remain. Thai and Vietnamese businesses dot the streets of Koreatown, and most recently, a four-block area on the northwest of Koreatown was designated Little Bangladesh to reflect the growing cultural and culinary impact of L.A.'s Bangladeshis. Outside of Koreatown, there are numerous Asian communities—Historic Filipinotown, San Gabriel Valley—home to many new and old Chinese immigrants, Little Tokyo, and Thai Town, among others.

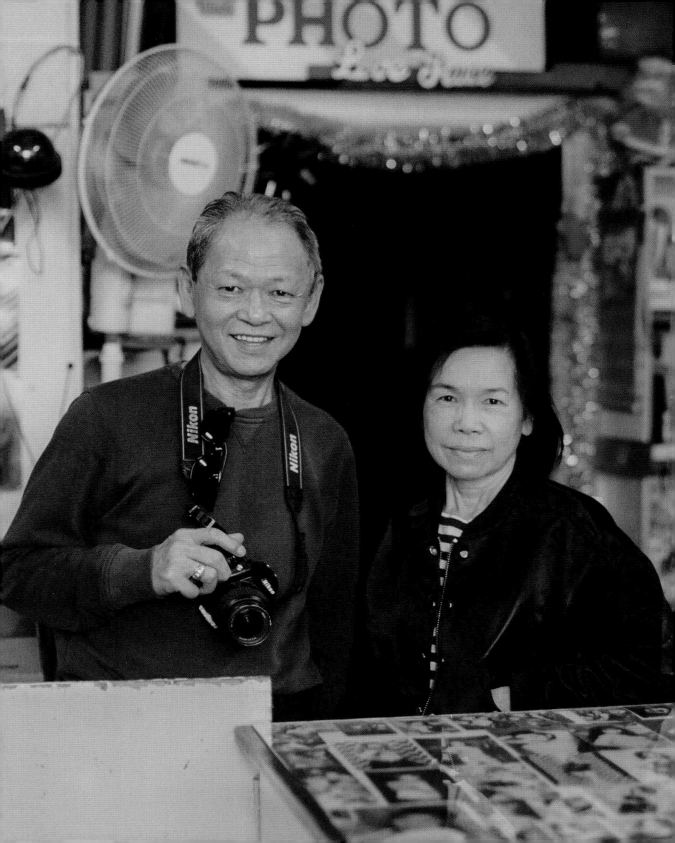

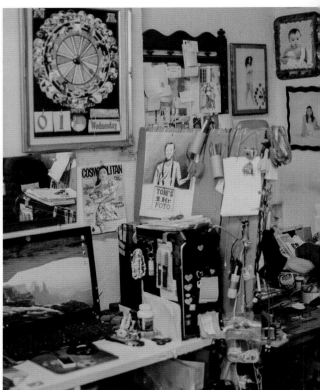

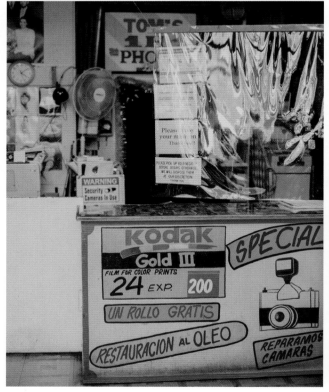

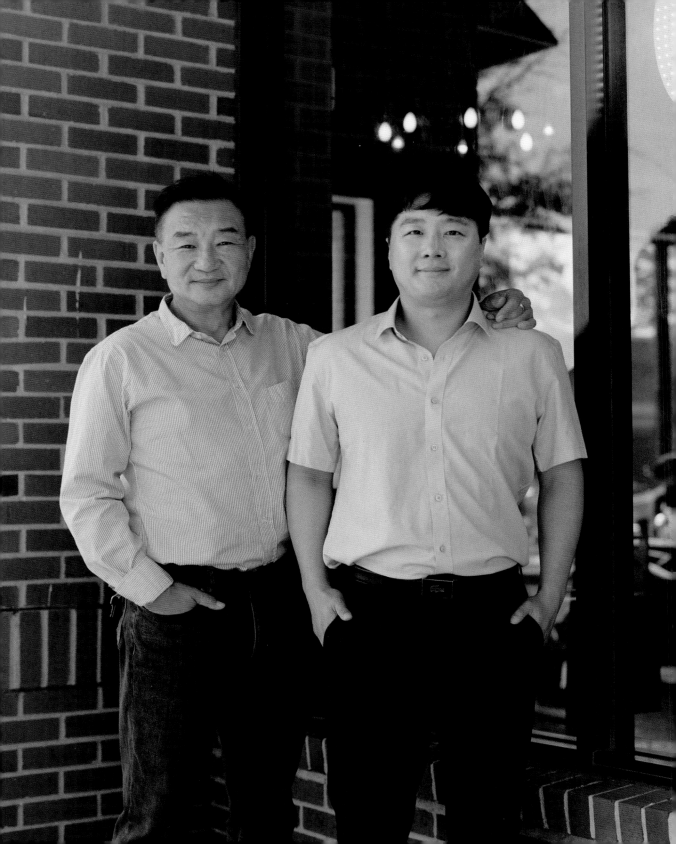

SHILLA BAKERY
(ANNANDALE, VA)

RICHARD AND SONG HUN YU
7039 Little River Turnpike, Annandale, VA 22003

SHILLA BAKERY BEGAN AS A PASSION PROJECT BY RICHARD AND SONG Hun Yu, two Korean immigrants who missed the taste of the baked goods they were used to. Before chain Asian bakeries like Paris Baguette and Tous Les Jours arrived on the scene, the Yus worked together with bakers and chefs from South Korea to develop a menu that would serve the Korean immigrant community in Virginia. Shilla Bakery opened in 1999 and was an immediate success, as immigrants nostalgic for the taste of red bean donuts and curry croquettes flocked to the store for their fill. Later, competitors and saboteurs sprang up, but Mr. Yu credits his bakery's longevity to his and Mrs. Yu's commitment to fresh ingredients and the reliability of their service. After rebuffing many offers to franchise their brand, Mr. Yu finally relented, but only after his son Richard became involved in the process.

Richard remembers growing up without seeing his parents much because they were always up early to bake bread. As the years went by, he witnessed the clientele of Shilla Bakery diversify until one day, in 2017, he was struck by how unique the business was, to be a juncture for so many people from all walks of life. That was the moment when it clicked for him that he wanted to be more involved. He quit his job in corporate law and began working at the bakery and devising a franchise strategy with his father. He learned all the legal and procedural intricacies and put together a franchisee operating manual. Over the next five years, the family was able to open three new franchises. It remains a work in progress, trying to balance quality control while allowing each franchisee autonomy in decision-making.

Even in the face of corporate competitors, Shilla Bakery thrives. Customers enjoy the mom-and-pop feel of the small franchise. Richard's favorite thing about Shilla Bakery is that it's a place that brings joy and warmth. What more could you want?

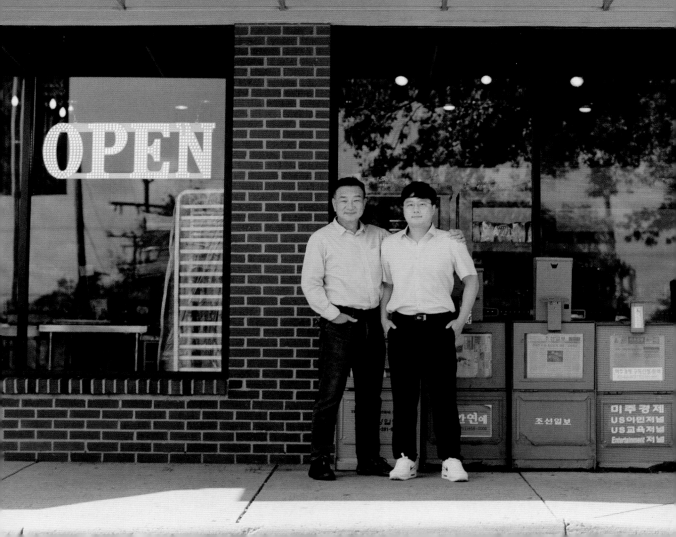

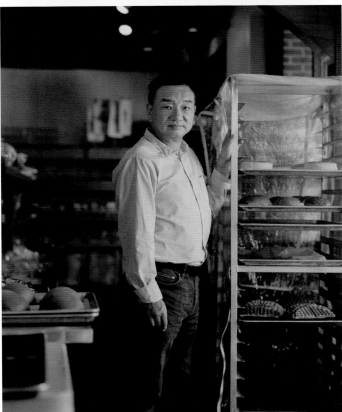

MOORIMGOONG MARTIAL ARTS

YONG MOON, ARI MOON, AND DAVID MOON
1149 Crenshaw Blvd., Los Angeles, CA 90019

BORN INTO A FAMILY OF MARTIAL ARTISTS, GREAT GRANDMASTER YONG Moon has taught martial arts for more than fifty-three years. In 1979, he immigrated to the United States through the invitation of the New Orleans mayor to open a martial arts school. After teaching for more than a decade, he moved to L.A. and opened Moorimgoong Martial Arts in 1992 after witnessing a fight between a father and son in his neighborhood. In addition to teaching fighting and self-defense techniques, Great Grandmaster Moon wanted to create a place in the community to teach discipline and character and also to deter teenagers from falling into drug and gang activity. He recalls many students over the years who were going down the wrong path who he helped mentor and are now successful members of society.

Great Grandmaster Master Moon and his wife, Grandmaster Ari Moon, see their mission as being a pillar of support and strength in their community. David Moon, their son, plans to take over the school in the coming years. He plans to continue teaching moorim-do, a mixture of the best techniques of kung fu and tae kwon do, while modernizing the school to attract and train participants who are interested in competing in mixed martial arts (MMA) or Ultimate Fighting Championship (UFC). Moorimgoong has students of all backgrounds and ages, and for many of the younger students, the martial arts center was a valuable reprieve during a tough pandemic year. Great Grandmaster Moon says that there is no greater blessing than to see his son take over his life's work and continue his legacy.

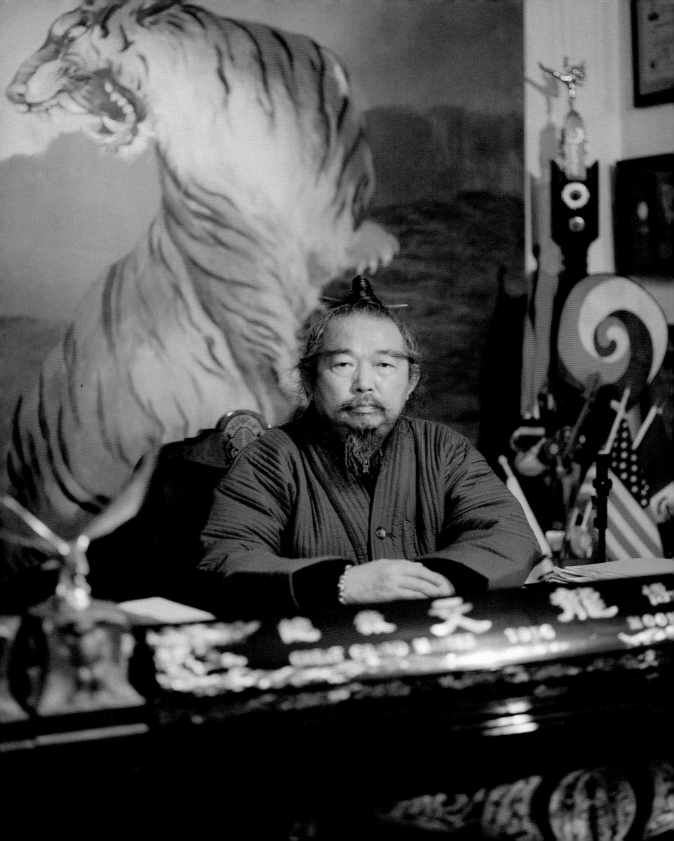

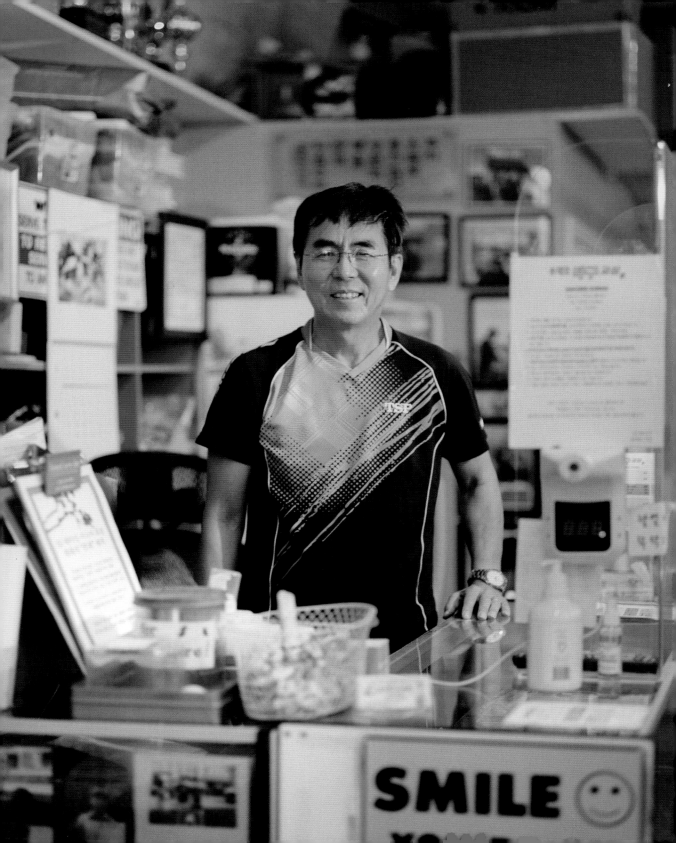

SONG JEHO
TABLE TENNIS CLUB

JE HO SONG
송제호

1049 S. Grand View St., Los Angeles, CA 90006

SONG JE HO FIRST VISITED THE UNITED STATES IN 1980 AS A TABLE TENNIS athlete competing in the US Open. After seeing the opportunities available to him, he formally moved stateside in 1983 with nothing but a clothing trunk and a table tennis bag. When he first arrived, he wasn't preoccupied with attaining a visa or finding a permanent home; he just wanted to play table tennis with his fellow gyopo (compatriot immigrants). He played in parks in Koreatown and attended invitational tournaments. After a few months, however, he ran out of money and began a series of odd jobs such as cashiering, janitoring, and painting. He reached a low point when his visa ran out and was about to return to South Korea when he met his wife.

As his family grew, Song forgot about table tennis for almost twenty years, working hard at various jobs to provide for his family. One day, a fellow church member approached him and said he wanted to support him in starting a table tennis club and gifted him ten thousand dollars. With additional support from friends and family, Song Jeho Table Tennis Club was born in 2009. For many older Koreans who spent decades only working, this space has become an outlet to exercise and socialize with community members. Song said that this club has allowed him to share his love with all who enter the door. He loves the life he's been given.

Before the pandemic hit, there were more than one hundred members who played regularly, including a ninety-four-year-old man. Since the lockdown started, the club was closed for eleven months and only reopened in 2022. Places like these are integral to the social fabric of a community like Koreatown, serving as a hub where people can have a third space outside of their work and home lives, all while engaging in healthy activity. I believe these places will become even more important as more first-generation Korean immigrants enter retirement age.

1-2-3 PRESCHOOL

JIN KYUNG LEE
이진경
811 S. Manhattan Pl., Los Angeles, CA 90005

MRS. LEE MOVED TO THE UNITED STATES IN 1980 THROUGH HER HUSBAND'S work. Back then, there wasn't a Korean kindergarten; most of that work fell to local churches and its volunteers. When she initially arrived, she observed that many children were living like orphans—their parents working incessantly to eke out a living, leading them to be isolated. Given her heart for children, she worked at various churches and informal kindergartens to care for these neglected children. In 1987, she decided to start her own preschool.

In the early days, it was stressful trying to take care of children with limited staff and expertise. Mrs. Lee had to develop a curriculum from scratch and iterate every year based on how her children responded. Though she was initially concerned with teaching essential fundamentals, she realized over time that her lessons had to be fun and sensory. While children might forget facts, their bodies would remember strong sensations that they experienced through activity. She used to feel competitive and offended when teachers from other schools stole her curriculum, but now she likes the idea of her curriculum being shared widely.

These days, more and more non-Korean children attend her school, and they enjoy learning Korean and eating Korean food, no doubt thanks to the influence of K-pop. She believes that this tradition helps children learn empathy and grow to appreciate diversity. She is thankful that parents go out of their way to enroll their children in her school. She says that she is still full of energy and will keep going for as long as she can.

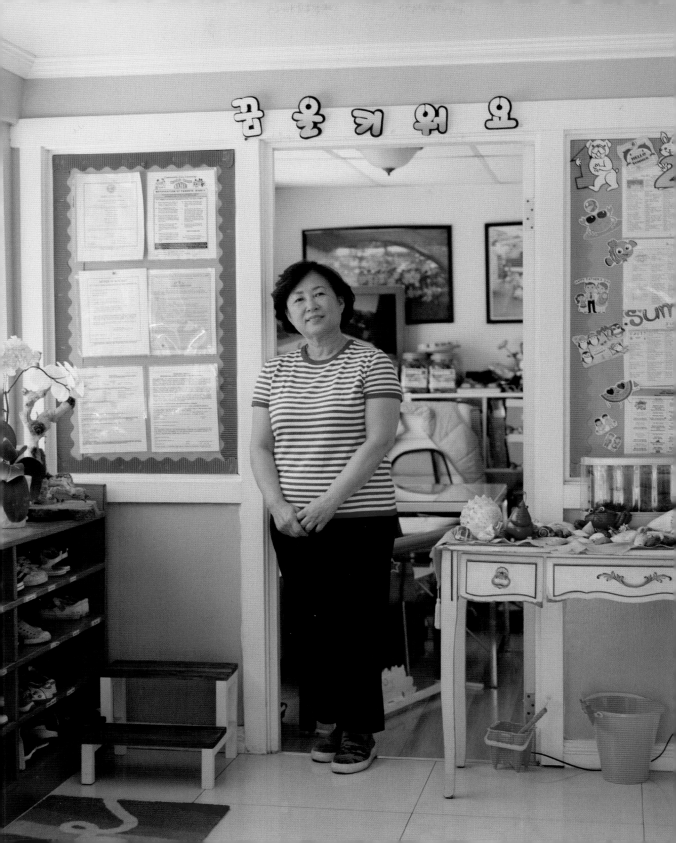

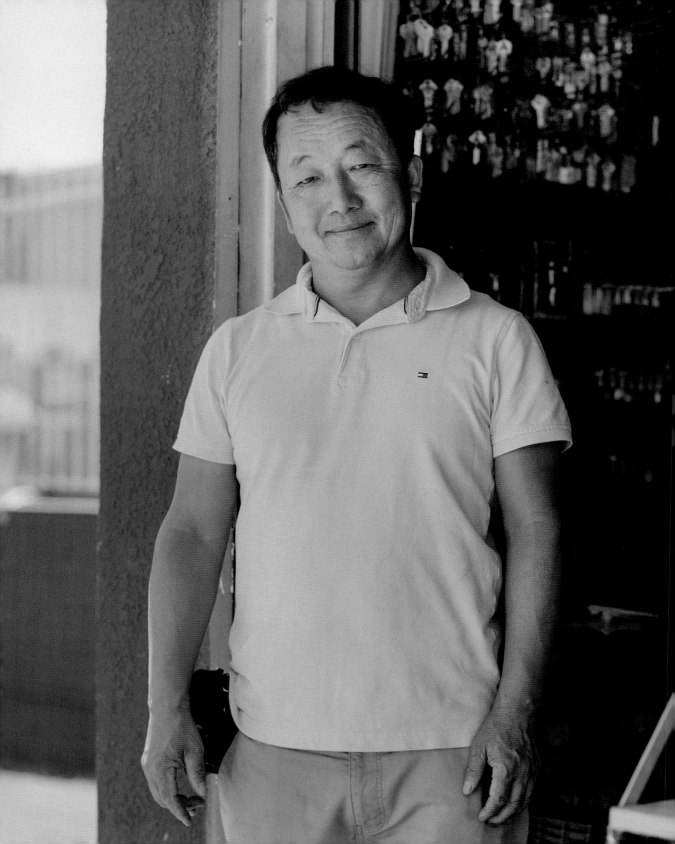

ARIRANG LOCKSMITH

DOUGLAS KIM

1901 W. 8th St. #L, Los Angeles, CA 90057

DOUGLAS KIM ARRIVED IN THE UNITED STATES THROUGH THE INVITATION of his brother-in-law in 2003. After decades-long stints in military-adjacent fields, he had several interactions with American GIs and from them developed a curiosity about living in America. As opportunities for advancement in his field waned in the early 2000s, Mr. Kim arrived in the United States and worked in business marketing, handling accounts between clients and printers. For many years, the company did well, and Mr. Kim settled into a comfortable life. But their company abruptly restructured, forcing both Mr. Kim and his brother-in-law out of the company.

While that was unfolding, his brother-in-law started a locksmith business, and within a few years, it was thriving. At his brother-in-law's behest, Mr. Kim also joined the locksmith business, a trade that he found easy to enter, given that he was good with his hands and had prior experience from working in mechanical roles in the military. The learning curve was easy and he picked up new skills rapidly. Twelve years later, he still enjoys learning about new lock systems and technologies, the intricacies of his trade. He learns everything from watching YouTube videos and trying things out. As newer technologies emerge, especially with the advent of mobile keys, he thinks the concept of a physical lock and key is becoming obsolete. He feels fortunate that he was able to work in a time when his skills were most valuable and useful. His favorite thing about being a locksmith is that it's an inherently helpful role—people are always grateful when he shows up to help them out of a predicament.

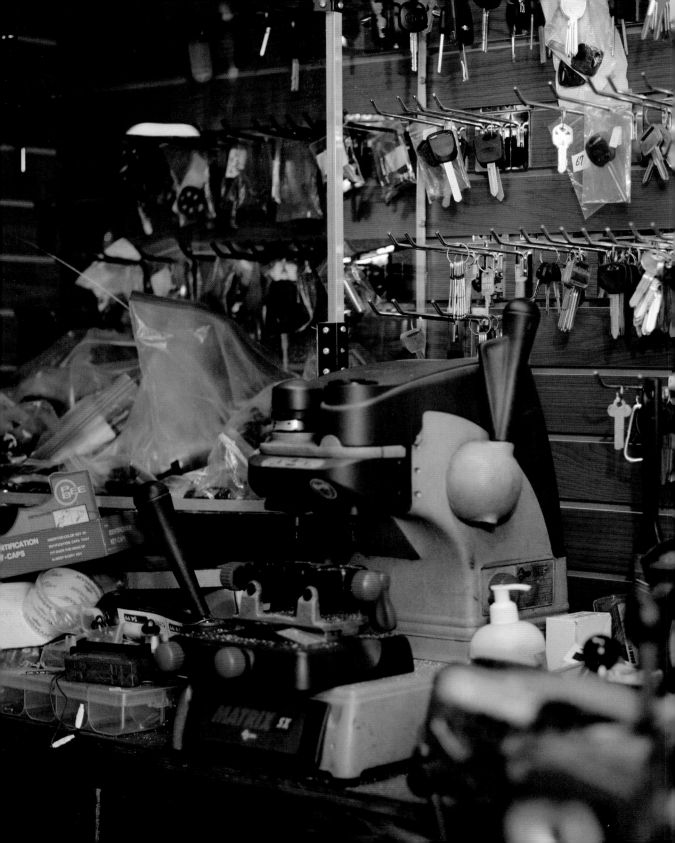

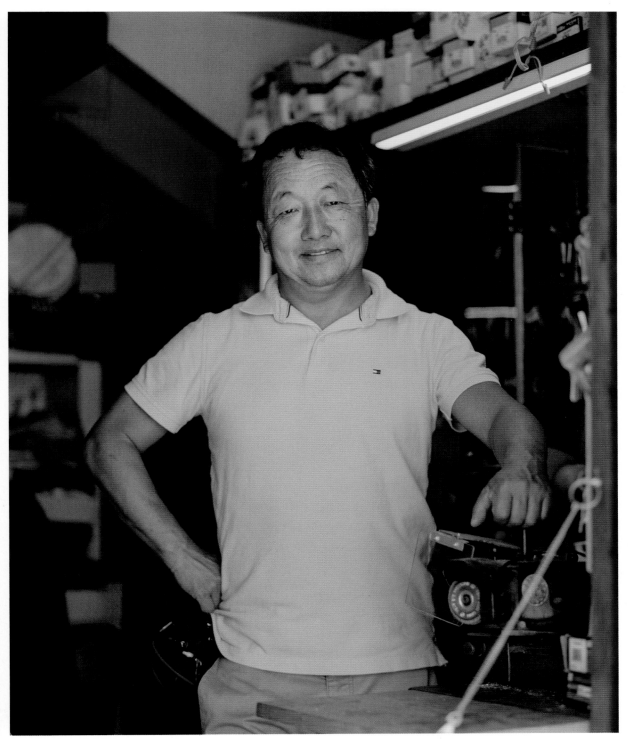

HIGH SOCIETY

RICHARD LIM AND DAVID LIM
8406 W. 3rd St., Los Angeles, CA 90048

RICHARD LIM FOUNDED HIGH SOCIETY, THE FIRST KOREAN CUSTOM TAILOR in Koreatown, in 1968. Before immigrating to the United States, Lim studied engineering and then worked at the front of the house at a tailor, where he learned the trade. His business started because Korean immigrants had no place to get their suits repaired, and over time, he expanded so much that he was able to bring over his brothers from South Korea to open their own tailoring businesses. Many customers came to him through word of mouth, as they heard of his fast, efficient, and affordable working style. As word about Mr. Lim's business grew, Hollywood costume designers and stylists came calling and he started designing for L.A.'s A-list celebrities, including Prince, Kobe Bryant, and Angelina Jolie. In more recent history, he created the iconic custom jacket for Ryan Gosling in the hit action movie *Drive*. While Mr. Lim took the helm on design and client relations, his wife handled the accounting. Mr. Lim's skilled chief tailor, Mr. Han, still works at the store, even since Mr. Lim has passed away.

Mr. Lim's son David, who grew up witnessing his father measuring athletes and celebrities, tried his best to forge a path for himself outside of tailoring. He entered the denim market in its heyday in 2001, a journey that took him all over the United States and the world working with iconic brands. When Mr. Lim passed away in 2018, David committed to continuing his father's legacy by taking over the business. His father's loyal customers continue to come in, regaling him with his father's antics and sharing fond memories and stories. David was struck by how gregarious and charismatic his father had been with clients, even as he was stoic and aloof at home. Mr. Lim's aspiration for his business, and the vision to name it High Society, was surprisingly forward-thinking and bold for an immigrant who landed in a new country in 1968. His lesson to David was to move confidently in this world and create a space where people can aspire to something higher than themselves. As the landscape of fashion changes, David relishes the challenge of maintaining the craft of tailoring, while merging it with something more modern and retail-focused.

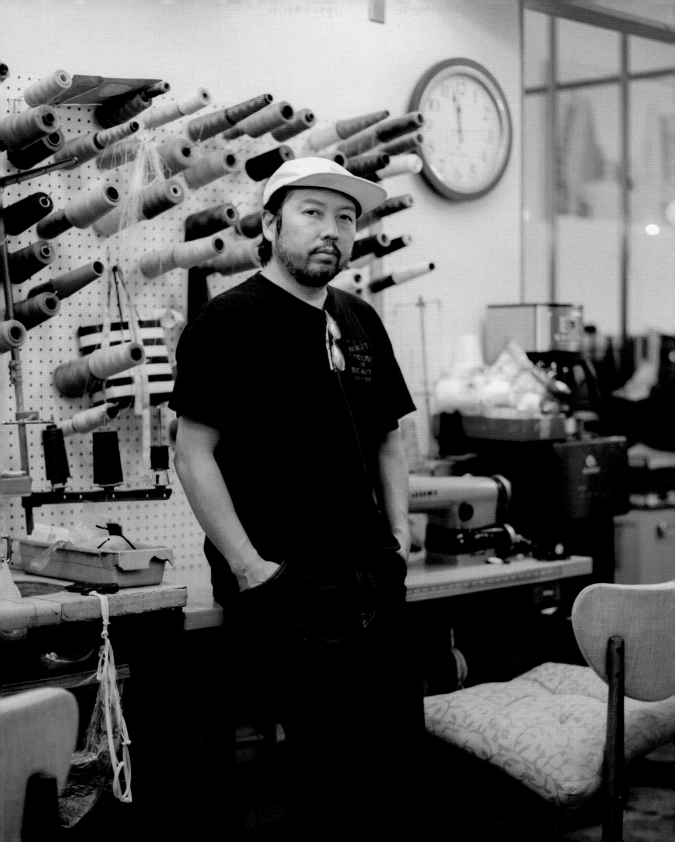

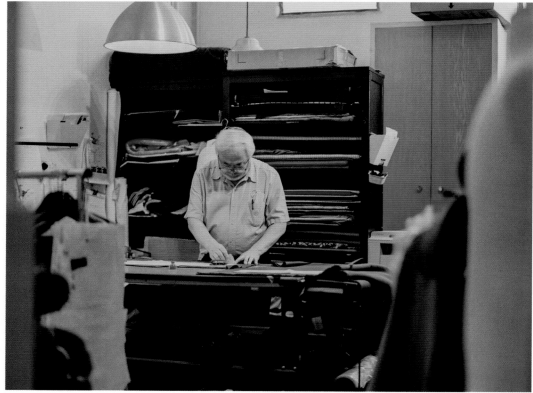

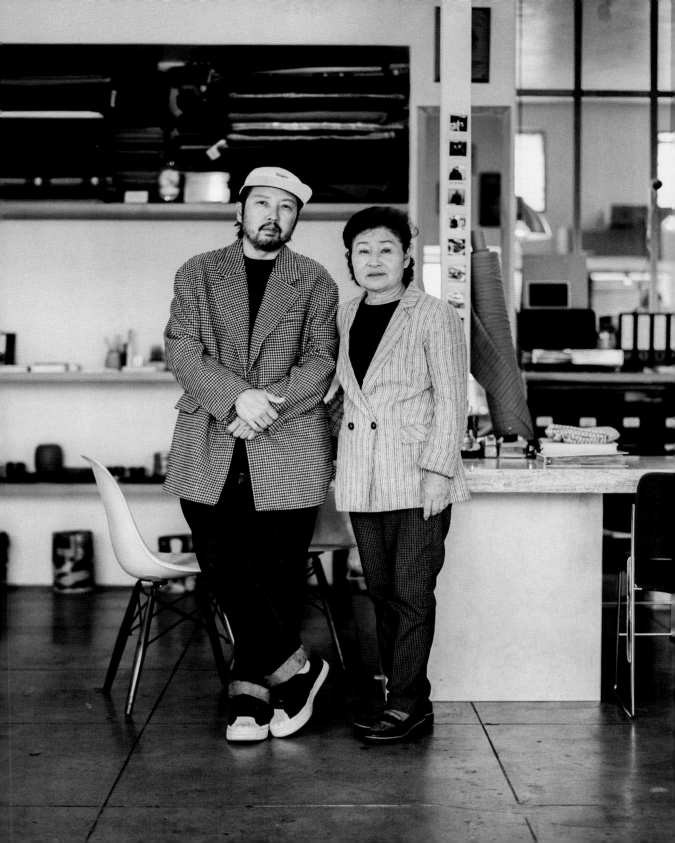

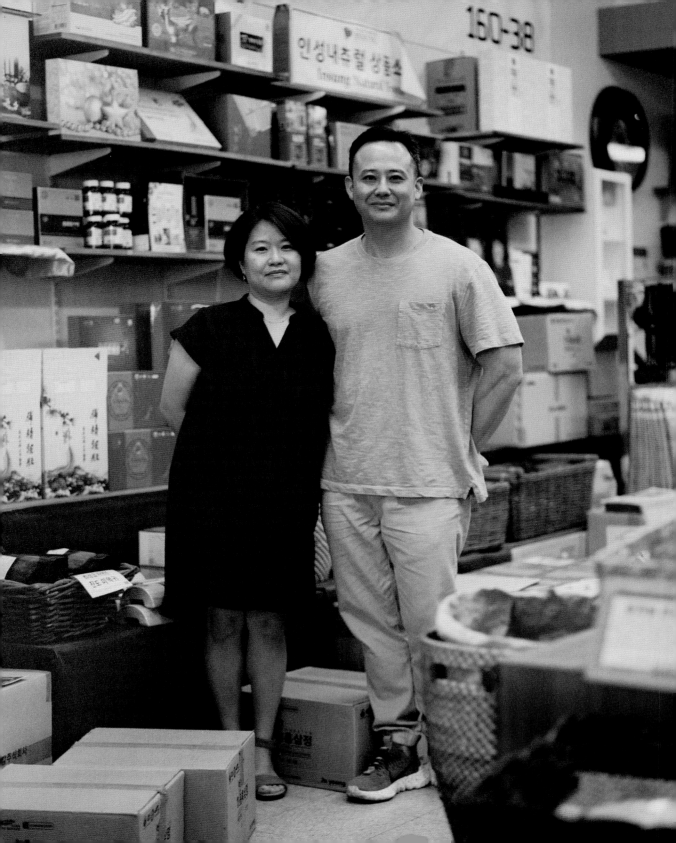

CHILGOK, NATURAL AND HOLISTIC FOOD MARKET
(FLUSHING, NY)

BYUNG GUN PARK
160-38 Northern Blvd., Flushing, NY 11358

CHILGOK, NATURAL AND HOLISTIC FOOD MARKET OPENED IN 1998 AND WAS inherited by the owner's nephew Byung Gun Park ten years later. Mr. Park initially moved to the United States to study acupuncture and psychology. He had an abiding interest in meditation and healthy living, so when his uncle offered him the store, he naturally took it. The store was one of the only family-run stores on the East Coast that milled and ground grains into healthy mixes, all of which were concocted by Mr. Park and his uncle over the years. For instance, misugaru, a popular multigrain powdered drink among children and adults, was only available at their store before there were other commercial offerings. The store's popularity spread through word of mouth, and numerous athletes, including world-renowned soccer player Pelé, have visited. Mr. Park remarked on the diversity of the store's clientele, which includes athletes, pastors, pilots, students, health practitioners, and others. The unique blends and mixes offer quick, nutritious meals that are ideal for people who are constantly on the go.

Flushing, Queens, used to be a Korean hub from the '80s up until the mid-2000s, when the Chinese community began investing in property near the Main Street 7 subway stop. Since then, many Korean businesses have moved farther east along Northern Boulevard to Murray Hill and Bayside. Flushing continues to be home to a large immigrant population and is considered a destination for many youth of the Asian diaspora who are willing to ride the 7 train all the way to the end for authentic food that is hard to come by anywhere else.

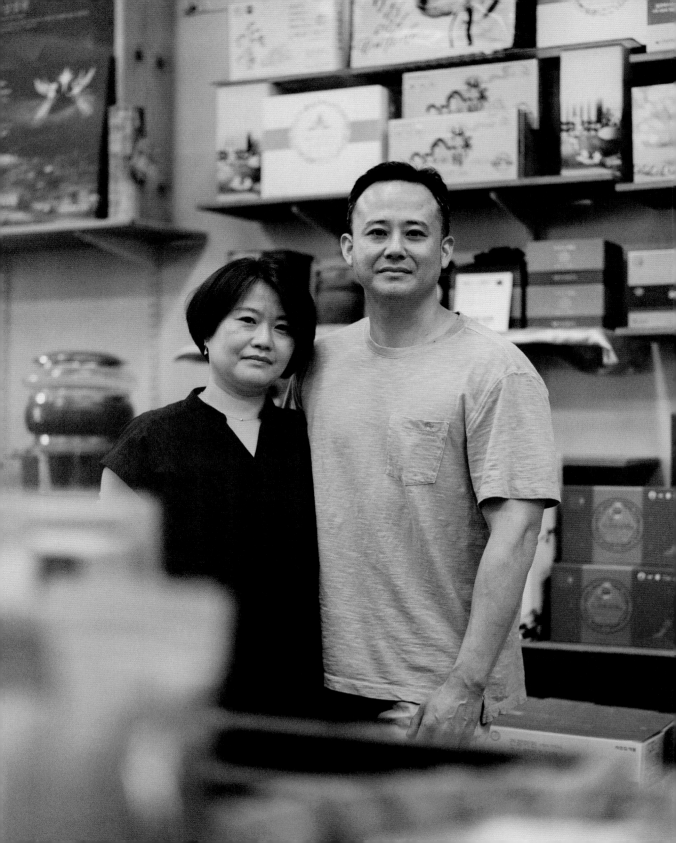

HANGAWI
(NEW YORK, NY)

TERRI AND WILLIAM CHOI
12 E. 32nd St., New York, NY 10016

HANGAWI'S FOUNDERS, TERRI AND WILLIAM CHOI, INITIALLY MET AS FAMILY friends in Singapore and reconnected in New York in the '80s. During the period when William took over his brother's restaurant in Flushing, Queens, he became a vegetarian for health reasons. It didn't sit right with him, working in a restaurant that served meat while he himself was a vegetarian, so he started ideating on creating the first upscale Korean vegetarian restaurant in Manhattan. While vegetarianism is commonplace now, it was a bold move to start a purely Korean vegetarian restaurant in 1994. With William's culinary and operational nous and Terri's background in fashion PR, the two created Hangawi, complete with a beautiful interior space, rich with Korean cultural motifs and artwork. Within months of opening, the restaurant received two stars from *New York Times* food critic Ruth Reichl and has been packed ever since, attracting celebrities like Richard Gere, Nicole Kidman, and Gwyneth Paltrow.

Even after the glowing reviews, it took Hangawi three to four years to develop and maintain a steady clientele. The pair constantly evolved to ensure their menu wouldn't be stale. They had to adapt to their customers as well, such as by installing a well under their seated table so that their non-Korean customers would be able to endure sitting on the floor while eating. They adapted their menu from jungsik (proper meals), where all the dishes were served at once, to a more familiar three-course meal. Every staff member had to be meticulously trained to explain the ingredients and meaning behind the dish. Hangawi takes pride in the provenance of its ingredients—sannamul (edible leaves) from Gangwon-do or wild green tea from Jiri mountain, among others, shipped via airfreight directly to New York.

While Koreatown in Manhattan changes at the speed of light, with new restaurants catering to the latest trends and buzzworthy dishes, Hangawi has seen many come and go in the past almost thirty years that it's been open. By committing to a truly unique offering and still being the only Korean vegetarian restaurant in the country, Terri and William have created a bold legacy, a stronghold in a city that is ever-evolving.

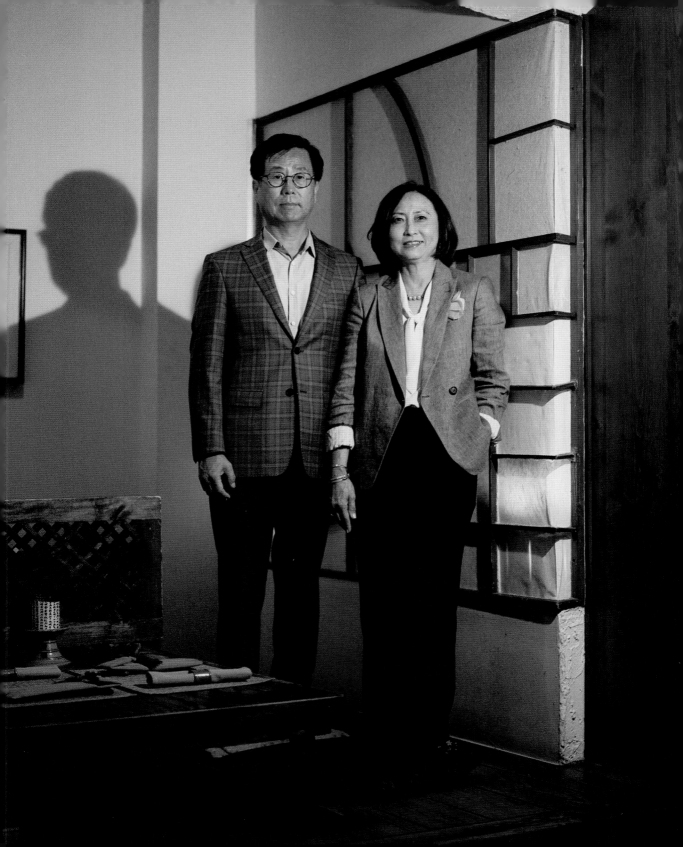

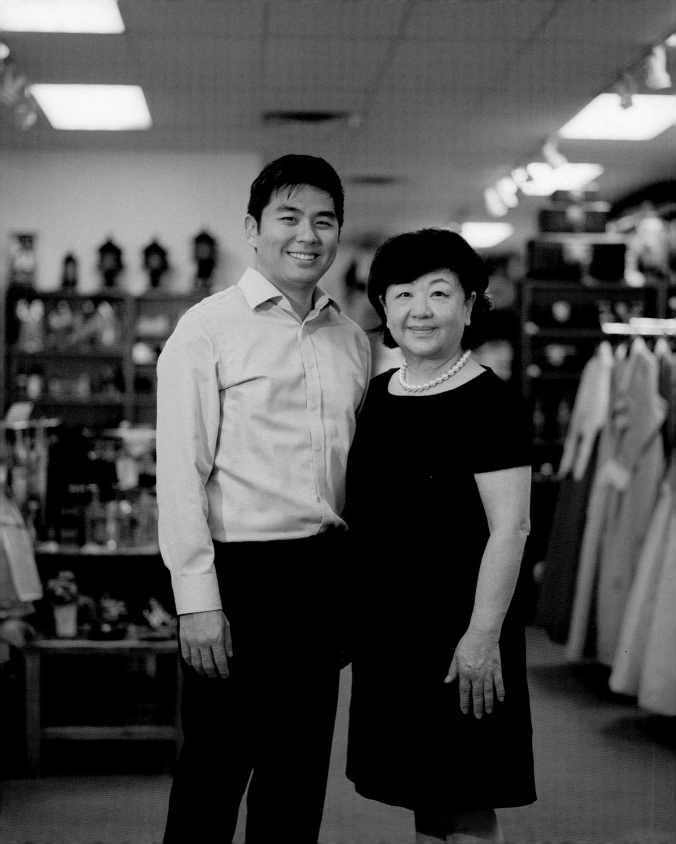

ROSE BEDDING & INTERIOR
(PALISADES PARK, NJ)

SUNG MI LEE
407 Broad Ave. Ste. D, Palisades Park, NJ 07650

SUNG MI LEE ARRIVED IN THE UNITED STATES IN 1981 INTENDING TO STUDY music at New York University (NYU). Her husband was pursuing a PhD at NYU Stern at the time and asked whether she could help out financially while he completed his studies. Sung Mi opened a small Korean craft store on the second floor of a building in New York. Customers flocked to her store, given that it was the only one of its kind back then, fascinated by Korean craft supplies and extra-plush blankets they had never seen before. As her business thrived, her mother in South Korea continued supplying her with inventory and eventually joined Sung Mi in the United States, where she opened her own store in Flushing, Queens. Sung Mi opened Rose Bedding and Interior in Palisades Park in 1997 as more Koreans began moving to New Jersey.

Palisades Park has hosted Korean life and immigration for more than twenty-five years. Ms. Lee's store is one of the few that have kept their doors open that whole time. While initially just a Korean craft store, the business has since expanded to include all things cultural. Today, Sung Mi rents out hanboks and emcees paebaek (wedding) and dol (first birthday) ceremonies as a service. She has become the de facto spokesperson in her area to talk about Korean culture at schools, community events, and so on. Eventually, her son Aaron Lee joined the business by emceeing paebaek ceremonies because a fluent English speaker is often needed to help guests who are not Korean understand the customs. Aaron started hosting paebaeks in college as a favor to his mother, but over time he has become more formally involved in the business, on top of maintaining his full-time corporate job. He finds the process of educating and sharing his Korean culture meaningful, and it really hit home when his own friends started to marry and he got to be intimately involved with the process.

While Sung Mi wants to retire, she is passionate about sharing her Korean culture with friends and customers. Her dream would be to open a museum with an exhibition space on the first floor and an event space on the second. Through her work, she continues to play the vital role of being a bridge between two cultures, not just for her own descendants but for anyone who wants to learn.

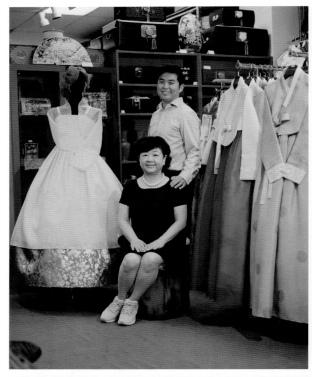

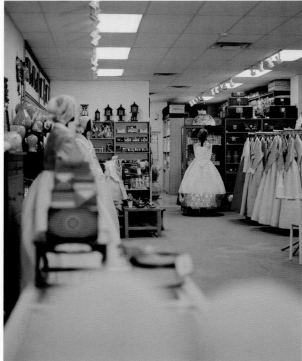

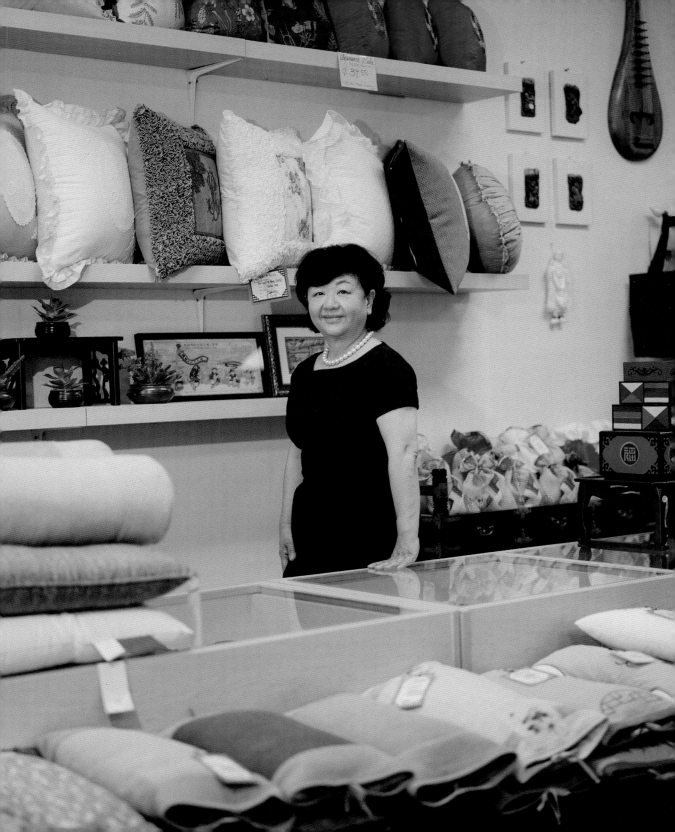

BADA STORY
(FORT LEE, NJ)

BRANDON PARK
799 Abbott Blvd., Fort Lee, NJ 07024

WHEN BADA STORY FIRST OPENED IN 2010, IT WAS THE FIRST SEAFOOD restaurant that served fresh Korean seafood flown in from South Korea. While Japanese seafood enjoys a vaunted reputation in the United States, the delicacy of Korean seafood is largely unknown to those outside of the Korean community. Kevin Park, who has been a manager at the store since its initial days, remembers how the original owner would fly to Korea to source region-specific abalone and sea cucumbers that would then be air-freighted to the East Coast.

In 2018, Bada Story was purchased by its current owner, Brandon Park, who acquired a taste for seafood through his parents and the frequent visits he and his family made to the coastal city of Busan. It was a taste that was unforgettable and deeply lodged in his nascent memories, so when he encountered Bada Story in New Jersey while working in New York, he felt an instant connection. He worked long days and nights back then and would look forward to eating Korean seafood as a salve to his busy life. When the opportunity came to purchase the store, he didn't hesitate. He didn't change much about the store; store operations remain largely the same with Kevin at the helm, the only major change being the updated menu items that appeal to a more modern clientele. With its reputation of top-quality seafood enforced continuously through hard work, Bada Story hopes to bring in a diverse group of customers for many years to come.

Many Koreans settled in New Jersey because of its proximity to New York City, combined with its relatively more affordable homes and excellent schools. Koreans built communities in Palisades Park and Fort Lee, both places that are accessible from the city via a quick bus ride, while feeling like a suburb that made it attractive to families. It is common for Koreans from New York City to often take day trips to New Jersey to get their groceries at the giant H Mart, indulge in spas, and dine at Korean BBQ restaurants before returning to the city.

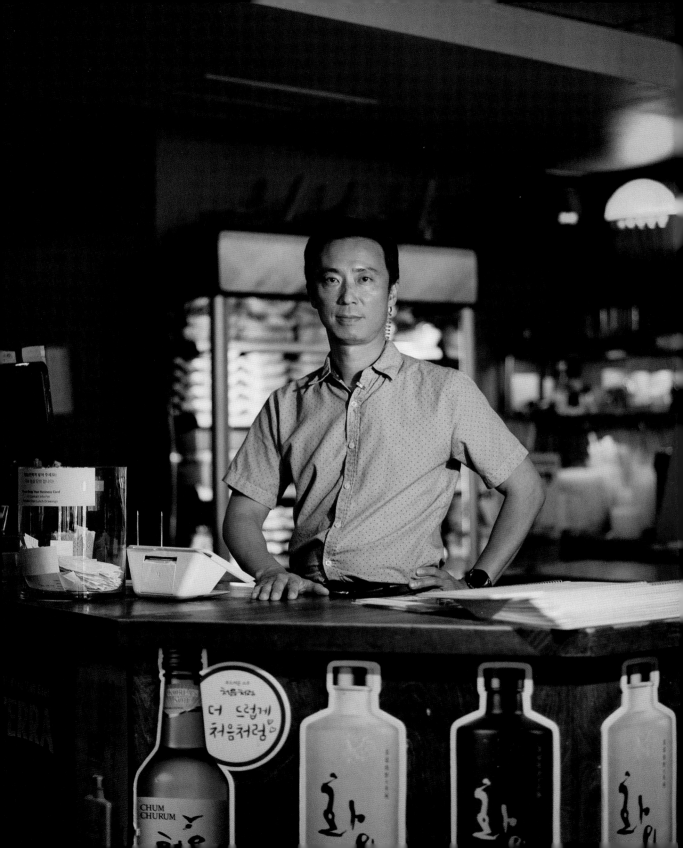

Restaurants

음식점

Dreaming Through Food: The Evolution of Koreatown's Restaurants

BY CATHY PARK, CONTRIBUTING WRITER AT *EATER*

Koreatown may not be the flashiest or most glamorous part of Los Angeles. However, locals and visitors alike will attest that Koreatown houses some of the greatest eateries in the world. Whether through marinated meats sizzling on a charcoal grill, hearty stews served in stone pots, or stir-fried rice cakes doused in a spicy red sauce, Koreatown embraces the vast array of foods eaten and shared in a distant Korea.

Restaurants, through the course of their lives, typically adapt and expand their offerings. Yet, a part of the intrigue of Koreatown comes from knowing that most of its old guards have held relatively firm to their original menus and recipes. Maybe that's a reflection of reluctance to acclimate, or perhaps it's a display of the testament of these restaurant owners—how they aspire to retain the dishes they remember from their past lives without allowing new realities to dilute their craft.

FOOD AS COMMUNITY

When Koreans began immigrating to the United States and settling in California, they quickly developed close-knit communities that revolved around food, and many worked in the industry as fruit sellers, grocery owners, and farm laborers. Koreans, like many other immigrants, relied on food as the centerpiece for their livelihoods and their sense of purpose and belonging in the United States.

Korea House was the first Korean restaurant that opened in Los Angeles, with a menu of nostalgia-inducing, standard Korean dishes. Before the establishment of Korea House and the quintessential Koreatown restaurants that L.A. knows and loves today, the restaurants opened by Korean immigrants served mostly Chinese-style dishes. Yet, to many of the immigrants who resided in Koreatown, restaurants—tucked away in these strip malls—reminded them of home and their past lives.

Over time, Koreatown restaurants have continued to serve as a safe haven for

immigrants. Dan Sung Sa, inspired by the tented street pubs of Korea, was the first pojangmacha-like bar in Los Angeles. Open 365 days a year, the late-night bar has served as a place for immigrants to celebrate holidays or let loose over bottles of soju and familiar Korean street food. Hat Bat Sul Lung Tang, another Koreatown classic, has been serving comforting Korean bone broth for more than thirty years. Though the restaurant is a favorite among longtime Koreatown residents, its growing percentage of non-Korean visitors exemplifies how Koreatown is solidifying its presence in L.A. through its food.

Though many eateries have come and gone on the streets of Koreatown, the resilience of the long-standing gems emphasizes the communal value of restaurants. Not only have they enabled newly arrived Koreans to build businesses through food from their homelands, but they have also empowered immigrants to share a piece of themselves with the surrounding community.

PRESERVING THE COMMUNITY

Since its inception, Koreatown has been through its fair share of tumultuous events. But for restaurants in particular, 2020 may have been the toughest of all. Through shifting start-stop regulations, restaurants had to navigate new financial insecurities unlike any they had ever faced before. No one could

have imagined how much the pandemic would change the restaurant landscape, with an especially drastic, adverse effect on small, independently owned eateries.

The hardships required many Koreatown restaurants to embrace change, implement new business models, and reinvent themselves. Myung Dong Kyoja, a spot specializing in knife-cut noodles and dumplings, embarked on a new chapter as an outdoor pocha, though this endeavor proved challenging, and noise complaints eventually led to its closure. For most, the continued focus on to-go orders was to be expected, as they pivoted to focus on takeout items to help meet the rising overhead costs. Still, the owners of Myung Dong Kyoja and others remained optimistic in their battle to keep their businesses afloat.

However, not all were so lucky. Some of Koreatown's longest-running restaurants that set up shop decades ago—like Dong Il Jang, Beverly Soon Tofu, Nak Won, and Jun Won—had no choice but to permanently close. They are no longer there to serve as sites of celebratory moments, community milestones, and congregation for many Koreans to savor in their favorite dishes.

Though the pandemic has undeniably been a threat to beloved Koreatown restaurants, it has also proven the resilience of Koreatown and its people. Local community

support has been especially crucial for restaurants, and in many ways, it revitalized the community and encouraged locals to band together in support of the very spots that have helped create the magic of Koreatown.

UPLIFTING THE COMMUNITY

Now in its recovery, Koreatown captures the heartening spirit of revival. Crowded outdoor tents still blanket familiar strip mall parking lots—some locals and visitors might even say that Koreatown has never looked better.

Koreatown embodies a duality that cements its humble essence. It thrives off of its old-time restaurants, but it also encourages new immigrants and restaurateurs to embark on their own, unique food ventures. In recent years, treasures have continued to pop up all across the neighborhood, as Koreatown has fully embraced its role as a hub for food trends—both old and new.

For example, Gol Tong Chicken, a one-man fried chicken shop that opened in 2017, tops classic Korean fried chicken with a slew of unexpected ingredients like pineapples, avocados, peaches, cheese, and peppers. Since 2014, Escala has fused bold Colombian flavors and ingredients with bits and pieces of Korean cuisine. Koreatown, with its entrepreneurial spirit, has certainly emboldened its people to get creative with food.

Though Koreatown's food scene is ever-evolving, we can only hope it will retain its history and charm, while paving the way for new tastes and restaurants to emerge. For Koreans, food is often seen as a vessel, not just for nourishment or cultural expression, but to care for one another. This view has always been at play on a larger scale in Koreatown—an unassuming pocket of L.A., where community truly prevails.

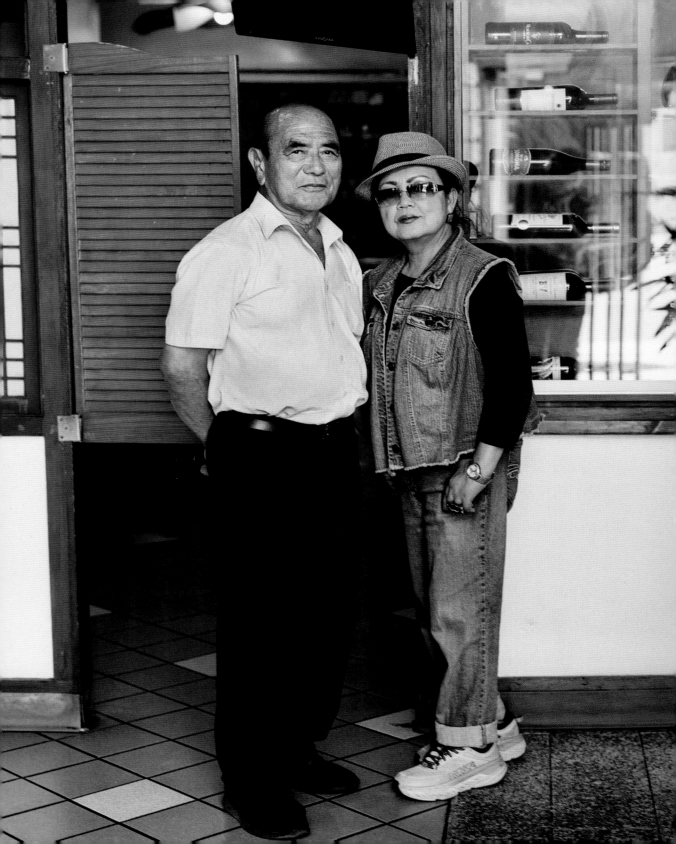

KANG NAM RESTAURANT

SANG HEON LEE AND ENNY LEE
4103 W. Olympic Blvd., Los Angeles, CA 90019

MR. AND MRS. LEE ARRIVED IN THE UNITED STATES IN 1971 AS TWO OF THE earliest members of a then-nascent Koreatown. They moved first to New York, where Mr. Lee worked in news, and then to Ohio, where the couple worked at a Ford factory in the morning and at a restaurant at night. When the energy crisis happened in the late '70s, the couple decided to move to Los Angeles and start their own business. Given Mr. Lee's prior restaurant experience in South Korea, there was no other option but to start a restaurant.

Kang Nam opened in 1983 as one of the first few Korean restaurants. Given their unique offerings, they've hosted some of the largest Korean figures in Los Angeles, both domestic and foreign. The neighborhood they were in was considered rough, and Mr. Lee formed strong friendships with the owner of a nearby bar, which was known to be a hub of gang activity. The bar owner took to Mr. Lee and would offer protection help whenever things got rowdy. In the late '80s, the neighborhood began to change, and his area became one of the safest places in Koreatown.

As owners of probably the oldest Korean restaurant still standing, Mr. and Mrs. Lee intend to keep going. To them, there's no one capable of taking over what they've built. As they approach close to forty years of business, their restaurant serves as a legacy to the contributions that Korean immigrants have made to the city of Los Angeles and beyond.

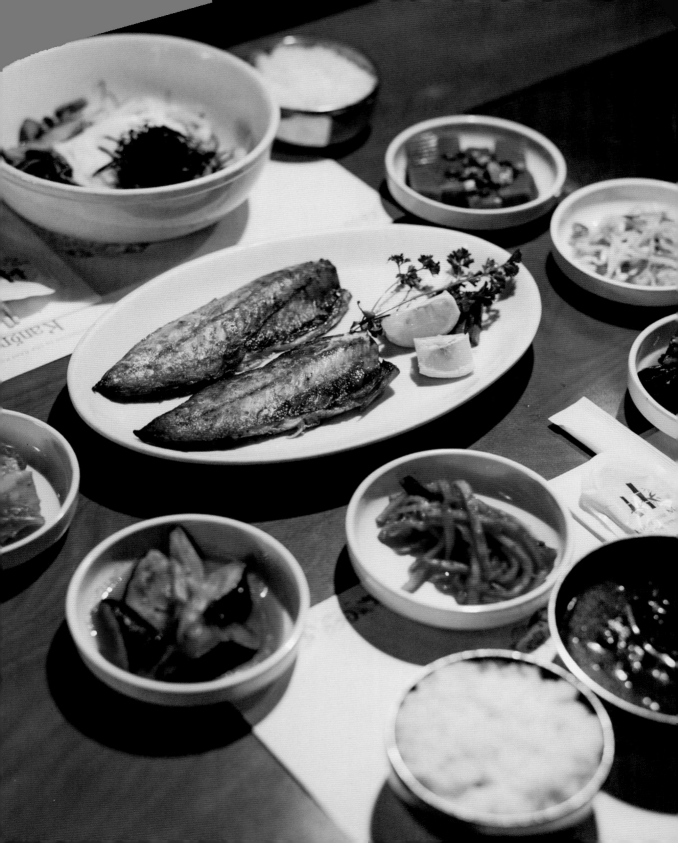

KOBAWOO HOUSE

BANA BAIK

698 S. Vermont Ave. #109, Los Angeles, CA 90005

BANA BAIK MOVED TO THE UNITED STATES ALONE IN 1976 IN SEARCH OF a better life and tried his hand at many odd jobs, including flipping burgers, before eventually opening Kobawoo House in 1983 on Beverly Boulevard. His friends called him Kobawoo, a famous cartoon character who was known for being bald but for a single strand of hair. Thus, his restaurant was named Kobawoo House, serving a Korean specialty known as bossam, a boiled pork dish.

Baik had no experience making Korean food when he first moved here, but a kind grandmother helped him in the initial stages for a few months. His parents were from Pyeongando in North Korea, where bossam was commonly eaten due to the region's colder climate. As he recollected his memories of food from his childhood, he started to develop and test recipes for what would become his signature dish at Kobawoo House. It was a difficult time when he first opened, when there were at most tens of thousands of Koreans, compared to the million-plus now. However, as one of the long-enduring pioneer restaurants, Kobawoo House enjoys wide appeal from locals and non-Koreans alike.

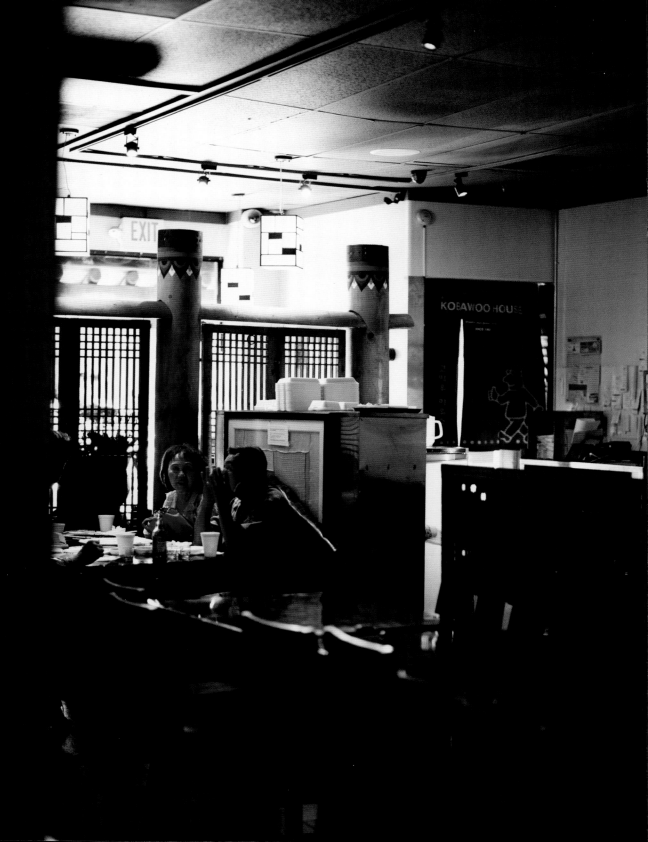

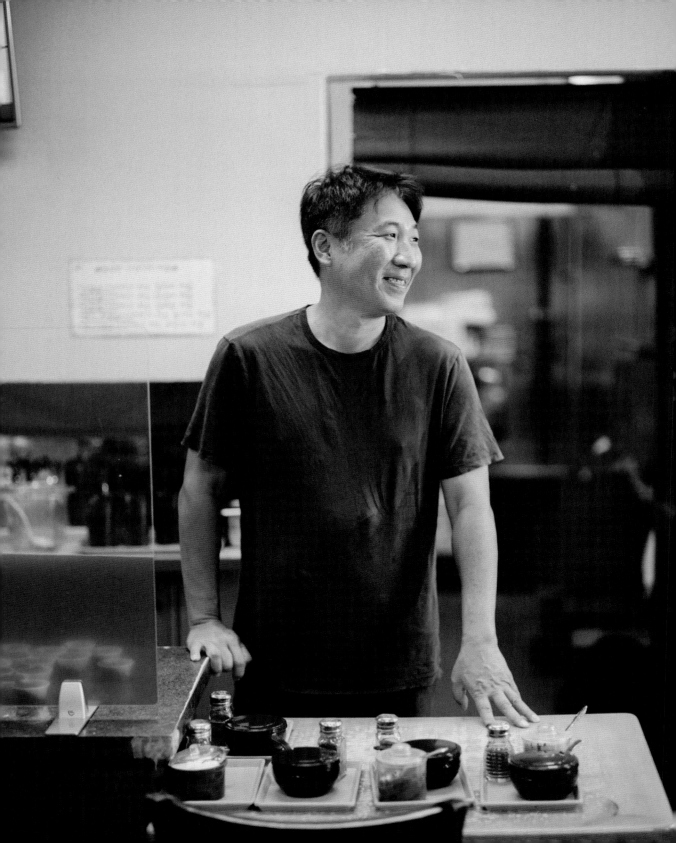

HAN BAT SUL LUNG TANG

JOHN HAN
4163 W. 5th St., Los Angeles, CA 90020

HAN BAT IS A THIRD-GENERATION SEOLLEONGTANG (OXBONE SOUP) restaurant that has achieved cult status in Koreatown. In 1953, the original restaurant was founded by John's grandmother in the South Korean city of Daejeon, colloquially known as Han Bat (meaning "large field"), where the recipe was developed. John's parents then opened the next Han Bat in Seoul and ran it for many years before bringing the restaurant stateside in 1987. They have been in business at the same location for thirty-four years.

The restaurant grew entirely through word of mouth from the beginning. Han Bat quickly became a mainstay among the Korean community who craved their comfort food. Over the years, Han Bat's clientele diversified, and John mentioned that about half of his current customers are non-Korean. John, ever so humbly, suggests that the one legacy that they are proud to leave behind was that they were able to introduce seolleongtang to an American audience.

The family still runs the business every day—John's parents arrive at the store at 4:30 a.m. to make the broth. Despite their old age, they insist on working. John admitted that his parents still make the best broth because of their son-maht, which literally translates to "the taste of one's hands"—that's the secret ingredient of Han Bat. He and his brother have tried to replicate the same recipe and taste, but they're always slightly different. His brother comes over around 7 a.m. and works until noon. John then takes over from noon until closing time.

John mentioned that when you work a repetitive job, the years seem to fly by, and he would be astounded once in a while to see children he had served in the past all grown up now. While he hopes that Han Bat can continue on to the fourth generation, he does not want to pressure his children to take over. He just hopes that he can continue serving his customers for a long time.

DAN SUNG SA

CAROLINE CHO
3317 W. 6th St., Los Angeles, CA 90020

CAROL STARTED DAN SUNG SA IN 1997, INSPIRED BY THE POJANGMACHAS (street food stalls) she frequented in South Korea. The restaurant is named after the first Korean theater that opened in Seoul after the Korean War. She wanted to create the first pojangmacha in L.A. for the then-small Korean community to have a "home away from home." Since then, it has operated seven days a week, 365 days a year. Dan Sung Sa became a communal place for corporate employees, night-shift workers, friends, and families. Carol recounted the times when family members would unwittingly bump into one another, not knowing that they were sharing the same space.

The restaurant closed for the first time when the lockdown was enforced in March 2020. It was an extremely tough year for Carol, who suffered anxiety and panic attacks, worried that the establishment would have to close and put its employees out of work. The kitchen staff are a tight-knit family, some of whom have worked for more than twenty years at the kitchen. Through it all, Carol is thankful that the business survived, for the constant support in her community, and that many of her employees can work again as COVID-19 restrictions ease and indoor dining is possible again.

Her message is this: We are always humble and always here to serve—4 p.m. to 2 a.m. every day. All she wants is for people to get a taste of Korea and feel like they're transported to a special place. If she could just create the same atmosphere and experience for her community for the next twenty years, it would be enough.

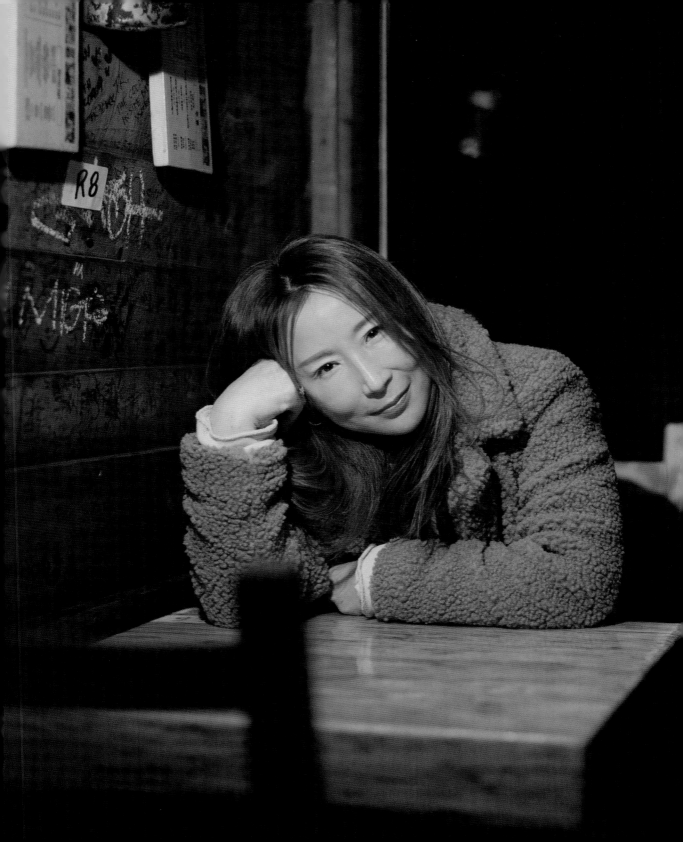

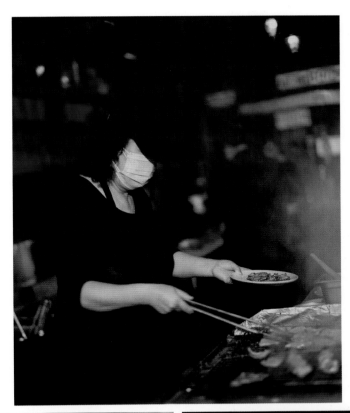

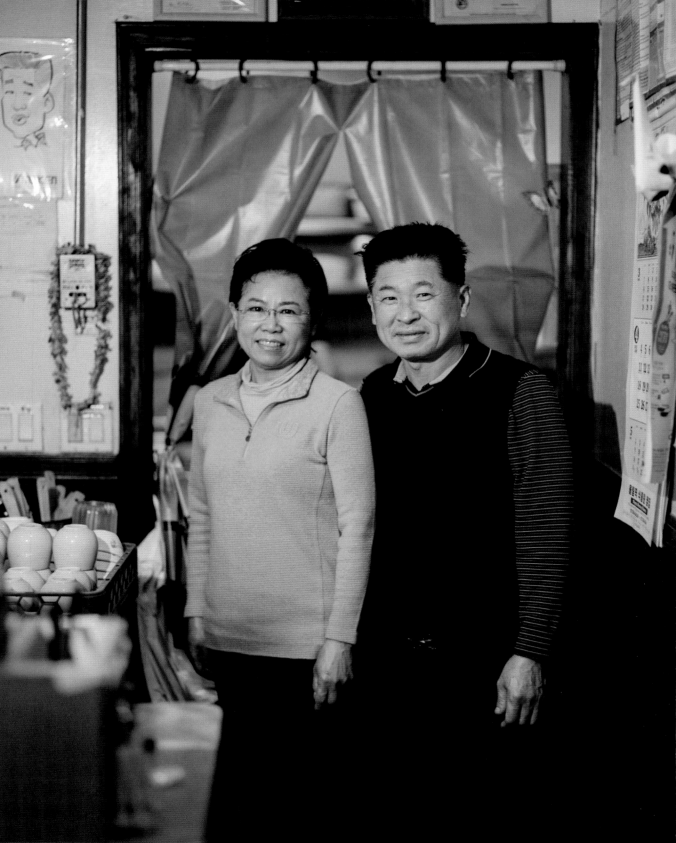

SUN HA JANG

YOON HO YU AND YEON JONG YU
4032 W. Olympic Blvd., Los Angeles, CA 90019

MR. AND MRS. YU MET WHILE WORKING AT A RESTAURANT CALLED HOBAN in the '80s. Mr. Yu was working in the kitchen and Mrs. Yu as a server. After they got married, they saved up some money and started a galbi (rib) stew restaurant, which they operated for many years. Following that, they pivoted to Korean beef barbecue when such restaurants were still sparse in Koreatown. As BBQ places started popping up, the couple had to pivot once more and eventually decided to specialize in duck meat. Today, they are one of the few duck specialty restaurants in Koreatown and one of the most acclaimed, with regular celebrity visitations. But they don't kick up too much fuss about it.

Mr. Yu mentioned that Koreatown is rife with competition and you have to be constantly on your toes. The Yus had to pivot to specializing in duck meat because the beef BBQ market was too saturated. So, for days and nights, the husband-and-wife team spent countless hours in the kitchen, perfecting the recipe and making their own banchan (side dishes) from scratch. Mr. Yu mentioned that because there are so many restaurants in K-Town, at Sun Ha Jang you really have to offer something that no one else can. You have to innovate to survive.

While they were running the kitchen for decades, their children grew up in the restaurant with them, doing homework in the basement and helping out when they could. It's been a hectic life, but Mrs. Yu is grateful that their restaurant is doing well, despite their lack of marketing. She says that in America, no one cares what you do; you can succeed in any field as long as you put your mind to it.

The restaurant life is grueling—the Yu family regularly works fourteen- to sixteen-hour days and rarely takes breaks. Still, they're proud of what they've built and feel a sense of responsibility to their regular customers. While Caroline has been helping out with the restaurant during the pandemic, Mrs. Yu does not want to see her take over the business. At the same time, it would be a shame to sell her life's work to a stranger. This is perhaps a common dilemma for many immigrant-founded restaurants.

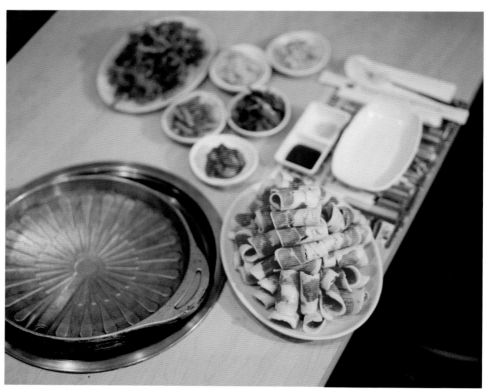

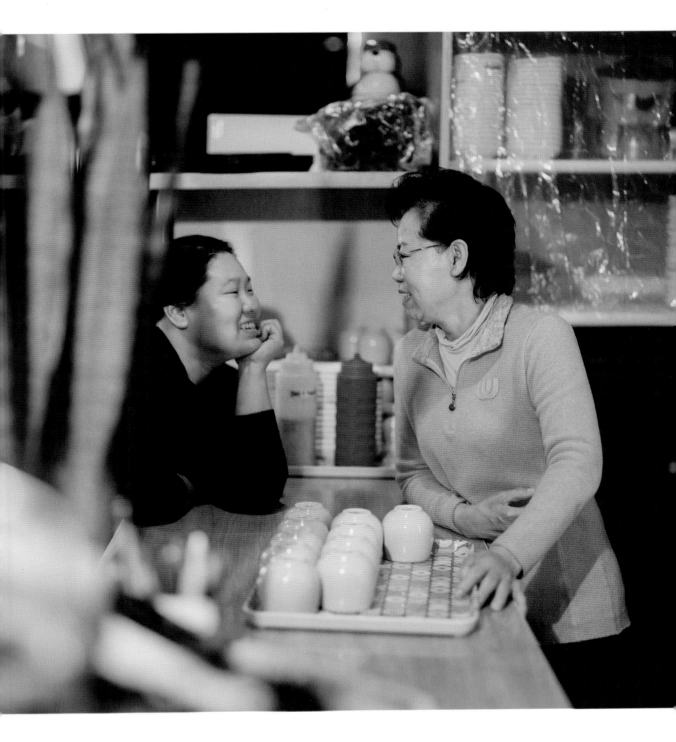

HAM HUNG RESTAURANT

SAMUEL OH

3109 W. Olympic Blvd., Los Angeles, CA 90006

HAM HUNG RESTAURANT WAS STARTED IN 1985, SERVING NORTH KOREAN— style naengmyun. Samuel Oh took over the restaurant from his father in 1998. He had been working as a chiropractor until then for fifteen years. When he took over, Oh did not know anything about running a restaurant, so he had to learn from scratch. The restaurant still uses original custom-made machinery from 1985. Oh's family built it themselves because they were determined to get their noodles to be a specific consistency and weight.

Making naengmyun requires precision and good timing—the noodles have to be boiled quickly and then rapidly cooled to keep them bouncy and chewy. Their specialty is a spicy soupless version—bibim-naengmyun, coupled with barbecued L.A. galbi. Oh's mother still shows up every morning to help make the sauces. When asked about the future, he said he was not averse to closing because that was the way of life. But he was more concerned about having a purpose every day in retirement. His motto in life is that as long as you wake up every day, that you get on with life and do the things that you have to do. If things fall apart, you have to put them back together.

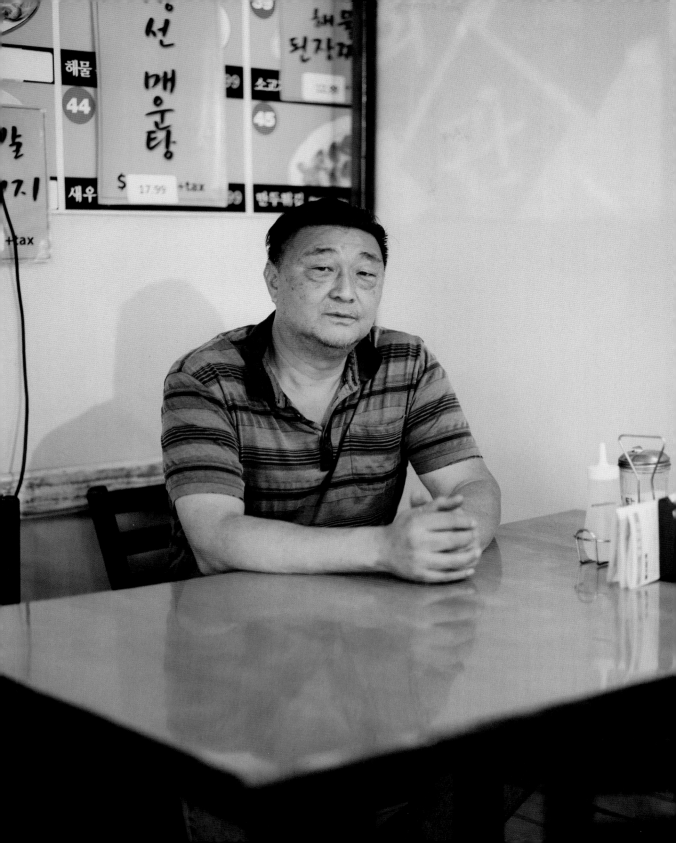

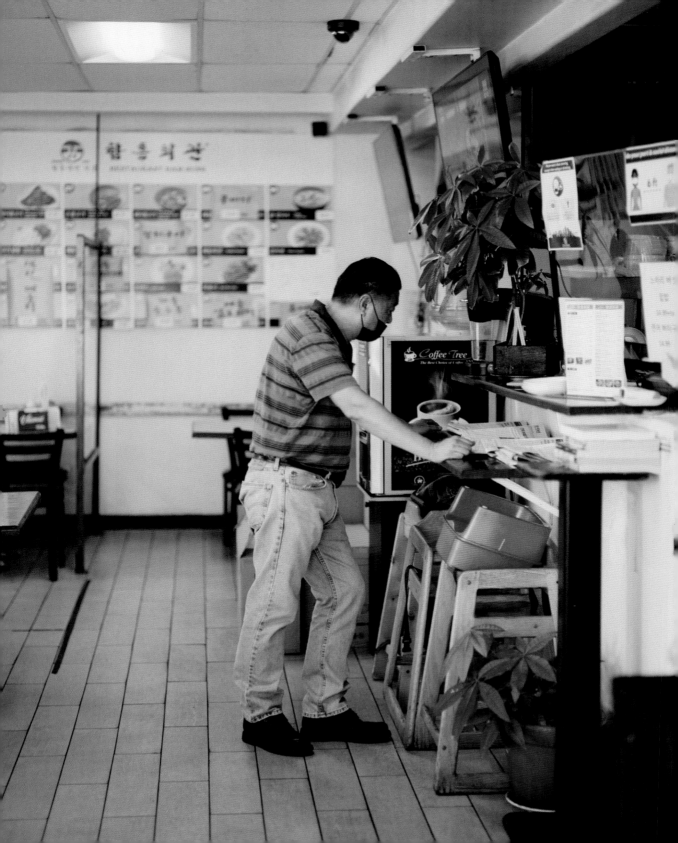

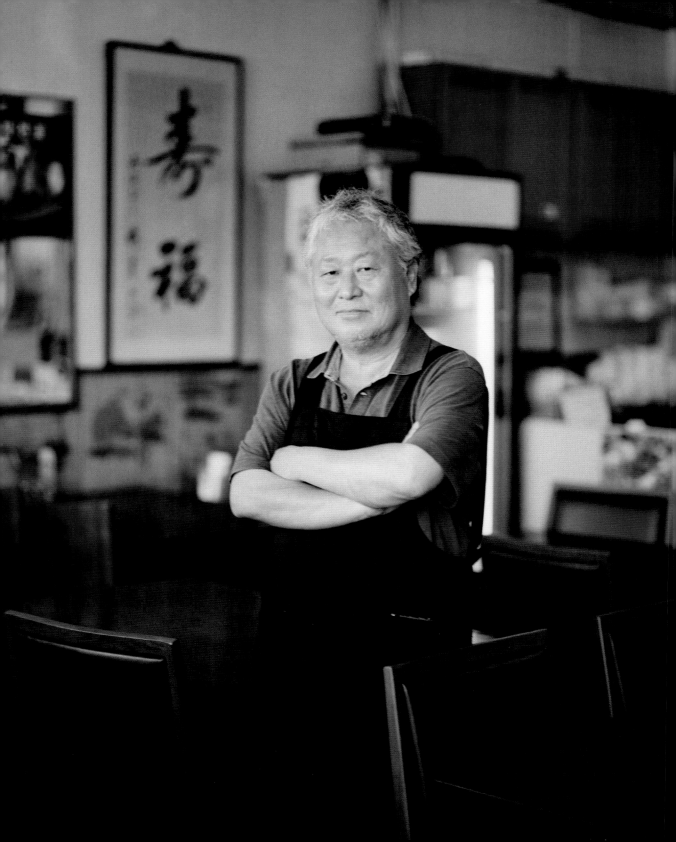

UMMA JIP

DONG JU JANG
장동주
3126 W. 8th St., Los Angeles, CA 90012

UMMA JIP OPENED IN 1985 WHEN THE NEIGHBORHOOD WAS A HOTBED of gang and drug activity. The third owner, Dong Ju Jang, recounted many customers who came in to eat late at night after partying because his restaurant was open twenty-four hours a day. Over time, the neighborhood changed and the clientele diversified, and these days many of the customers are Hispanic, as reflected by the menu signs in Spanish.

In the 2000 dot-com crash, the area suffered greatly, and there were numerous Korean beggars in the area. Jang created a menu item of seolleongtang and sold it for $2.99 so that people could afford a decent meal. He remembers wanting to feed people because there were so many people struggling. It's one of the things he's most proud of in his time as the owner of the restaurant. He raised the price by a dollar every few years to make it affordable for the restaurant, and it currently stands at $6.99.

양곱창볶음 $24.99
김치 전골 ？？.99
돼지갈비
꽁치조림 $17.99

＃ Nuevo Menu (새 메뉴)
Olla Caliente de kimchi
de Costillas de Cerdo,
- 묵은지 돼지갈비 전골 -
$33.99

-NEW MENU
돼지 갈비 김치
찌갑담
$33.99

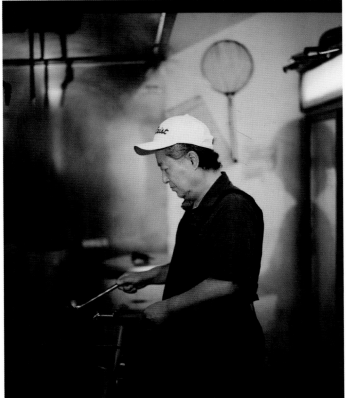

CHUNJU HAN-IL KWAN

AUDREY JANG
3450 W. 6th St., Los Angeles, CA 90020

IN 1992, AUDREY JANG FOUNDED CHUNJU HAN-IL KWAN, NOW ONE OF the oldest restaurants in Koreatown. After immigrating to the United States in 1990, she quickly set her mind to learning about the restaurant business so that she could start her own. After working in another kitchen for a couple of years, she developed a menu around budae jjigae (army stew) and bought out the space of another restaurant, the classic wooden interior of which remains the same. While growing up in South Korea, she frequented a restaurant that specialized in budae jjigae, and after experimenting and making her own version, she realized that she had a hit on her hands, as evidenced by her neighbors' effusive praise. By offering budae jjigae on her menu in the early '90s, she believes that she effectively introduced the dish officially to Americans for the first time.

In the beginning few years, the surrounding area was dangerous, to the point where people would wait inside her store before getting picked up. The restaurant faced intense competition from nearby food offerings, and Ms. Jang barely broke even every month. But over the years, as their restaurant grew in popularity for its consistent food and late-night availability, Chunju Han-il Kwan is now a go-to destination for both older regulars and the nightlife-loving youngsters. Even as new Korean restaurants change their menu to feed a more diverse palate, her recipes have remained consistent since the beginning. As she thinks about the future, she is reluctant to pass the restaurant on to her daughter because she knows the physical and mental toll it has taken on her. She doesn't think the next generation has the resilience to maintain and run a restaurant.

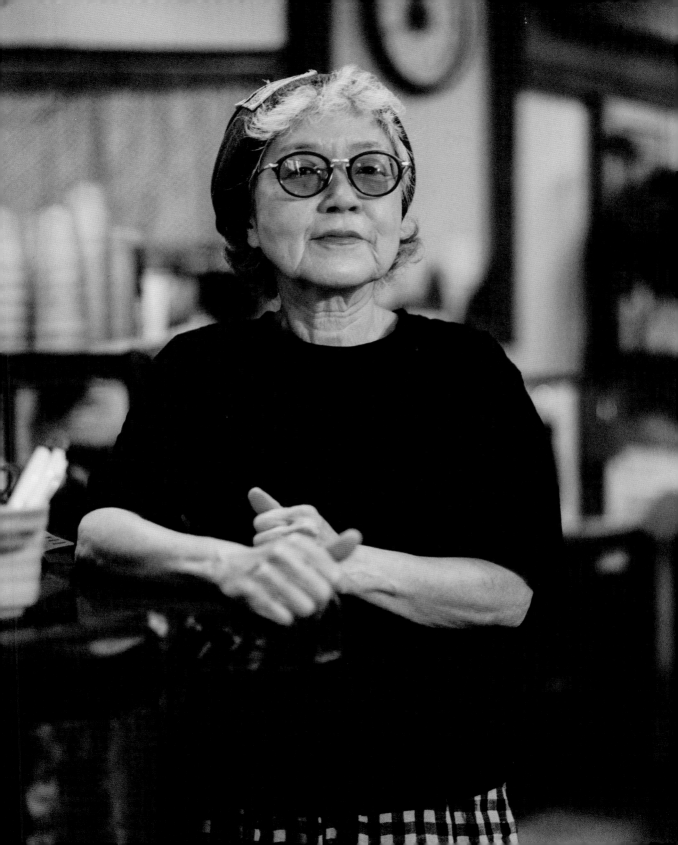

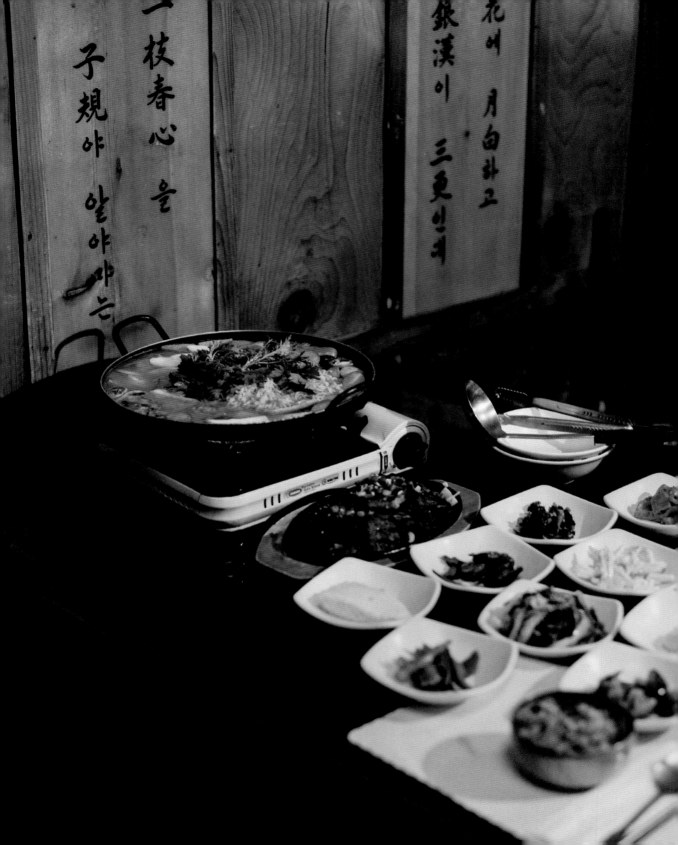

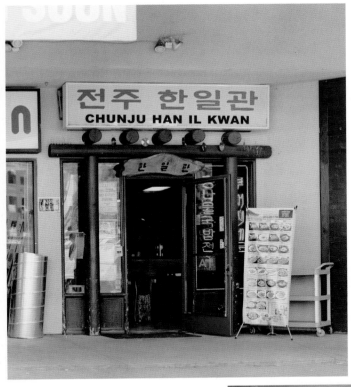

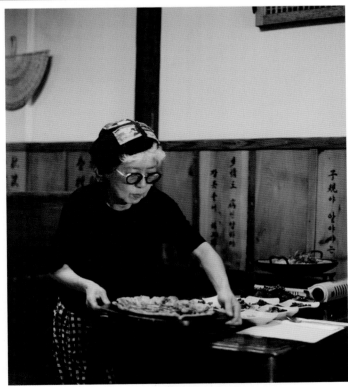

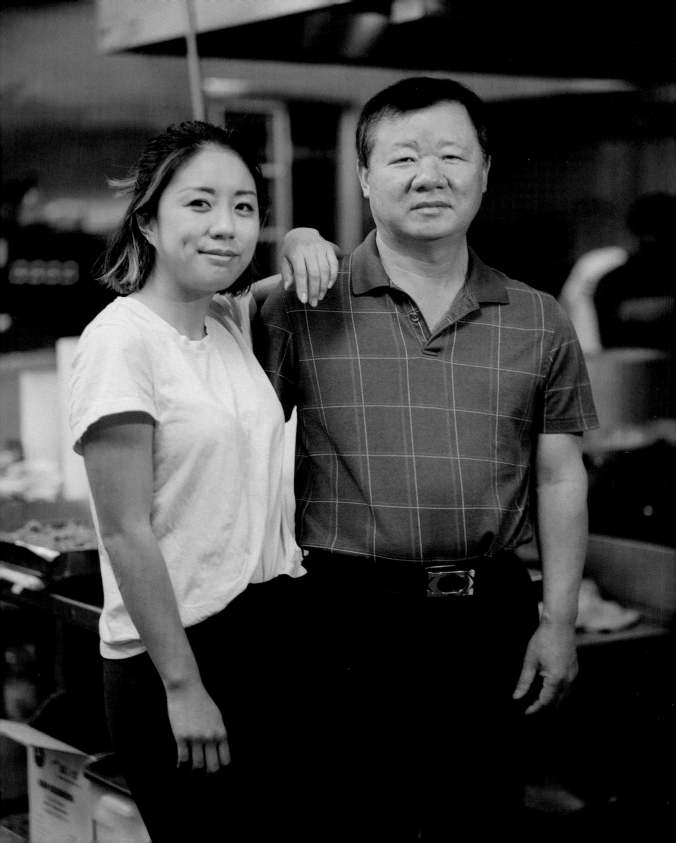

MDK NOODLES

CHUL HEAY SHIN AND STELLA SHIN
3630 Wilshire Blvd., Los Angeles, CA 90010

MDK NOODLES IS A KOREATOWN ESTABLISHMENT SERVING THE FINEST kalguksu, dumplings, and kimchi. A few months before the pandemic arrived in the United States, Stella took over the restaurant from her father with a bold ambition to expand to Houston and beyond. Within a few months, with lockdown arriving, MDK closed for several months, incurring recurring monthly losses because of steep overhead costs. Stella had to take out loans to keep the family restaurant going, even taking on a second job to pay for her own expenses. The pandemic forced Stella to be creative and resourceful. When outdoor dining was allowed last summer, the restaurant shifted to an outdoor pocha and bar concept but had to abruptly stop because of noise complaints from neighbors. Stella described the infuriating stop-start nature of pandemic dining and inconsistent messaging from Governor Newsom as the most challenging part. With the latest reopening of outdoor dining, many loyal customers have returned, but business is still slow. Despite this challenge, Stella is optimistic for better days to come.

CHOSUN GALBEE

KYONG M. JI
3330 W. Olympic Blvd., Los Angeles, CA 90019

KYONG JI MOVED TO THE UNITED STATES IN 1979. AFTER OPERATING A successful soup restaurant for seven years, in between other endeavors, she eventually opened Chosun Galbee in October 2001. Today, Chosun Galbee is one of the premier Korean barbecue restaurants, known for its consistent high level of service and serving a diverse clientele. Ji credits her success to her borderline-foolish bravery and can-do spirit. When the lot where her current restaurant resides was available for purchase, Ji did not blink twice at the steep price and took out enormous loans to secure the location and hire architects to design a beautiful space.

She recounted the trials and tribulations of running such a huge operation (she employs more than one hundred employees) as immigrants and admitted that opening the restaurant was the hardest thing she had ever done. When the pandemic hit, she was bleeding hundreds of thousands of dollars a month, and she had to dip into her personal funds to keep the restaurant going. For many immigrants, there are no separate business and personal accounts because their stores are their lives. Ji said that all her sacrifice was worth it because she was able to give her children the lives that they wanted. Now, Chosun Galbee is back to business as a popular destination for diners looking for high-quality Korean barbecue.

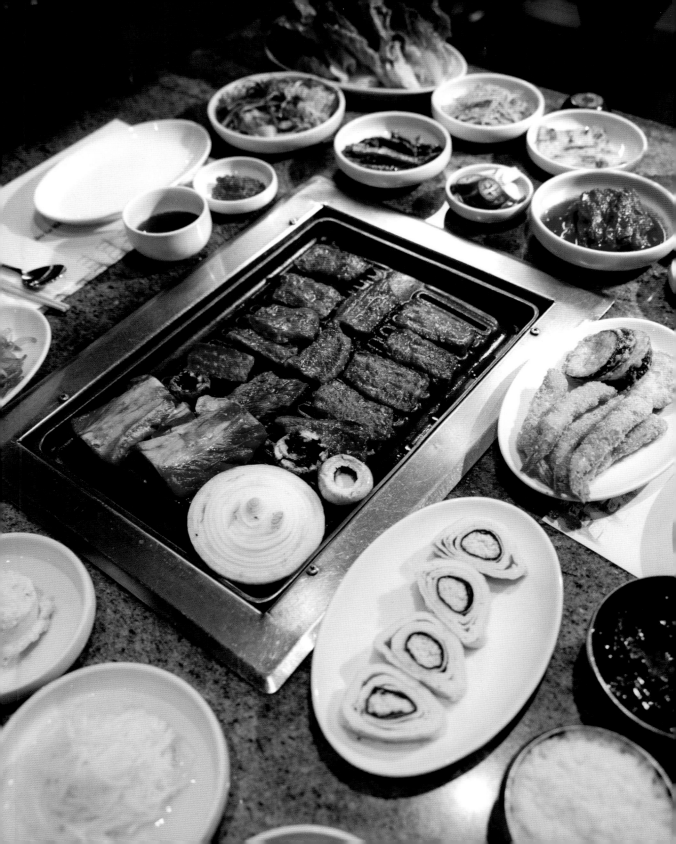

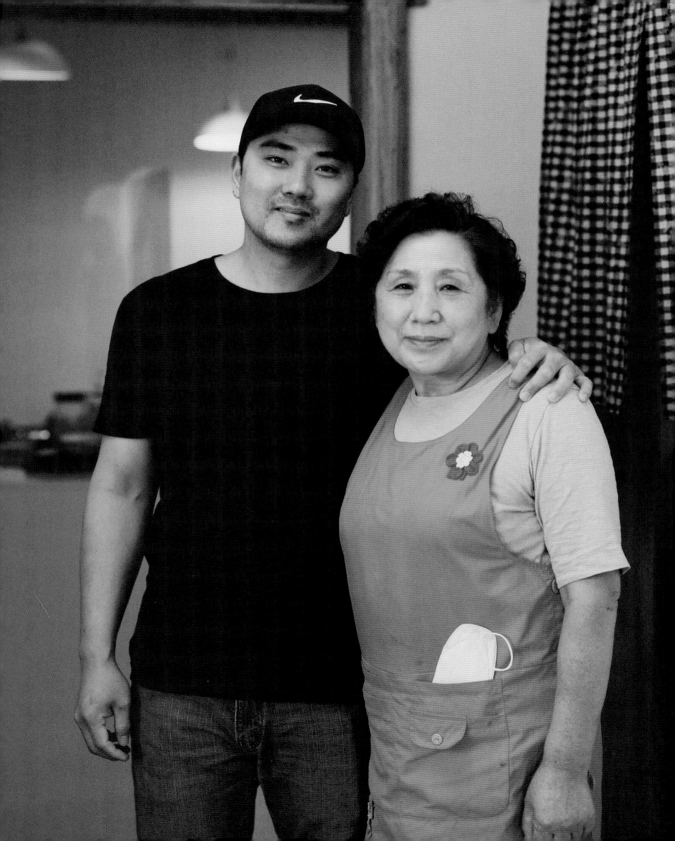

EIGHTH STREET SOONDAE

HYUNG SOON KANG
강현순

2703 W. 8th St., Los Angeles, CA 90005

HYUNG SOON KANG MOVED TO THE UNITED STATES IN 1988 BEFORE the Olympics began in South Korea. She worked at a Korean restaurant for a few months, where she learned how to make soondae (blood sausages). She started her own soondae restaurant on 8th and Ardmore, where the first few years were focused on figuring out her recipe and experimenting. One of her customers even offered to teach her how to make soondae in the early days. After nineteen years, she moved to her current location on 8th Street in 2007.

Given the laborious effort required to make soondae, Kang and her team make all the sausages by hand at night after the restaurant closes. Most days, she works fourteen- to sixteen-hour days. When her husband passed away in 2002, her parents-in-law came to help with the business for five years before returning to Korea due to old age. Her son is planning to take over and has started to assist with day-to-day operations.

SISTERS DUMPLING

IRENE KIM
1032 Crenshaw Blvd. Unit B, Los Angeles, CA 90019

SISTERS DUMPLING HAS BEEN AROUND FOR TWENTY-SEVEN YEARS, although the ownership has changed four times. Irene Kim, the latest owner, took over in June 2019, committed to keeping the same recipe as the original owner's. Irene's family had worked for more than thirty years in the textile manufacturing business and decided to move into the restaurant world after the clothing industry slowed down in recent years.

Dumplings are comfort food that people keep returning to—for many people, the taste of dumplings reminds them of their mothers. Dumplings are a staple in Korean cuisine, especially during special occasions like New Year's and Mid-Autumn Festival. All the dumplings are still painstakingly handmade in house by a group of older ladies, some of whom have been working there for more than twenty years. The owners taste-test all the ingredients and dumplings daily to ensure the quality is up to standard. In addition, frozen dumplings are available for sale.

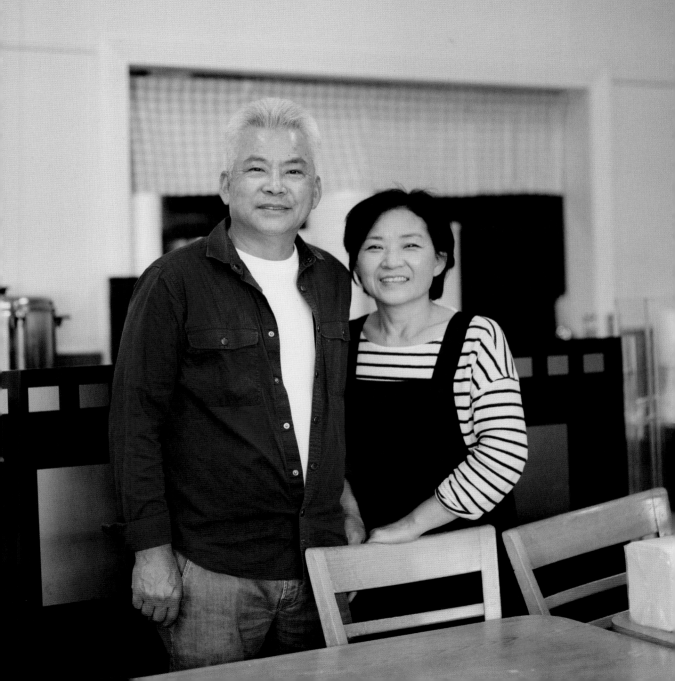

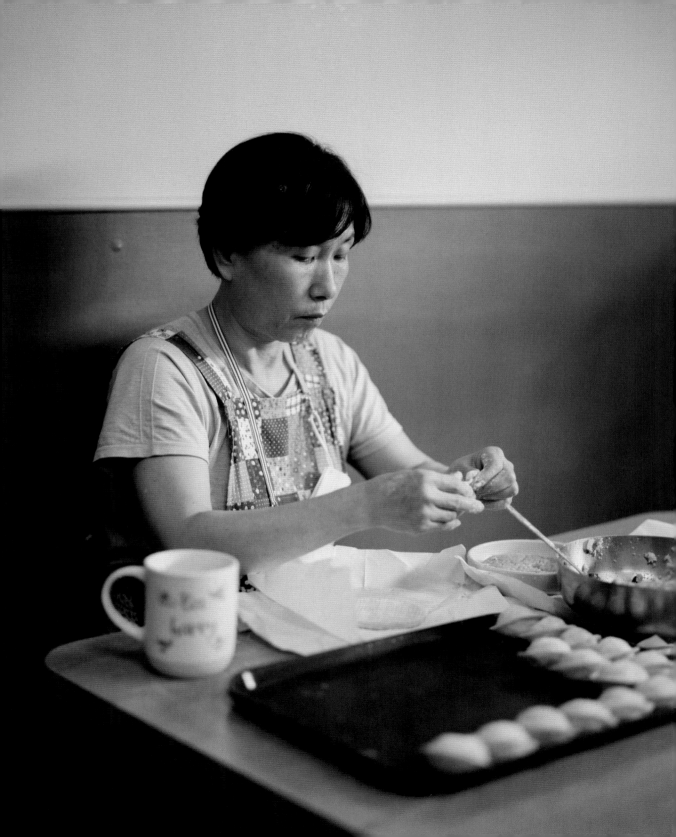

ESCALA

OG CHINO
3451 W. 6th St., Los Angeles, CA 90020

ESCALA IS A COLOMBIAN-KOREAN FUSION RESTAURANT FOUNDED BY OG Chino, whose story would require an entire book to tell. OG Chino, raised in both Colombia and Los Angeles, is a multihyphenate entrepreneur and music producer and in a way is a reflection of the diverse mosaic that is Koreatown. When OG Chino grew up in L.A., he hung out with the Mexican community, given that Spanish was pretty much his first language. Growing up in Koreatown, OG Chino got into a lot of trouble as a teenager because of drug and gang activity.

As the hip-hop scene grew in his early twenties, he moved to Dallas first, where he hung around with musician Erykah Badu's crew, and then on to New York, where he lived for seventeen years. As the industry evolved, OG Chino contemplated his next move and had an opportunity to open a bar in the famed Chapman Plaza in 2013. A family friend wanted to keep the space in the hands of an independent operator, instead of another chain store like Starbucks, which had just opened next door. OG Chino always wanted to run a bar, and he expanded his idea to offer food that reflects his multivariate life experiences. For him, Escala was a homecoming moment to return to his roots and contribute back to the community that raised him.

GOL TONG CHICKEN

KIL CHAE JEONG
361 S. Western Ave. #101, Los Angeles, CA 90020

STUBBORNNESS IS A TRAIT OFTEN ASSOCIATED WITH KOREAN SMALL business owners; it might actually be a quality necessary to endure the vicissitudes of running a business. Kil Chae Jeong, chef and owner of Gol Tong Chicken, is perhaps the epitome of stubbornness and idiosyncrasy. He started off as an entrepreneur in K-Town in the early '90s, made his fortune and took that to Korea to direct a few movies, lost it all, and then returned to run a one-man fried chicken joint in a nondescript store on Western and 4th. Here is a man who so stubbornly forged his own path in the unwavering belief in oneself that he earned the moniker "Gol Tong" director, which translates to being mercurial and stubborn. In some ways, he is more American in his individualism than anyone else, a breaker of the model minority myth since the '90s.

When his movies in Korea flopped, Director Gol Tong was at the lowest point in his life and contemplated suicide. However, he quickly found his feet, and when he saw a TV program one day on making fried chicken, he thought it would be easy and decided to give it a shot. With some proceeds from his last movie, he opened up a fried chicken restaurant in South Korea that grew incredibly popular. Not content with that, he decided to forge his own path, moving back to L.A. to start a fried chicken joint where he would have complete creative control. Gol Tong Chicken offers a menu that's unlike anything you've seen—soy garlic fried chicken topped with blueberries, pineapples, avocados, and cheese; flavors that cause an unexpected gestalt in your mouth.

One might wonder why a man advanced in his years would put his body through that stress seven days a week. But I think his compulsion to work in a way that is uniquely his is an embodiment of a way of life and worldview of many Korean immigrants. Many Korean immigrants became small business owners so that they can maintain some sort of control over their destiny—they made it wholly their own and took no nonsense from others. Perhaps being "Gol Tong" is a unique trait of all Korean immigrants.

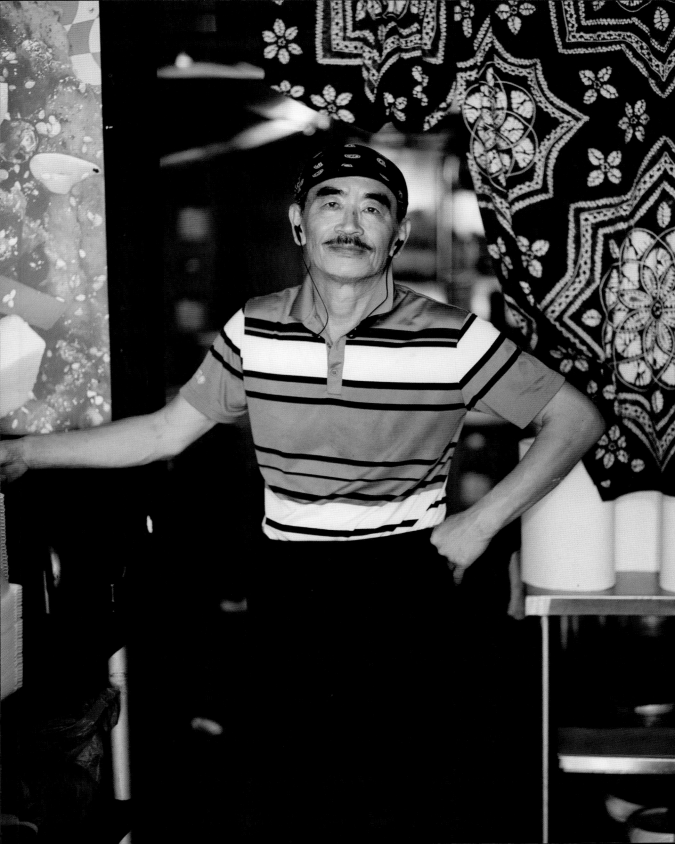

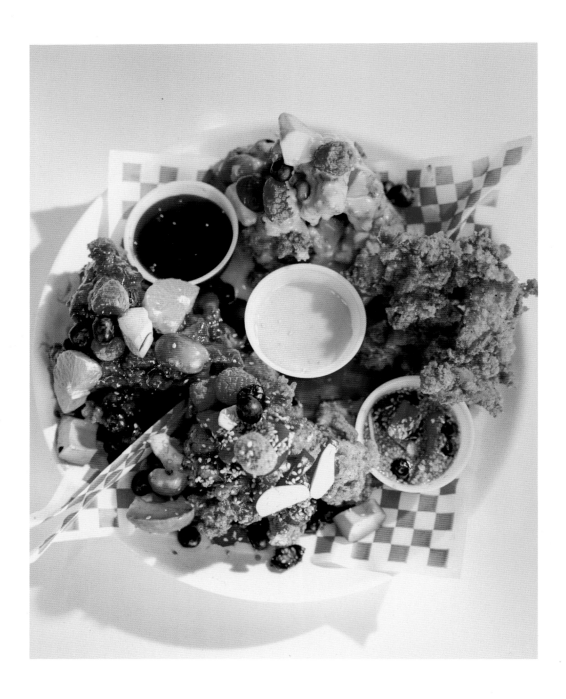

SURAWON TOFU

SUNNY LEE
2833 W. Olympic Blvd., Los Angeles, CA 90006

JOUNG AND ESTHER LEE ARRIVED IN THE UNITED STATES IN THE MID-eighties and started and operated a few iconic Korean restaurants, including Price, Shilla Buffet, and OB Bear, that they eventually sold. As serial restaurateurs, the couple built successful businesses and eventually ended up starting Surawon, specializing in seolleongtang (ox bone broth soup), intending it to be their swan song. Their hard work enabled their two daughters to attend prestigious universities and work in professional fields like law and psychology. Much to their surprise, Sunny, their oldest daughter, expressed an interest in taking over the restaurant and leaving her mark in the crowded food world of Koreatown. Joung remembers being vehemently opposed to that idea and literally barring Sunny from entering the restaurant.

For Sunny, food was always a big part of her life. When she attended university, her walls and desks were covered with recipes, and she would frequent restaurants to satiate her curiosity about different foods. She credits her refined palate to her mother's home-cooked meals growing up. Her mom recalls an incident when Sunny visited her friend's house and complained about the bland kimchi jjigae, offering to cook it herself. After graduating from college and working as a school counselor, Sunny began experimenting with soondubu and perfected her recipe. Even her mother's adamant resistance broke down when she tried Sunny's home-cooked meals. In 2016, Sunny fully took over the restaurant and has been preparing every single dish of soondubu herself. For her, every percentage of an ounce of an ingredient makes a difference, and she is steadfast in cooking every dish herself, her trait of diligence no doubt picked up from her parents.

When I asked Esther how she learned to make food in the United States without any prior experience, she mentioned that her own mother was renowned in her town for making delicious food. She remarked that being raised with a refined palate was a gift that enabled her to succeed, a gift she has passed on to her daughter.

JINSOL GUKBAP

BOK KYUNG KIM

4031 W. 3rd St., Los Angeles, CA 90020

JINSOL GUKBAP IS A RELATIVELY NEW ENTRANT IN LOS ANGELES THAT has quickly cemented its place as one of the most beloved comfort food restaurants among the locals who are in the know. The restaurant, started in 2016, specializes in dwaeji gukbap (pork broth soup) that originated from South Korea's southern coastal city of Busan. Bok Kyung Kim followed her daughter to support her when she initially moved over to study. When she grew bored of idling around, Bok decided to start Jinsol Gukbap as a way to pass the time, and soon her husband, a retired police officer, joined to run the operations.

The term *jinsol* speaks to the integrity and purity of the broth that is served—there are no preservatives or additives, just a whole lot of time and dedication. The pork broth derives its rich flavor from the constant boiling and simmering of pork bones and other ingredients. The fire in fact runs 24/7, reflecting the nonstop lives of immigrants who are constantly moving to eke out a living for themselves.

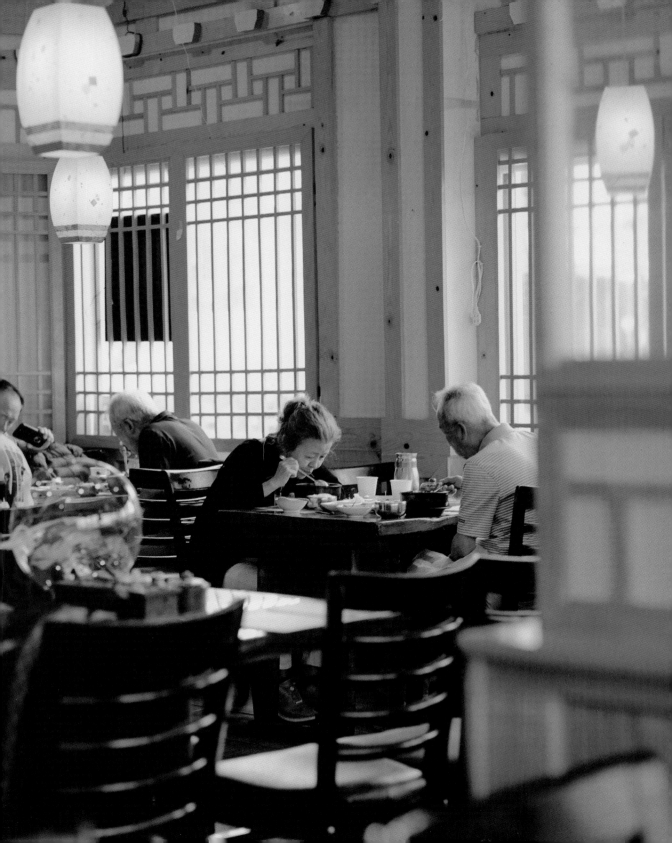

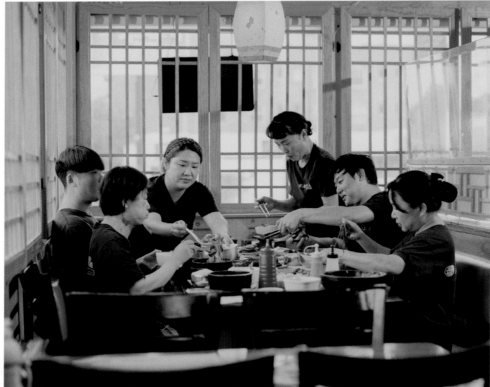

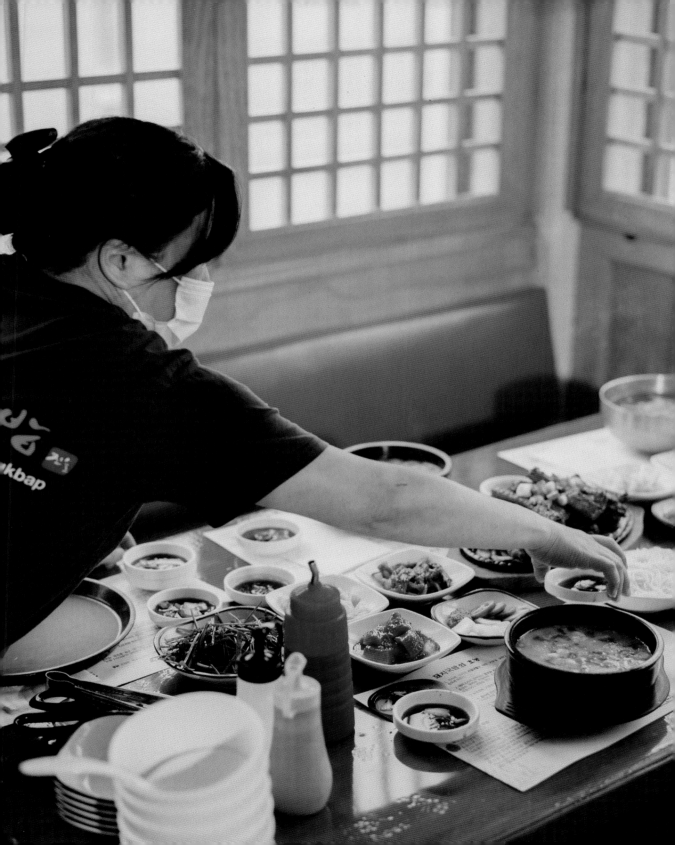

CHECK INS AND
MIC RETURNS
ARE DONE AT THE
REAR BAR.

ENCORE FAMILY KARAOKE
(DALLAS, TX)

JIN SHIN
11433 Goodnight Ln., Dallas, TX 75229

ENCORE FAMILY KARAOKE WAS FOUNDED IN 1999 AS PART OF AN EARLY wave of Korean immigration to Dallas. Jin Shin was a regular in the space and recalled spending countless nights singing karaoke with friends during his younger years. When the original owner passed away, his wife reached out to Shin, who then offered to buy the business from them. He knew how important the spot was to the Korean Dallas community as well as to him personally, and he felt compelled to continue its legacy. After taking over, he made some adjustments to cater beyond just Korean customers to reach the wider Dallas population. Over the years, the business accommodated everything from birthday parties to hackathons and has even been used as a cultural space for people to learn about Korean culture. Shin, who passed away in August 2022, was known as a pillar in the community, bringing people of different backgrounds together, with Encore Karaoke at the center. To Shin, karaoke appeals to Koreans because it's one of a few places in their busy lives where they're allowed to just be. After grueling hours of work in pursuit of the American dream, karaoke offers a fun way to let off steam and be in touch with one's emotions; the free-flowing drinks help as well.

Today, Encore Family Karaoke remains a beacon of old Koreatown, in the Garland neighborhood of Dallas, even as newer Korean and Asian communities have moved into more-affluent parts of the city like Carrollton. Shin took pride in being among the first wave of about two thousand Koreans in Dallas, back when everyone knew one another by name. While he faced intense racial prejudice growing up, he was surprised to find that today, many Texans embrace Korean culture. Asian kids these days have it on "easy mode," he said, seeming to revel in that fact.

CONCLUSION

THE FUTURE OF KOREANS IN AMERICA

IN RECENT YEARS, KOREAN IMMIGRATION TO THE UNITED STATES HAS slowed as there are fewer economic and political incentives for Korean nationals to emigrate. The total Korean immigrant population dropped by 5 percent between 2010 and 2019, indicating fewer recent immigrants entering the country. This decline means the future of the Korean population in the US will largely be determined by naturalized and US-born Korean Americans. This group's tastes, desires, and decisions will chart the future of places like Koreatown and other areas with significant Korean populations. We will start new businesses and organizations, becoming artists and policy makers and so on, with our own convictions and beliefs that have been informed by a Korean upbringing in an American landscape.

As immigrant generations age and neighborhoods change, documenting the histories that have occurred in these places has become paramount. In an era of heightened racial discrimination from various pockets of bigots in this country, telling our stories makes the case that we've been here and will continue to be here, because this is our home, too.

As a Korean American who has a stake in this country for many more years to come, my most meaningful work has been to help cement Asian Americans' place in the American narrative. Asian Americans have always held a tenuous position, othered in both seemingly complimentary ("model minority") and unabashedly derogatory ("gook") ways. Storytelling has been, for me, the antidote to ignorance and a way for me to connect with other people. I hope this book plays a part in the larger story of what it means to be Asian American in a country that, for all its faults, I am still proud to claim.

EPILOGUE

BY JON "DUMBFOUNDED" PARK

WHEN I WAS IN MY LATE TEENS, DURING THE LAST LEG OF MY first-ever rap tour, I got my first tattoo: KOREATOWN in Olde English font across my scrawny bird chest. It was bold and aggressive, which made me avoid water parks for a good few years. It also didn't help when I wore V-necks and you could only see the middle three letters—"EAT"—but I couldn't think of anything else to permanently get on my body that would represent me for a lifetime.

That tour experience provided an eye-opening glimpse of thirty different cities across the United States. During my travels, I soon realized how lucky I was to be from K-Town, a place where Koreans wear their culture on their sleeves. In each city, I would hear the same stories from different Asian kids about being the token Asian in their town and how shocking it was for them to see someone like me on stage. I attributed my confidence to my K-Town upbringing, being raised around unashamed, unapologetic AZNs chain-smoking Parliaments in parking lots while in kimchi squats. I was never one of those kids, but looking back, I admire them.

As a latchkey child, I was raised by the city—and I literally mean like every part of L.A. I was skating with Latino kids from Pico-Union, rapping with Black kids in Leimert, and partying with white kids in Silverlake and Hollywood. But my home base was Koreatown. The neighborhood always drew me back to my roots, whether it was through family, food, the businesses—and of course the FOBs, respectfully.

But as I was growing up, there was a time when I didn't like K-Town. My family landed here to pursue the American dream—a dream that I felt ultimately tore our family apart. And I blamed K-Town for it. Working fourteen-hour days, my father fell into heavy drinking and gambling. My parents constantly fought, and my mom fell into deep depression, which left me and my younger sister to fend for ourselves. I was jealous of immigrant success stories like the Forever 21 family empire, with whom our family attended church. (I definitely should've married in.) I couldn't help but feel

like my parents had failed in their pursuit of a better life. As I started pursuing a career in entertainment, a large part of what fueled me was this goal of finishing the job my parents couldn't.

But what I considered my parents' failure was actually their sacrifice; through my resentment, it took me a while to understand that. My parents had given up so much—not only what they left behind in the motherland but also, most importantly, any time for themselves. Terms like "vacations," "therapy," and "mental health" were as foreign as they were.

For years, while I was so focused on my grind, I slowly realized that I was repeating history. My niece barely recognized me and even nicknamed me "Uncle Stranger." I was touring while missing out on loved ones' birthdays; and I was obsessed with my career while fooling myself into believing it would ultimately be for the greater good of our family's legacy.

Now, in my mid-thirties, I realize that there isn't a better time to let my parents know that everything they sacrificed was worth it. These days I don't put my life's value in money or success like they did at one time. I've chosen to live, actually *live* the life they've given me an opportunity to enjoy. I don't want my life to be consumed by work, hustle seminars, and Gary Vee podcasts. I want to show my love through actually being present.

I know a lot of kids from around here can relate to this story and feeling, so trust me: if you want to honor your parents' legacy, go out and live your truth and best life. *You* are their story. Go out into the world with everything this neighborhood has taught you, rip your shirt open, and proudly show off that KOREATOWN tattoo, if you have one.

ACKNOWLEDGMENTS

I AM IMMENSELY GRATEFUL TO EVERYONE WHO PLAYED A PART IN MAKING this book a reality.

To Ada Zhang, for believing in and advocating for this book so fiercely as well as the moral support to get the production over the line.

To the contributing writers—Katherine Kim, Lisa Kwon, Cathy Park, and Jon "Dumbfoundead" Park—for their invaluable perspective on Koreatown.

To Jiyoon Cha, my earliest advocate and design extraordinaire on the original version.

To David and Nicole Um, for their mental support and assistance in getting early connections to Koreatown small businesses.

To Gee Young Moon, for pushing me forward when I was burnt out.

To Lisa Danbi Park, for your friendship, support, and encouragement.

To Open Market, for their consistent support in the early days and giving me a platform to share my images in a public space.

To Digital Photo Printing and Studio, for their painstaking work on processing and scanning my photos. Feeling your support each time I dropped off my film meant the world to me.

To Richard Tranley, for your generous help in storing the original books, and willingness to help.

To Kim's Home Center, the OG Koreatown store, for your continuous support and love for the project.

And finally, to all the small business owners who made time to share their precious stories with me and trusted me to take their portraits.

INDEX

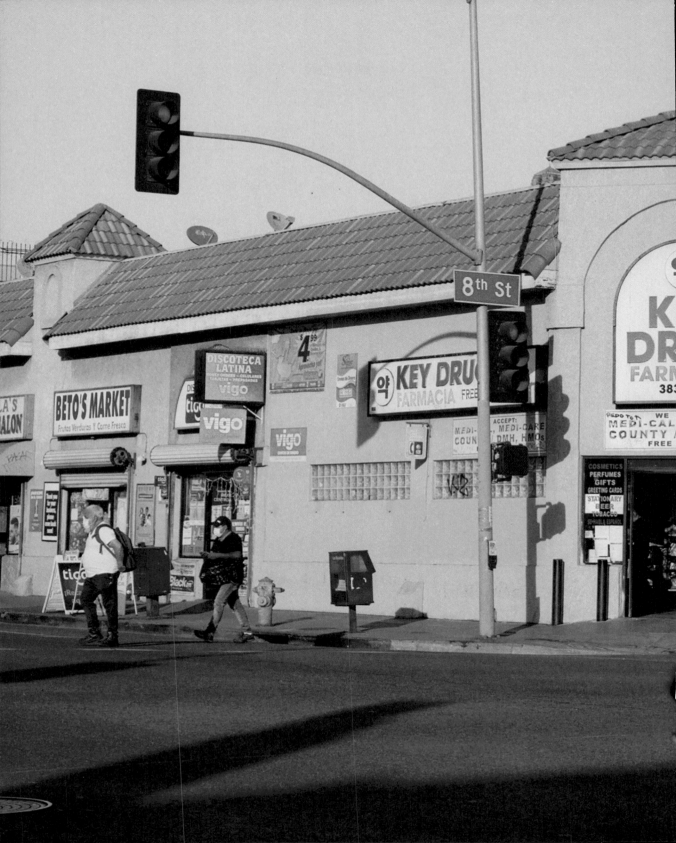